TEACH YOURSELF BOOKS

ANTIQUE FURNITURE

This book is intended not only as an introduction to the whole
subject of English Furniture but also as a guide to those 'collectable'
items that are within the reach of the man or woman of moderate
means. For this reason there is a detailed analysis of the furniture
made from 1800 up to the end of the nineteenth century. Through-
out, furniture is considered both from the aesthetic angle and from
the viewpoint of the practical conditions from which it evolved.

All interested in furniture, its origins and contexts, should enjoy this book: the amateur with the hope of knowledge and the expert without shame . . . A very good reference book to own.

Art and Antiques Weekly

TEACH YOURSELF BOOKS

ANTIQUE
FURNITURE

Ernle Bradford

ST. PAUL'S HOUSE WARWICK LANE LONDON EC4P 4AH

First printed 1970
Third impression 1974

ISBN 0 340 05933 8
Printed and bound in Great Britain for The English Universities Press Ltd
by Butler & Tanner Ltd, Frome and London

CONTENTS

LIST OF PLATES

Reproduced by courtesy of
the Victoria and Albert Museum.
Crown Copyright.

INTRODUCTION

Everybody, in one sense or another, is a furniture collector. Other aspects of collecting may be reserved for the rich, or for those with specialist tastes and aesthetic interests, but furniture is a necessity in every home. Inevitably there are those who can afford to take a connoisseur's interest in the masterpieces of furniture that come up from time to time in the great salerooms of the world. This book is clearly not for them, being intended as an introductory guide to the evolution of furniture in this country—from its humble beginnings to its glorious summer in the 18th century.

If the peak of English furniture craftsmanship was attained at some point between 1700 and 1800, it would seem natural that the greatest proportion of this book should be devoted to that period. It is not, for the simple reason that 18th-century furniture—except on a rare and lucky day—does not come within the reach of the ordinary citizen. Similarly, the antiquarian interest of early furniture (and sometimes its grand simplicity) is touched on comparatively briefly. More space is devoted to the furniture made from 1800 onwards than to any other period, for the good reason that this is the furniture with which most people come in contact on the few occasions that they venture into a saleroom or into an antique dealer's shop.

At the same time, for any understanding of antique furniture, it is essential that its early history be grasped. Why certain woods were used at certain times, how different styles of craftsmanship and design were evolved, and what influences were brought to bear on our native designers—these are matters which must interest the

man or woman who is concerned in buying furniture for a home. No matter whether it is a Victorian sofa that is being contemplated, a Regency 'carver' dining-room chair, or a china cabinet made about 1900, there is a lot to be said for knowing of what wood it is made, and what style (or styles) of design are shown in it.

The acquisition of knowledge about some art or craft is always pleasurable, but the acquisition of knowledge about furniture has the added attraction that it is practical. It is practical to buy for the home things that are attractive and of lasting value, just as much as it is pleasurable to appreciate the furniture in the magnificent collections to be found in private houses and public galleries throughout Great Britain. At the same time it is always wise to bear in mind those lines of Alexander Pope:

> A little learning is a dangerous thing;
> Drink deep, or taste not the Pierian spring.

The object of this book is to whet the appetite, but it is important to bear in mind that every subject touched upon here—from Tudor furniture to tea-tables—has occupied the attention of many specialists and antiquarians. It is safe to say that there is not a single object of antique furniture, however obscure, that does not have several learned monographs or even full volumes devoted to it. This is where at a later date, when the beginner begins to specialize, that a great deal of the excitement and pleasure begins. To track down elusive pieces, or to be able to date particular articles within a decade or so, is an enjoyable mastery. This is the moment when the apprenticeship ends, and the qualified understanding of the pleasures of furniture begins.

1970 E. B.

CHAPTER ONE

MEDITERRANEAN ORIGINS

Although the English and continental furniture which
interests the antique collector, the dealer, or the museum
official, stems mainly from the 17th and 18th centuries,
the history of furniture proper begins thousands of years
earlier. In ancient Egypt, in Sumer, and Babylon, and in
many other ancient civilizations, the craft of the furni-
ture-maker had reached a high degree of skill and artistry
when Western Europe was still inhabited by barbarians.
Most of the shapes, forms, and even styles, which would
appear in European furniture after the 16th century, had
been evolved in these early civilizations. Thus one finds
arm chairs, couches, beds and day-beds, stools and foot-
stools in the tombs of Egyptian monarchs. Some of the
most splendid of this early furniture was found in the
tomb of Tutankhamen.

At a later date, when the Greek and then the Roman
civilizations had penetrated the Eastern Mediterranean
and the Middle East, their artists and craftsmen copied
the work to be found in that part of the world. Inlaid
woods, the use of ivory, precious stones, and metals in
ceremonial chairs and thrones, were a feature of this
Eastern influence. But it would be many centuries before
the craftsmen of France, Holland or England would be in
a position to compete in terms of excellence with this
sophisticated craftsmanship.

The cultural desert which opened up for Western

Europe after the fall of the Roman Empire, coupled with the invasion of barbaric tribes from the north, meant that for centuries the craft of the joiner, let alone that of the cabinet maker, almost disappeared. In a primitive society—as can be seen in many parts of the world to this day—furniture has little or no place. Carving extends to statues of the gods, to weapons of war, war canoes and the like, but the interior of a mud-hut or a simple wooden shed does not demand furniture. In any case, furniture is a luxury, and in a world where there is no luxury it cannot exist. Kings or tribal chieftains may have one or two articles of furniture that are handed down from father to son, but the bulk of the population do not even have a bed, let alone comparatively sophisticated articles like wooden stools or chairs or tables. To the modern man, accustomed to regarding furniture as a simple necessity, it is difficult to conceive that it is indeed no more than a luxurious refinement. Just as life from birth to death can be lived without books, music, paintings or any of the arts, so too it can be lived without furniture. Civilization, as we understand it, is in all senses a product of a prosperous society. One of the first signs that a society is emerging from barbarism to civilization is the arrival of furniture upon the domestic scene.

It is hardly surprising, then, that for most people in Western Europe furniture as such did not exist throughout the long centuries that are sometimes loosely termed 'The Dark Ages'. It is true that at the far end of Europe, in remote Constantinople and the Byzantine Empire, the traditions, the culture, and the customs of ancient Rome were still carried on. There it was not only Emperors, the nobility, and the court who were used to elaborate

furniture, central heating, paintings and ornate interior decoration. The middle class trader also demanded, and got, a standard of comfort that was not known in England until the 16th century. Indeed, in many respects it was not until after the Industrial Revolution that the great majority of the British people attained a standard of living that had been known in Constantinople in the 10th century A.D.

As Avray Tipping wrote on *Interior Decoration* (1932):

> In the earliest middle ages domestic life, such as we understand it, can hardly be said to have existed at all. Furniture and equipments had to be of a kind convenient for transport from one place to another. They were solid and strong, and in number they were kept down to the indispensable minimum. Military equipment formed a large part of the travelling baggage. There was no question of a separate furnishing of each temporary abode. Above all, it was necessary for the owner to be able to hold what he had. His habitation was rather a strong-hold than a dwelling-house . . . [Mr. Tipping is here referring to kings, nobles, and chieftains. The peasantry on the land, and the soldiers who accompanied the leaders, were in no position to aspire even to 'long trestle-tables, easily movable for dancing or displays'.]

It was natural that in England, with its great oak forests, this native wood should have been used for the construction of such furniture as existed. From the middle ages right up to the 17th century, oak was the prevailing wood used for all forms of interior decoration and furniture. Hence, a convenient title for all this early work and for the period in which it was made is 'The Age of Oak'. Naturally other native woods such as ash, beech and elm were also used for complete constructions, or for simple inlay and decoration, but oak remained the basic wood for all kinds of work. In the middle ages this might range from trestle tables to the long permanent

table reserved for the lords and ladies. Except for folding chairs (of the familiar X-type which was an inheritance from ancient Rome) which were often made of metal, there were few chairs to be seen in the great hall of an Anglo-Saxon or even a Norman baron. Most of the company sat on backless stools or on long plain benches.

One of the principal articles was the coffer, or hinged chest, which was used as a 'travelling trunk' when the company was on the move, and which served as a simple table or side-table when in residence. Travelling beds, rather like palanquins and serving as litters for the ladies of the household when on the move, were usually stuffed with straw. The idea of featherbeds and of comfortable cushions, pillows and stuffed materials did not reach England until after the Crusades. Along with glass, tapestries, silks, and so many other refinements of living, feather bedding was an importation from the East.

It is important to realize that, while in the eyes of early European historians the story of the Crusades is the story of civilized Christians bringing the benefits of their religion and their culture to 'heathen Moslems', the real benefits accrued to the West out of the East. It was not only in the Byzantine Empire that the legacy of Greece and Rome had lingered on. In great centres of eastern civilization such as Alexandria, Cairo, and Damascus, the Arab conquerors had combined the traditional inheritance of eastern craftsmanship with the craftsmanship inherited from the Byzantine and Roman Empires. It was the Crusaders who were considered barbarians—and not only by their enemies, the Moslems, but by their co-religionists, the Orthodox Christian Greeks.

It was not until the early 13th century that domestic

and living conditions in Britain and neighbouring countries began to approximate to anything that the Romans, the Greeks or the Egyptians would have called civilized. One of the main reasons for the almost rapid change-over from primitive living to embryonic civilized conditions was the conquest of Constantinople by the soldiers of the Fourth Crusade in 1204. There was suddenly unleashed upon the Western European world a flood of works of art and craftsmanship (together with a steady influx of the artists and craftsmen themselves) that proliferated throughout the next two centuries.

To the amazement of most of these European knights they discovered that in the far east of their continent there was a civilization in existence where silk clothes, jewellery, elaborate architecture and furniture were taken for granted. For the first time they saw for themselves the inheritance of imperial Rome—fountains of bronze and marble, gold and precious-stone mosaics, elaborate wall-hangings, beds and bed-covers, chairs, stools, tables, sideboards and all the other domestic appurtenances of civilized living. They could not hope, with their primitive technology and inefficient society, to emulate the glories of Constantinople—but they could learn gradually, and their own workmen could also learn how to ape the culture of these conquered Greeks.

Very similar was the effect upon the Crusaders in the territories of the Levant, where they came into contact with the luxuries and civilization of the east. In Outremer, or the 'Land across the Sea', the Crusaders grew used to refinements of living such as comfortably-stuffed beds and chairs, baths, and comparatively efficient water-supply and sanitation. They realized that life as it was lived in their barbarous castles in England or

France or Germany could well be improved by the importation of some of these eastern refinements. The idea that furniture was not a luxury but a necessity dawned on these westerners—and that comfortable furniture, too, was something that their own native craftsmen could learn to make.

The first areas of Europe to feel the effects of these eastern influences were Norman Sicily and Spain. Gradually, as trade increased with the eastern Mediterranean and as more and more Crusaders became acquainted with furniture that was more than just utilitarian, countries as far afield as England began to show an improvement in their interior decoration and appurtenances. Curtains made in the East were draped to conceal bare castle windows, bed-coverings grew richer, beds themselves became permanent fixtures, their mattresses were stuffed with feathers, while tables and chairs began to reflect an interest in decoration.

That basic item of mediaeval furniture, the coffer, was fairly quick to reflect the change. A chest, used also as a side-table (but from which everything had to be cleared whenever it was necessary to get at things stored inside) was clearly unfunctional. From now on the chest, as such, emerges as a separate item—ultimately to give rise to every other variety of trunk, travelling- and suit-case that has followed it. But the coffer's function as an item of furniture for use in the great hall or in the private rooms was increased by fitting small doors into its front, so that the contents could be removed without disturbing whatever had been placed on what was formerly the lid. An inevitable extension to this—once the top of the coffer no longer opened—was the erection of a back to it, fitted with shelves, or with further cupboard space. The

humble coffer-chest thus gave rise to every form of cupboard, armoire, dresser, and nest of shelves, and has subsequently led to some of the finest pieces of European furniture.

The decorative devices and motifs used in all early English furniture reflected inevitably those used by the architects of the period. To some extent it would be true to say that furniture is an extension of architecture. But it would be many centuries before furniture designers became miniature architects in their own right—able sometimes to dictate even to the architect or interior decorator the basic shape and design of the rooms themselves. In these early days, the carpenter-joiner, who made the furniture, took his decorative motifs from the windows of church or castle—so that we find Norman or Romanesque window-shapes in coffers or chairs.

It is hardly surprising that very little of this early furniture still survives, and the little that does is almost inevitably found only in museums—like the Victoria and Albert Museum in London. At the same time it is important for the embryo collector or plain house-furnisher to have some idea from what roots stem the many articles with which we have become familiar over the ages. In the case of English furniture, it is important to remember that the influence towards refinement and comfort came from the East, largely through the Crusades—and that the native oak was the principal wood used for everything from tables to the first forms of cupboards.

OAK FURNITURE
AND TUDOR STYLE

If the Age of Oak can be said to cover the period from 1100 to the mid-17th century, the first definitive age in furniture styles emerges in the late 15th century. This is generally called the Tudor Period. It covers the reigns of:

Henry VII 1485–1509
Henry VIII 1509–1547
Edward VI 1547–1553
Mary 1553–1558

The following reign of Queen Elizabeth is so important stylistically (particularly as showing the influence of the Italian Renaissance upon England), that it is classed under its own separate heading. Now it is true that, throughout the reign of Elizabeth, many of the styles and motifs generally used in furniture—particularly country furniture —were unchanged from what had gone before. But this is something that occurs throughout the history of the domestic arts and crafts, furniture in particular. The collector or student of furniture will soon grow used to finding that, say, at the height of the 18th century, a country or provincial piece of furniture (undoubtedly made at that time) will take its style and even its use of technique and woods from fifty or more years before. During the many centuries when communications were slow, and when provincial centres developed quietly along their own lines,

without reference to what was happening in London, the time-lag between fashion in the city and the provinces was immense. Even today, with modern mass-communications, it is not uncommon to find a country cabinet-maker or chair-maker reproducing designs which have not been seen in London for a quarter of a century or more.

Whereas early Mediaeval furniture had been extremely primitive—oak planks split or sawn out of a log and held together by wooden dowels or pegs—by Tudor times the joiner had appeared upon the scene. He was just that one stage removed from the simple carpenter, as his successor the cabinet-maker would in due course be removed from him. The joiner's main technique was to use mortise and tenon construction in place of wooden dowels. What is called panelled framing, from its resemblance to the familiar wall panellings, became the accepted and almost standard form among joiners working for the kings, court and nobility, who could afford better than the simple country carpenter's skill.

Gothic decorations, such as grotesque heads, still ornamented chairs, buffets and chests. Oak was still the prevailing wood, although beech, chestnut and cypress were also used. Since it had been not unusual for the wooden ceilings of the main halls to be painted, the same practice was extended to furniture, and some pieces surviving from this period are lacquered or painted. Although more pieces of furniture were now being used in important homes, they were still restricted to comparatively few types: chests or coffers, tables, bedsteads, small buffets, benches, chairs, cupboards, and settles.

By the reign of Henry VIII some Renaissance motifs begin to appear in a few of the more important articles of furniture that still survive.

As David Reeves has written in his *Furniture* (1959):

> Renaissance motifs were introduced in some of the carved decorations; but the Renaissance elements were entirely subordinate to the general Gothic appearance, both in decoration and in form. The pointed arch of early Gothic tracery was replaced by the depressed Tudor arch. Panels were carved with the linen-fold *motif*, of which there were many variations. The 'curved-rib' pattern was often used instead of the linen-fold. (This pattern is sometimes called 'strap-work', since it was thought to have derived from leather-work; however, experts now consider that it was taken from needle-work). Curved-rib patterns were developed to a very high degree of complexity by the English carvers of the first half of the sixteenth century, and were executed with great skill.

The famous linen-fold motif, long dominant in panelling, was easily adapted to the requirements of coffer-sides and chair-backs.

Chairs, in general, now had high backs and were quite often elaborately carved. Sometimes—and increasingly so as the period advanced—the chairs had recessed seats so that cushioning could be dropped into the space left available. In all the great houses the family bed had now become a permanent fixture—though not necessarily as yet housed in a separate room. Quite often such a permanent bed would be placed in a corner of the great hall, screened off by bed curtains from the rest of the living space.

The influence of the Renaissance proper did not reach England until the reign of Henry VIII, a king who did a great deal to improve domestic design in this country by importing foreign architects, artists, and craftsmen. Although oak was still the prevailing wood, we find walnut being used for the first time in the houses of the rich. Walnut, a wood more tractable than oak, had long been used in Italy. It was certainly Italian influence, and

possibly Italian craftsmen, that first introduced it to this country.

Another important influence upon furniture dating from Henry VIII's reign was the release upon the lay world of many artists and craftsmen who—before the dissolution of the monasteries—had been entirely engaged in the monastic or ecclesiastical sphere. The monasteries, long the repositories of learning and the arts, now spread the talents of their workmen among the houses of the noble and the rich. The combination of Renaissance influences, the arrival of foreign craftsmen in England, and the release of monastic craftsmen, undoubtedly contributed to make the latter part of Henry's reign the first rich period in the history of English furniture.

The comparative stability of the country also meant an increase in wealth and an increase in trade. This in due course led to the emergence of a prosperous middle class. The scene was now set for the full dawn of the Renaissance, and for a period when, as the antiquary William Harrison wrote, 'Even unto the inferior artificers and manie farmers' expensive furniture had become an accustomed luxury. But a luxury it still was, and it was many generations before a quantity of furniture was to be found in the homes of more than a comparative handful of the population.

It is worth remarking that it is only towards the close of the 16th century that we find the King and a few privileged nobles and rich able to live in a state anything approaching that which a Roman villa-dweller of the 3rd century A.D. would have considered 'civilized'. Even so, their eating utensils, their methods of heating, of interior decoration, and of architecture, would still have been considered by a Roman general or a rich Romano-Briton

of that period considerably inferior to his own. (Under-floor heating, such as was common in Roman villas, is still a luxury in Great Britain.) The history of furniture reveals as clearly as anything else how civilization, unless it is permanently and carefully cultivated, can—like a garden—regress to weeds and barbarism remarkably quickly.

ELIZABETHAN FURNITURE
AND THE RENAISSANCE

The reign of Elizabeth I, 1558–1603, covering as it does one of the most remarkable periods in English history, undoubtedly deserves to have a whole style of furniture and interior decoration named after it. It was during the reign of this great queen that the full tide of the Renaissance, which had long since engulfed the Continent, made its way throughout every aspect of the native arts and crafts in these islands. The first signs of it had been readily discernible during the last years of Elizabeth's father, Henry VIII. But now, as England became a prosperous trading country with a large fleet and new overseas interests, the money became available throughout a larger section of the community for carpets, hangings, furniture and furnishings to become considered a necessity. At the same time a court addicted to Italian fashions in clothing, dress, and even jewellery, was not going to be prepared to make do with the primitive chairs, beds, and tables of their ancestors.

Before considering individual items of furniture, it is worth outlining a few basic characteristics to be found in English furniture dating from this period. First of all, the Gothic influence which had survived since early Tudor days did not by any means die out. It remained strong in the overall design of almost every item of furniture, and it was only the decoration that was applied to the

furniture which reflected Italian or French Renaissance motifs. Oak was still the dominant wood, but with the distinctive difference that a great many oak pieces were now inlaid. Beech, box, cherry, ebony, ivory, sycamore, and walnut are all found used as inlays in furniture of this period. Most of these inlays were by later standards somewhat coarse, sometimes being as much as $\frac{1}{16}$th of an inch thick.

Many of the surviving tables had massive stretchers between their legs, so that the diners could keep their feet off the floors which were still in most cases covered with rushes. On the other hand, in great palaces like Hampton Court, the eastern habit of spreading carpets over the stone or wooden floors had become an established practice. An outstanding feature in the furniture of this period were the bulbous 'acorn-shaped' legs, to be found on tables, cupboards and many other pieces of furniture. These were quite often enriched by carved work such as acanthus leaves or other foliage. Archwork, of a Gothic style, but decorated with semi-naturalistic figures such as caryatids in the Italian manner, is to be found in large pieces—bedsteads for example. Similarly, caryatids, satyrs and other typical Renaissance figures were widely used wherever an area of wood big enough to take extensive carving presented itself.

That eminent authority Mr. Ralph Edwards, describing English furniture of the late Tudor and Elizabethan period, has remarked:

By this time (1587) the style had emerged from foreign tutelage and assumed a character distinctively English. It is coarse and vigorous, prodigal of material and floridly enriched. The round arch figures prominently with corbels and grotesque terminals; foliated strap-work fills the decorative areas, while nothing is more characteristic

of Elizabethan furniture than vase and melon-shaped supports of prodigious girth profusely carved. In the matter of new types there was little innovation, but capacious presses were provided for clothes, and mirrors of glass in highly decorated frames were becoming known at court. Chairs were more abundant. They had panelled backs and joined frames and could be readily moved; in some the woodwork was hidden by rich fabrics. . . .

A further marked improvement upon the past was the fact that the trestle table was now being steadily ousted by the draw table, with its extending top. At the same time the simple dresser (which had evolved out of the coffer) now gave way to increased elaboration as it became a monumental, and indeed massive, object designed to display a family's new acquisitions in terms of gold and silver plate. The Elizabethans, it must be remembered, were nothing if not ostentatious. If their craftsmen had been capable of the elaboration of the Victorian period, there can be little doubt that the Elizabethans would have far eclipsed their descendants in sheer vainglorious display.

It was hardly surprising that the once modest travelling bed, more like a litter than anything else, should also have suffered a rich 'sea-change' in Elizabeth's days. The family bed *par excellence* now made its appearance, perhaps the most famous of all being the Great Bed of Ware (now in the Victoria and Albert Museum). This was renowned even in Shakespeare's day, for Sir Toby Belch refers to it:

. . . as many lies as will lie in thy sheet of paper, although the sheet were big enough for the Bed of Ware in England, set 'em down.

The panelled back and bulbous posts, supporting a ponderous tester, now became normal features of the beds of the rich and the noble. Certainly, with their heavy hangings and with their improved mattresses and coverings, they must have been a great deal warmer for their

occupants than the beds in which the Normans had slept in their stone-built, draughty castles.

Chairs, apart from becoming more easily portable, began to have their wooden seats replaced by stuffed seats. The X-shaped chair never fell from favour, but a particular type of upholstered X-chair, known sometimes as the Curule or Savonarola chair, became popular. In this the seat and back were usually made of stretched leather, but velvet was sometimes used instead, and in all cases a comfortable cushion was placed in the seat itself. The leather was usually held to the frame with round-headed nails of brass or iron, which helped to form part of the chair's decoration. For some types of chairs 'Turkey work', that is to say a knotted wool pile on a canvas base (similar to the Turkish carpets that were being imported), formed the upholstery.

Elaboration is the great and distinctive feature of Elizabethan furniture—that, and one might add, ostentation. The element of vulgarity implicit in much of the Renaissance work that reached England from the Continent was never completely absorbed or refined by our native craftsmen. Their work has vigour and vitality—just as has the work of Elizabethan architects—but it does not reflect the finer qualities of the Renaissance. It would not be too unfair to say that most of the English furniture of this period is a little like a plum-pudding: good, even excellent for a short while, but too rich for a prolonged diet.

JACOBEAN AND COMMONWEALTH

The Jacobean period of furniture is usually taken to cover the reigns of James I, 1603–1625, and Charles I, 1625–1649. Although furniture changed little during the Cromwellian era (1649–1660) it has usually been found convenient to designate this time quite separately as 'The Commonwealth Period'.

The really important thing that happened in Jacobean times was a gradual diffusion of wealth throughout a far wider section of the population. It was this that gave a distinctive flavour to the many pieces of furniture produced during these years. The influence of middle class tastes and of the comparatively small house made itself felt upon the craftsmen, who were by now becoming skilled in what had already become a specialized trade and activity. As domestic comfort gradually spread throughout the country, so innumerable small pieces of furniture became an accepted part of everyday life, even among people who a few generations before would have considered that furniture was something which belonged only to the rich. (In a much shorter period of time—due to the increased speed of transport and mechanization—we have seen much the same thing happen in terms of the motor-car, the refrigerator, the radio, and finally the television.)

The huge, ponderous tables which had suited the houses of the Elizabethan rich and nobility were clearly unsuitable for the comparatively modest town and country houses of the 17th-century merchants. The rectangular

table, which had originated in the great halls of the nobility in Norman times, proved to be an inconvenient shape—even when reduced in size—in much smaller rooms. Continental countries such as Holland, with its rising merchant class, often showed the way for the developments that later took place in England. Certainly during this period we find the gate-leg table (where one or two legs open out to provide stability for the let-down table-flaps) begins to be made in ever-increasing numbers. The gate-leg tables of the 17th century, moreover, do not necessarily follow the old rectangular pattern: The oval or round shape appears, to effect a pleasant and feminine feeling upon the domestic scene. Indeed, the influence of women upon the history of furniture is necessarily paramount—and all too often forgotten. It was the emergence of women out of the almost harem-like seclusion in which they had been kept during the early Middle Ages, that prompted a softening in the austere barrack-like furnishing of their lords' castles. From the reign of Queen Elizabeth onwards, as women played more and more of an active part in social life, so feminine demands were increasingly catered for by upholsterers and furniture-makers.

During the 17th century an elegance and lightness becomes evident in furniture. The heaviness, and the combination of Gothic design with Renaissance decoration that had characterized Elizabethan work, disappeared almost entirely. Although oak remained the principal material used by joiner and cabinet maker in England, there was an increasing use of chestnut, pine, and walnut. Sycamore is also found in quite a lot of work. Chairs became far lighter than in the past, often with their back legs turned.

Turning, the craft of revolving a piece of wood in a lathe

and cutting it as it revolves, was at first largely confined to chair-makers, but gradually turned legs begin to appear on many other articles of furniture. Ball turning was extensively used in the mid-17th century, with square intersections left at the points where stretchers and other pieces entered the turned leg. Although most chairs still had panelled backs, upholstery was used more and more as the century advanced.

Stools were in common use throughout the century, becoming graceful and well-designed although still retaining their sturdy construction. Rails joined the legs at the top to form a framework for the seat, while strength was provided just above the feet by plain stretchers. Again, they were mostly made in oak, although some examples in walnut and yew have been found. The stool was a good all-purpose piece of domestic furniture, comparatively easy and inexpensive to make, and requiring no upholstery. It was not until the last quarter of the 17th century that there was a large enough native weaving and textile industry to permit a more extensive use of materials in the furniture trade. Gradually, as Huguenot emigrants settled in London in increasing numbers, there grew up a large enough industry to change the appearance of furniture.

Unfortunately, the Civil War put a serious restriction on all the arts and crafts, and this was intensified by the Puritan rule that followed. Luxury and comfort, 'silks and satins and bows', were regarded by the Puritans as symptomatic of the Devil, and were also closely allied in their minds with the late King and the Royalist cause. Honest men, it was felt, lived harsh and austere lives, dressed plainly, and eschewed all decorations, for these represented the pomps and vanities of the world.

Even before the Civil War, however, and indeed some time before the restoration of Charles II, the influence of new Continental tastes and fashions has become evident in English furniture. Padded and upholstered seats have survived which date from the reign of James I. In the Victoria and Albert Museum there are a few magnificent examples of furniture dating from the reign of Charles I, which show an attractive use of embroidery and silk coverings. The influence of both Holland and France is to be found in a number of the best quality pieces surviving from this period.

The marked angularity and stringency of furniture surviving from the Civil War period and the Commonwealth reflects not only the Puritan attitude towards the arts and crafts, but also the poverty of a country that had been laid waste by war. In all of the domestic arts the same thing can be seen, and it can only be paralleled by similar domestic objects (including jewellery) made during the two Great Wars of this century. The poverty of material and austerity of design reflects the mood and circumstances of the nation, for furniture, like many of the other crafts, is in a sense a microcosm of the society that produces it. A prosperous and self-confident society is reflected in the furniture of the Elizabethans, a war-torn, guilt-racked nation in that of the Commonwealth period. At a later date, the Augustan balance of England in the 18th century is reflected in its furniture just as clearly as in the prose of Samuel Johnson, or the urbane poetry of Alexander Pope. By appreciating one's country's history through the medium of furniture and the attendant crafts, a modern student can learn how to get the 'feel' of an age by looking at the architecture and the articles designed to go *inside* the architecture. There has never been a real

furniture expert who has not also had a good knowledge of both architecture and history. Many false attributions, both by dealers and by collectors, would be avoided if they had a better knowledge of these two salient subjects. The study of furniture is only a part of the study of history, and thus of mankind itself.

THE RESTORATION AND THE AGE OF WALNUT

The reigns of Charles II (1660–1685) and James II (1685–1689) constitute the period of furniture design that is usually known as Late Stuart, or Restoration. It is as distinctive in its way as is Elizabethan from early Tudor. Although many early forms are still in use, everything is suffused with a new style and approach to decoration and design.

Charles II, remarked the diarist John Evelyn, 'brought in a politer way of living which passed to luxury and intolerable expense'. A reflection of the Puritan mood is evident in that reference to luxury and expense, but the important thing to note is the 'politer way of living'. This is the salient characteristic that shines out from furniture made during the twenty-five years of the king's reign. Charles was no insular conservative Englishman when he returned in triumph from Holland. Indeed, even the description of the splendid yachting trip given to Charles by his Dutch friends on the news of his restoration has all the ring of the new age about it:

> Each yacht had her own steward, cooks, and officers, who were in charge of the pantry, kitchen and wines, and those yachts which had not suitable kitchens on board, were accompanied by other vessels, wherein stoves for the kitchens had been provided, also ovens for baking, and there had been made provisions of so great a quantity of all kinds of food, game, confitures, and wines, and the tables were all so fully served, that the stewards of the English lords, though accustomed to abundance, were astonished.

That feeling of 'abundance' which was ushered in by the Restoration is similarly to be felt in the new furniture of this period. Charles not only brought back foreign friends and manners with him to the English court; there also followed in his wake a considerable number of Continental craftsmen. From this moment on, furniture, silver, and other crafts begin to exhibit the styles and mannerisms fashionable on the Continent—in Delft, Amsterdam, and Paris. The Age of Walnut is ushered in by the return of the Stuart monarch, and although oak will be used throughout the whole history of English furniture, it will not again be found occupying pride of place among those who aspire to be 'in the fashion'.

The demand for walnut could not be met entirely by the stock of native trees (in England since the Roman conquest), and so this need was satisfied by importation from the Continent and from the new colonies in America. With the current use of walnut, the craft of the joiner developed considerably, at the same time as the veneer-cutter became an important figure upon the furniture scene. The old heavy veneers were superseded as improvements in technique enabled the craftsmen to cut fine, delicate layers of wood. Floral patterns in marquetry work were often inserted into the veneers, the whole effect being one of richness combined with elegance. The heavy opulence of the Elizabethan style has now been transformed by French taste combined with technical advancement.

To take that basic item of household furniture, the chair, as an example of the new style, is to indicate the general pattern to be found in all important furniture of the Late Stuart period. First of all, the stretchers between the legs are now moved several inches from the floor. They

are no longer just practical instruments to keep the feet off a dirty surface at the same time as strengthening the chair. They do indeed give rigidity to the chair legs, but they have now become highly decorative objects in their own right. A typical chair of the Charles II period might well contain in its centre the 'Boys and Crown' motif. This represented two cherubs or *amorini* holding aloft a crown—symbols of the Restoration. The back of the chair would be high and topped with an elaborately-carved 'cresting piece'. This section is itself supported not on a solid back as in former days, but on two carved wooden uprights, for the centre of the chair-back is made of cane. This introduction of the cane back, and the cane seat, is an important feature of the new furniture—one that made both for greater comfort, and for a far greater feeling of lightness about the pieces themselves. Another innovation was the use of 'barley sugar' turning, something that had been known in England prior to the Restoration, but which did not become generally used until the lathe-workers had learned how to emulate it mechanically.

Another distinctive feature to emerge from about 1670 onwards was the S-shaped curve used both as a motif, and as the actual shape for the front legs of chairs. Graceful and feminine, it is very typical of Late Stuart work. Typical too is the new delight in colour, for trade with the Far East had now brightened the European scene by bringing the native craftsmen into contact with the japanning or lacquering used in the Orient. As early as 1688 there was published a 'Treatise on Japanning and Varnishing' by Stalker and Parker. Screens and panellings previously imported from the East were now widely copied by British and Continental craftsmen. Diarists like Evelyn and Pepys make a number of references to 'japanned'

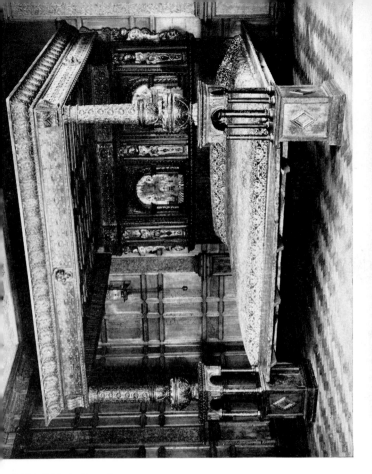

PLATE 1 The 'Great Bed of Ware',—the family bed *par excellence*. Oak with carved, inlaid and painted decoration. First mentioned in a diary in 1596. Late 16th century. H. 8 ft, W. 10 ft. 8½ in. *Victoria and Albert Museum. Crown Copyright.*

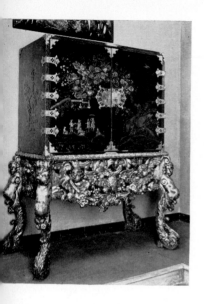

PLATE 2 Cabinet-on-stand. Japanned in colours on a black ground in the Chinese style. Wood stand carved and silvered in the European style of about 1670–80. H. 5 ft. 2¾ in., W. 4 ft. 6 in.

Victoria and Albert Museum.
Crown Copyright.

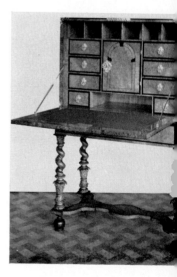

PLATE 3 Scriptor. Veneered with burr walnut on carved and turned stand, fitted with silver mounts. About 1675. From Ham House, Surrey, and mentioned in the 1679 inventory. H. 4 ft. 5⅜ in., W. 2 ft. 11¼ in.

Victoria and Albert Museum.
Crown Copyright.

articles in the homes of their friends. Indeed, any student of furniture or interior decoration should never be without the works of these, and other later, English diarists. More is to be learned about social customs and conventions (which themselves reflect upon the furniture of the houses) in such diaries than can ever be acquired by other methods. For the late 18th century, for instance, Parson Woodforde of Norfolk is a mine of information.

An important event in so far as it affected craftsmanship in this country was the Revocation of the Edict of Nantes in 1685, which drove a considerable number of French craftsmen out of their country and across the Channel to settle in London and other manufacturing centres. They brought with them a knowledge of the techniques and skills used in much of the fine French furniture of the period. This was particularly true in the sphere of marquetry work and veneering; two refinements of the woodworker's craft which from this time on are increasingly found in more important pieces of English furniture.

Just as new forms of decoration brought a change to the whole scene, so a number of new types of furniture made their appearance. Prominent among these was the day-bed, a type of couch with an adjustable end at the head. Made of walnut or mahogany, day-beds were cane-seated and often displayed elaborate carving in the feet, side-stretchers, and especially at the head. They in their turn were followed by a really comfortable item of furniture, the sofa, covered with elaborate imported velvets, or with the damasks now being woven in London. The winged armchair and the upholstered winged settee were further developments which brought considerable new comfort to the English domestic scene.

B

In an age which relished richness, it is not surprising
to find that the work of the carver was in especial demand.
Greatest and most famous of these was Grinling Gibbons
(1648–1721). Although primarily an architectural wood-
carver, the influence of Gibbons was reflected in the
work of innumerable humbler craftsmen of the period.
Peter Philp in *Antiques Today* has accurately described the
flavour of Gibbons' work:

> . . . heavy swags of fruit and flowers, cherubs and musical instru-
> ments, carved from soft woods such as pine, lime and acacia, were
> better suited to architectural woodwork than to furniture.

He worked under Wren at St. Paul's, and the organ-case
there is a perfect example of Gibbons's interpretation of
the *baroque* under a strict classical discipline. At Petworth
may be seen his more extravagant manner, described
by Horace Walpole as

> . . . much the finest carving of Gibbons that ever my eyes beheld.
> There are birds absolutely feathered; and 2 antique vases, as perfect
> and beautiful as if they were carved by a Grecian master.

Refinements upon the early basic forms of furniture that
emerged during this period were elaborate chests-of-
drawers, book-cases, and bureaux with enclosed desks.
As the merchants and middle-class executives became
more literate and lettered, so there was an inevitable de-
mand for everything associated with the arts of a cul-
tured man—books and receptacles for them, and all the
appurtenances connected with writing and reading.
Similarly, mirrors that reflected not only the image of
their possessors but, as it were, the fashionable desire
to be wigged and groomed in an impeccable manner,
became familiar objects—not only for the bedroom or
dressing room of the lady, but also for the gentleman's

rooms of the house. As Ralph Edwards commented in an article on 'Interior Decoration':

> Mirrors were no longer rarities after the Duke of Buckingham had established his famous glass-works at Vauxhall, the frames being carved, lacquered or inlaid. . . . An example of this extravagance is afforded by the tables, mirrors and stands covered with embossed silver with which the king's mistresses furnished their apartments.

Cabinets, enriched with inlay work in bone, ebony, hollywood, and ivory, now became minor works of art. Japanning in the 'Oriental Fashion' enlivened the sides or panels of the doors, while many of the cabinets (like the writing bureaux of the period) were fitted with plates and keyholds almost as elaborate as jewellery. The craft of the locksmith begins to emerge at this time, again an importation from the Continent. Other devices of his and the cabinet maker's skill, such as secret drawers (for money, valuables, or letters best concealed from the lady of the house) are to be found in some of the more exceptional pieces of furniture.

Among all the proliferation of new crafts and techniques, as well as new forms on which to employ them, that characterize this period, one most salient fact must be emphasized. Just as in the past the rough work of the country carpenter had proved to be insufficiently skilled to undertake improved forms of furniture—thus giving rise to the joiner—so now the joiner became superseded by the cabinet-maker. For almost the first time, at least in English history, furniture has become so elaborate and so specialized a craft that it calls into being a new type of workman. Not only did the elaboration of this late Stuart furniture require special crafts and skills, but no longer could a simple sketch by an unlettered artisan suffice before a new piece of furniture was executed. The

cabinet-maker had to be sufficiently skilled to be able to prepare a detailed drawing, and had to know enough of other attendant crafts like that of the Japanner, to be able to visualize in advance what his piece of furniture would look like when completed. Furniture, in fact, had now reached a stage similar to architecture in miniature. It was no longer an offshoot of the wood-craftsman, but a very distinct craft—almost an art in its own right.

WILLIAM AND MARY
AND QUEEN ANNE STYLES

The reign of William and Mary (1689–1702) served to confirm many of the influences that had become apparent during the Late Stuart period. At the same time, English furniture now began to speak more in its own particular idiom. The Continental grammar, as it were, which had been imported during the reign of Charles II, had not always been suitable for this country's native craftsmen. There was often a certain lushness and awkwardness in the attempts of the workmen to emulate Continental styles and manners. With the William and Mary period, English furniture sheds much of this, while retaining its improved techniques and skills.

Walnut retained its pride of place as the fashionable wood, while chestnut and oak still continued to be used extensively for almost all types of article. The influence of Dutch craftsmen made itself felt particularly in the use of marquetry work, while French influence inevitably persisted in much of the design of pieces. This was the great age of Louis XIV's craftsmen, who were infinitely more sophisticated than their English contemporaries. The now large colony of Huguenot refugees centred in London deployed their skill in nearly all the crafts, from jewellery and silverware to textiles, but in the sphere of furniture they dominated their English hosts. Marquetry and veneering were two aspects of the craft in which they

particularly excelled. This highly decorative work became an important feature of the period.

Following the French fashion, needlework coverings were extensively used during this period on chairs, stools, and settees. Needless to say, very few examples of good William and Mary, or Queen Anne pieces appear on the general market. They are extremely rare, and indeed deserve the high reputation that they have acquired; for many of them are elegant without being over-elaborate, and the needlework (where original) is of the highest order. Generally speaking, the principal foot to be found on all these pieces is the simple pad. The claw-and-ball foot had already made its appearance, but was not extensively used in this country until the early Georgian period.

The most important stylistic innovation was the cabriole leg. This delicate S-shaped leg was really a refined development from the earlier Scroll leg of the late Stuart period. It is a distinctive feature in Queen Anne furniture, to such an extent that at one time it was commonly known as a 'Queen Anne' leg. In England, in its earliest version, these S legs were often connected by underframing since the chairmakers were suspicious of their strength. As the 18th century developed, however, the S leg emerges quite independent of any tying-in frames. The knees of the leg were at first left completely plain, as was the leg itself, but gradually in the Georgian period the cabriole leg would develop those carved areas at the knees which are such a typical feature of the second half of the 18th century. Round about the turn of the century, the famous 'Windsor' chair also makes its appearance—one of the most successful and practical designs in history, and one which is still being copied today.

Another important feature in the elegant home was the long-case clock. These had been introduced from the Continent some time before, but now became far more general. With their walnut cases and elegant veneers, they now established themselves as important decorative articles in their own right. Brass spiked balls as finials foreshadowed the elaborations of the late 18th century, when the metalwork and mounts on long-case clocks would be almost as delicate as jewellery.

Tallboys (double chests-of-drawers), elaborate cabinets with shelves, and double-stage bureaux, contrived to meet a growing demand for more useful, and at the same time elegant, furniture. The vertical central panel in chairs, which in Late Stuart times had been filled with cane, now became an important feature. The splat, as it is called, was now a shaped piece of wood—often vase-shaped—running between the seat and the cresting rail. The cresting rail itself usually reflects an elegant flowing line to be found in the two uprights of the chair-back. Apart from the vase-shape, one of the most popular shapes for the splat was the fiddle, and this was to continue right through the 18th century. The appearance of the drop-in upholstered seat for chairs was practical from the point of recovering and cleaning, for in the past the embroidered stuffed seat had been an integral part of the chair itself.

Professor G. M. Trevelyan, in *English Social History* (Vol. III), accurately summarized the general feeling of furniture and architecture in the latter part of this period:

(The Queen Anne style), which seems to us today native English, in its origin owed something to Dutch influence. Nor was the internal decoration unworthy of the architecture: in 1710 a foreign visitor noted that 'now in England tapestry is no longer in fashion, but all is panelled at great cost'. Spacious panels, five feet high and

broad in proportion, were now preferred to the small pattern of earlier Stuart wainscoting. Big sash windows with large panes of glass replaced Gothic and Elizabethan lattices. High, well-lighted rooms were the new fashion.

China-ware, brought to Europe by the Dutch and English East India Companies, had become a passion with the ladies . . . Mahogany was beginning to come in from the American Indies, and with it the lighter and finer furniture that we associate with eighteenth-century taste.

It is interesting to note that the importance of the craft of 'japanning' or lacquering had become so established that we find towards the end of this period one of those perennial disputes between English labour and foreign competition breaking out. Because the price of home lacquer work tended to be high, importers took to having chairs and panels in lacquer work brought in from India and China. The London cabinet-makers thereupon reacted strongly and sent a petition to Parliament seeking some form of tariff protection. However, 'The Case of the Joyners' Company against the Importation of Manufactured Cabinet-Work from the East Indies' achieved no success. The demand for these 'Oriental Novelties' was too great for the home manufacturers to meet, and Eastern work continued to be imported at an increasing rate.

The William and Mary and Queen Anne periods constitute above all an age of transition. Gradually the Continental influences which had poured in like a flood during the reign of Charles II are becoming absorbed. As the English craftsmen improve, these influences are being transmuted into a cross between what is fashionable on the Continent, and what best suits English ways, tastes, and manners. There is a grave elegance, heightened by an attractive use of decoration, about the best of

the work produced at this time. The furniture, like the houses and other buildings of the age, provides—at its finest—a singular balance between proportion and decoration.

EARLY GEORGIAN: PROSPERITY AND ELEGANCE

> An Englishman delights to show his wealth; everything in his
> house, therefore, is expensive; a whole dwelling in our country is
> furnished at less cost than is bestowed here upon a single apartment.

These words, written by Robert Southey in 1807, pur-
ported to express the amazement of a Spanish traveller
when confronted with the homes, the fittings, and the
furniture of the well-to-do English.

Certainly there can be no doubt that during the pros-
perous 18th century the interiors of English homes
achieved a comfort and elegance that had never previously
been known in the island (always excepting the villas of
a few wealthy Romans and Romano-British officials,
centuries before). Such things as mirrors, at one time
considerable luxuries, were now common in middle-class
houses, while long-case clocks as well as bracket clocks
also appeared in considerable numbers. Upholstered furni-
ture, carpets, and comfortable beds were the rule rather
than the exception among the prosperous bourgeoisie.

On the subject of the general style to be found in the
early Georgian period, Mr. Ralph Edwards has written

> At the beginning of the 18th century a new style arose. It was
> simple and dignified, based upon curved lines and entirely admirable
> in its insistence upon form. The cabriole-shaped support with
> claw-and-ball feet or paw feet was a salient feature, and early in the
> development stretchers were eliminated. This style depended
> largely upon finely figured walnut veneers, and made but sparing use

of carved ornament . . . The furniture which had prevailed during
Anne's reign no longer satisfied the governing class, whose taste
inclined towards ostentatious magnificence. They demanded some-
thing grandiose and cumbrous, suited to the great Palladian houses
for which it was destined. Inspired by the contents of French and
Italian palaces, such furniture was largely the production of
architects.

As almost always in the history of fashion, while the
middle classes were aspiring to the condition of the upper
(and in the course of its achieving considerable elegance
and comfort), the upper classes were indulging in luxuries
which they knew that others could not emulate.

The term 'Georgian' is loosely used to cover so wide a
variety of furniture—as well as a period of over one
hundred years—that in itself it has become almost
meaningless. The first thing to establish, of necessity,
is that not all furniture made during this period was 'good'
either in taste or execution. The poorly-made furniture,
of course, has hardly survived, but a great deal of well-
made, yet aesthetically ugly, furniture remains. Natur-
ally enough, all 18th-century furniture now commands a
high price on the market, but the buyer with taste will
not (unless interested only in investment values) neces-
sarily buy something just because it is labelled 'Georgian'.
It must also be pointed out that, in view of the fact that
furniture of this period is so valuable, there are a great
many straightforward fakes, reproductions, and composite
pieces to be found in shops and salerooms.

Caveat Emptor! Even if comparatively knowledgeable, it
is always wise to buy from reputable sources. If you ven-
ture your own judgement in a saleroom, then that is your
affair—but it is often just as well to ask a reputable
dealer to bid for you, and to give you his prior opinion
of the piece and its value. His services will cost you only

a little, but they may save you a lot. Remember that if
you are buying 'Georgian', you are buying period furni-
ture that is increasingly in demand throughout the world.
Unless you are unusually lucky (and it rarely happens
nowadays), a good investment demands a good initial
buying price. It is not worth paying good money for a
composite piece, or one in poor condition—let alone for
a straight fake, or for a reproduction that has sneaked
in by mistake. And never forget that the Victorians made
a large amount of semi-reproduction 18th-century furni-
ture—all of which by now has acquired an almost antique
finish and patina.

The first question is to decide how to divide the
Georgian Period into sensible compartments, for clearly
Early Georgian is a far remove from Late Georgian or
Regency. If we take the accession of George I in 1714 as
being the beginning of the period, then the middle of the
century when George II was on the throne would provide
a convenient point for marking the termination. Early
Georgian, then, 1714–1750. The second period is often
designated as Middle Georgian by writers and authorities
who dislike the term 'Regency' for the last phase. My
own feeling is that 'Regency' has acquired so general a
usage that it would be unwise to attempt to overthrow
it. In any case the Prince Regent, or George IV as he
became, exerted a remarkable influence on the English
arts and architecture. With all his faults, and they were
many, the founder of Brighton deserves to be commemor-
ated by giving his name to a furniture style.

For the second phase of Georgian, I prefer the term
'High Georgian', which may be said to cover the forty
years from 1750 to 1790. By 1788 the madness of
George III was unmistakable, and although his son did not

technically become Regent until 1811, he was the domi-
nant Royal figure from 1790 onwards. It seems reason-
able, therefore, to date the furniture designated as 'Re-
gency', or Late Georgian, from this time.

Again, the definition of the Late Georgian or Regency
period is difficult to make—for the basic influences of the
furniture made during this time carried right on through
the early years of Queen Victoria's reign. However,
although George IV died in 1830, it seems right that the
period which goes under his name should be allowed to
extend beyond that of William IV and into that of the
young Queen Victoria. As a purely arbitrary suggestion,
therefore, I take the 'Regency' period to end about 1840.
The full hallmark of the Victorian period is to be found
eleven years later in the 1851 Exhibition.

Before going into any consideration of the 18th century
and its styles, it is important that the general definitions
by which one is working are quite clear:

> Early Georgian: 1714–1750
> High Georgian: 1750–1790
> Regency, or Late Georgian: 1790–1840

Any attempt to view these arbitrary periods as in the
slightest sense watertight is absurd. Right into Victorian
times country craftsmen were making furniture similar
to that which their grandfathers had made in the High
Georgian period. Similarly, when the full excesses of the
'Great Exhibition' mood were sweeping through the
furniture manufacturing factories (for such they then
were) of London, there were provincial cabinet-makers
using designs that had been fashionable in the metro-
polis in 1810. These labels, for they are little more, are
designed only to show the main trends of *fashionable*

design. Like all other labels used in the history of the arts and the crafts, they can do no more than indicate a broad sweep or outline. As I wrote in *Antique Collecting*:

> It is important at this point to bear in mind that no one craft should ever be looked at as divorced, or existing in a vacuum, from its fellows. What happened in furniture happened also in the companion crafts such as silver, metal work and jewellery. The eighteenth century was above all a period when form took precedence over decoration, and when a classical restraint chastened even the baroque carving of Chippendale, or the rococo ostentation of a silversmith like Lamerie.

The great, and indeed the one unmistakable, change in the furniture at this time was the change from walnut to mahogany among the rich and fashionable. Mahogany was not, of course, a 'new' wood in this country, but it did not become important until the 1720s. Two causes for this were an embargo on the export of walnut from France about this time, and a disease attacking walnut trees on the Continent which made the wood exceedingly scarce. With the Georgian period, therefore, we enter that other loosely-defined era, 'The Age of Mahogany'. As David Reeves has accurately commented:

> (The importation of mahogany) was still further encouraged in 1733, when the duty on imported timbers was abolished by the Prime Minister, Sir Robert Walpole. In spite of this, walnut furniture continued to be made for many years after the beginning of the age of mahogany—indeed, in the country much furniture was still made of oak.

Marquetry, too, was still much in evidence, although it was a far finer and subtler craft than in its early days. So, too, damask and needlework materials improved, and were increasingly used for hangings and materials. Carving, (in general no longer so florid and ostentatious),

was given active employment on the new 'Spanish' mahogany—mahogany, that is to say, not from Spain itself but from the Spanish colonies such as Cuba. Inevitably, the demands of this new hard wood occasioned a revolution in the craft, as carvers learned to fashion tools, and train their techniques to execute crisp carving and deep undercutting in this rich new texture.

Along with this new ease in carving, came an elaboration of such items as the backs or splats of chairs. No longer simply divorced from the two main uprights that supported the cresting, the splats became as elaborate and delicate as lacework. The cabriole leg—without any stretchers—was adapted for use on practically every item of furniture. Its graceful curves suited the new delicacy of decoration. It was not until later in the century that the cabriole leg itself became somewhat ostentatious, and the knees became over-elaborate with carving in the shape of lion's heads, satyr's masks, and shells. The claw-and-ball foot superseded the plain paw foot. In all of these refinements the overriding influence was the capability of mahogany to take great stresses and strains. Whereas it had once been necessary to thicken a leg, or to impose stretchers for security, it was found that carved and comparatively thin mahogany would stand up to any ordinary usage.

It was during the early part of the century also that the craft of the metal-worker—long established in this country as a highly individual and competent craft in its own right—began to play an important part in the appearance of furniture. The handles and plates of chests-of-drawers received considerable attention—pear-drop handles at first being fashionable, but later yielding to the more elaborate loops and rope-shapes, so typical of this

furniture. Because of constant usage these plates and
handles have often had to be replaced over the years.
(The Victorians, in particular, were liable to rip 18th-
century metal-work off furniture—considering it too
simple—and replace it with their own more complex
and ostentatious pieces.)

As the age advances, so the simplicity of the Queen
Anne period gradually yields to the Baroque. This term,
Baroque, applied to everything from pictures to furniture,
is Continental in origin, deriving from the Portuguese
barroco, meaning no more than roughly or irregularly
shaped. It was a florid style, the opposite in almost every
way to the Classic. Its heights and depths are to be found
in the architecture, painting, and interior decoration of
Latin countries such as Spain, Italy, Portugal, and Sicily.
Baroque always entailed, through its very complexity, a
high degree of ability on the part of its artist or crafts-
man executors. In England its abundant and grandilo-
quent nature was usually tempered by a certain native
restraint, so that the worst excesses of Continental
Baroque are rarely to be found in the furniture or other
attendant crafts of this country. In so far as it compelled
woodcarvers, gilders, and other craftsmen to push their
abilities to the limit, it may well be said to have been a
beneficial influence.

A combination of native craftsmen and foreign refugees,
of opulence and reserve, produced in the 18th century a
manner of furniture that was distinctively English. If the
manner of the carving and decoration is often baroque, the
overall style and design is classic.

MID-GEORGIAN: THE GOLDEN AGE

From the middle of the century onwards the influence of the French Rococo style made itself increasingly felt throughout all the arts and crafts in this country. A feminine elaboration of the Baroque, Rococo belongs very much to the world that one associates with the paintings of Watteau, or even Greuze. It would not be too harsh to say that it is really a 'boudoir style'—and at its best, there is certainly nothing wrong with that. At its worst it ends in a kind of asymmetry for asymmetry's sake, that is as irritating as the worst excrescences of Art Nouveau. (Again, it is worth pointing out, a French importation.)

Far more important, at least from the point of view of comfort, was the use of the coil spring which was increasingly used in upholstery from the mid-18th century onwards. It led inevitably to the stuffed and 'lumpy' furniture of a later period, but its contribution to the art of furniture and to the changed design of armchairs, sofas, and the like, is almost immediately apparent. Within twenty-five years of its arrival, the shape of ordinary articles of furniture begins to change. The emphasis on line and wood becomes subordinate to the upholstery itself. The modern standard armchair derives from the invention of the coiled spring, and has little relation to craftsmen and designers such as Chippendale and Sheraton.

It was during the reign of George II (1727–1760) that that distinctive furniture, ever afterwards to be associated

with the name of Chippendale, began to permeate the
houses of the rich and fashionable. Although almost all
the furniture that now passes under the name of 'Chippen-
dale' never originated from his workshops (indeed, often
bears little resemblance to his style), the influence exerted
by this master-craftsman was enormous.

Born the son of a Worcestershire carver, Thomas Chip-
pendale first began business in London in 1749, moving
to new premises in St. Martin's Lane in 1752. In 1754
his book *The Gentleman's and Cabinet Maker's Directory*
appeared, and it was the influence of these designs upon
other craftsmen that led to the general prevalence of what
it is only right to call the Chippendale style. The folio
contains 160 engraved plates (many of the pieces were
probably never made up) and ran into a second edition in
1759, and a third in 1762. Much of the work is derivative,
showing particularly a French influence. Indeed, the
prevailing tone of Chippendale's work might be said to
reflect the influence of the Louis XV cabinet-makers, but
with two separate influences making themselves felt—
Gothic and Chinese.

Chippendale was above all a master of proportion, and
the feeling of heaviness to be found in the furniture of his
lesser imitators hardly occurs in the authentic pieces of
the great craftsman's work. Of course it would be absurd
to envisage Chippendale as engaged solely on the factory
floor, let alone at the workbench. He was an employer
of labour, a business man, and a great deal of his time
was spent soliciting custom from wealthy clients and
patrons of the arts. The serpentine front was one of his
favourite devices, while the knees of chairs and table legs
were often ornamented with scrolls and acanthus leaves.
The claw-and-ball foot is seen at its best in his work,

while delicately chased mounts of brass were used to enliven the wooden surfaces of chests-of-drawers and bureaux.

It has been accurately remarked that 'The primary characteristic of his furniture is solidity, but it is a solidity which rarely becomes heaviness'. Even in delicate work like ribbon-backed chairs, Chippendale's pieces are soundly and durably constructed. Indeed, his chairs are probably his masterpieces, for it is here that the combination of delicate design with good workmanship is best displayed. The openwork backs display immense grace and elaboration, yet are never in themselves a source of weakness. The legs are well-proportioned and stretchers are used only in the case of chairs with square legs. Armchairs, on the other hand, follow the French fashion and have solid or stuffed backs.

His next most successful work is probably to be found in tables, particularly those with delicate fretwork galleries. Other tables favour sunk or 'dish' tops, while the pie-crust or ribband tops are a feature of his work and design. Mahogany, of course, is the favourite wood of Chippendale and the other craftsmen working at this time. All the same, quite a lot of Chippendale's work was in common wood, which was afterwards japanned or gilded.

Chinese Chippendale deserves a place all to itself, for it is in the extravagance and delicacy of these Oriental designs that the great craftsman displays so sure a touch. The rage for *Chinoiserie* that swept England in the latter half of the 18th century led to a revolution in fashions and fabrics and furniture. Chippendale's designs in 'the Chinese taste' were mostly in the use of fret and carved lattice ornaments. From about the date of the publication of his book, the Chinese style stayed in fashion for

some twenty years. It is particularly to be found in the elaborate mirrors, overmantles, and candle brackets of the period. Many other cabinet-makers besides Chippendale made articles in the Chinese style, among them Edwards and Darley, and Ince and Mayhew. Thomas Chippendale himself died in 1779, although his business continued to be carried on by his son, in partnership with others, for a number of years.

At the height of his fame Chippendale almost certainly put out articles of furniture to other cabinet-makers in the form of sub-contracts. Quite apart from this, the immense success of his folio of drawings led many others to copy the master's style. The result is that, with comparatively few exceptions, little furniture is on the market today which can confidently be said to have originated in Thomas Chippendale's own workshop. Nevertheless one continues to see pieces of 18th-century furniture confidently labelled 'Chippendale', whereas the most that should be said of them is 'after the manner' or 'in the style' of Chippendale.

Another dominant influence in the second half of the 18th century was that of the Adam brothers. Robert and James Adam came from a Scottish family of architects and worked together in London, Robert being the principal figure of the two. Again, as with Chippendale, the popularity of their style stemmed from the publication of a book of designs in 1775. Whereas Chippendale was a master-carver and craftsman, Robert Adam was predominantly an architectural designer. He was deeply influenced by the prevailing classicism of the period, and nearly all his work to one degree or another shows the influence of ancient Rome or Greece. Perhaps it would be more accurate to say that the 'Roman' or

'Grecian' style used by Adam was not so much a *pastiche*, as a re-invention of classical taste. At its best, his work shows extreme delicacy and refinement and, when partnered by the work of artists like Angelica Kauffmann, Robert Adam produced what were probably the most elegant rooms and accompanying furniture ever to be seen in this country. Unlike Chippendale, who loved mahogany above all other woods, Adam took particular pleasure in satinwood and in rich inlays. Whereas inlay is rare in Chippendale work it is widely used by Adam, together with painted decorations which the older craftsman would never have envisaged. Among other articles in which Adam specialized were side-tables, and indeed it is almost possible to say that Adam 'invented the sideboard', as we understand the term. The brothers also introduced to fashionable England the construction of decorative details in *papier mâché* or, another wood substitute, *carton pierre*.

Two other cabinet-makers who exerted a great influence on the history of English furniture design during and after the High Georgian period were George Hepplewhite and Thomas Sheraton. Hepplewhite's book of design was published in 1788, two years after his death. His widow carried on the business under the title Hepplewhite & Co., and her husband's designs exerted a great influence on both late Georgian and early Regency furniture. Satinwood was largely used with mahogany, sycamore, and chestnut. The style is quite different from that of Chippendale, although not so far removed from Robert Adam's.

Graceful and feminine, the chairs and sideboards of Hepplewhite owe a great deal to the neo-classic influence. Chair backs were often oval, also with ladder and wheel

designs in the splats. Legs were often of square section but gracefully tapered and decorated with strings of carved flowers. The *anthemion* or Greek honeysuckle was a favourite motif, either in carving or inlay, while vases, drapery, and the Prince of Wales' feathers are also typical.

Similar in many respects to the work of Hepplewhite was that of Thomas Sheraton, who published his *Cabinet Maker's and Upholsterer's Drawing Book* in 1791. The dominant influence in Sheraton's designs is that of the French Empire, leading to a lavish use of brass ornamentation. Inlay work, brass inlay, oval-shaped decorations, and reeded legs, are all typical of the Sheraton style. It is (like Hepplewhite's work) essentially a feminine, almost 'boudoir', type of design. A great amount of Sheraton's work is painted or japanned, while underframings of chairs are often festooned and the legs themselves decorated with floral chains. We are moving away from the era of the great carvers, and into a period of design when marquetry comes into its own.

Sheraton's favourite wood was undoubtedly satinwood, decorated either with painting or with inlay work. As in the designs of Hepplewhite, chair legs are usually square in section but delicately tapered. Kidney-shaped tables are distinctive of this style, as are chairs with shield-shaped backs that have the line of the top rail broken either by a panel in the centre or by a straight line. Sheraton's greatest achievement undoubtedly lay in his deservedly famous sideboards. Made of mahogany, often inlaid with satinwood, they were usually set on tapered, reeded legs. They sometimes had convex corners. Like all of Sheraton's work, the sideboards were exquisitely fitted, and often constructed with most ingenious compartments. A similar taste for an almost jewellery-like finish is to be

found in the secret drawers and compartments that this great craftsman liked to fit into his writing tables and desks.

The furniture made in the middle of the 18th century might be called predominantly 'masculine' in style. It is furniture that goes well in the study, in the dining room, and in the gentleman's country house. Classical influence is strong, but it is the classicism of Rome—or rather what our ancestors conceived to be 'Roman'. To generalize, these pieces had dignity and restraint, but were a little heavy in their overall feeling. Gradually, as the neo-classic became the fashionable theme, everything seems to get lighter and more graceful. We are moving, as it were, out of the study and into the drawing room, bedroom, and boudoir.

Although the highest prices in furniture are still fetched by works by, or 'in the style of', Chippendale, the furniture made to the designs of Adam, Hepplewhite, and Sheraton are probably the finest in the history of the craft in England. They show the influence of France in their detail, but they are not 'fussy' as Continental work often tends to be. They combine ideas and motifs taken from the classical past, and mix them with a native restraint and sobriety. The last quarter of the 18th century reveals the English genius for compromise at its full flight in the craft of the cabinet-maker and the furniture designer.

LATE GEORGIAN AND REGENCY

An indication of what is to be found under the style known as Regency or Late Georgian is to be found in a book published in 1805. This *Collection of Designs for Household Furniture* by George Smith (described as 'Upholder Extraordinary to His Royal Highness The Prince of Wales') is prefaced by an 'advertisement' in which the author writes:

> In selecting the articles, and in composing the designs for this work the Artist is anxious to exhibit principally such as are suitable to elegant and polite life, and for adorning the most extensive mansions: he flatters himself the works will display a variety of the newest fashions, combined with classic taste, for the most useful and most superb articles of modern furniture, studied from the best antique examples in the Egyptian, Etruscan, Greek, and Roman styles; and he presumes it will be found particularly useful to Noblemen and Gentlemen who are curious in the decoration of their houses; also to Cabinet-makers, Upholders, Paper-hangers, &c., who may have the arranging, furnishing, and fitting-up of houses committed to their care.

'Upholder', perhaps it should be pointed out, is the old term for an upholsterer. (Although no doubt there were often occasions when the Prince Regent need 'upholding', this was not what Mr. George Smith meant.) But what is particularly interesting about this advertisement, and clearly reveals the trend of the times, is that Mr. Smith speaks of 'the newest fashion' and then goes on to refer to 'Egyptian, Etruscan, Greek, and Roman styles'. At once we seem to be in a familiar world—the world where Fashion

decrees that 'this is smart now', but that such-and-such is already out of date. Then again, we see that there is not just one style in fashion, but a whole composite group of them. You can have your study in the Etruscan style, while your drawing-room is in the Greek, and so on.

Times have changed greatly since the mid-18th century, when there was 'style' but not 'fashion'. A 'style' like Chippendale's could exert an influence for a whole generation or more—to be gradually superseded by another style, such as the neo-classic popularized by the Adam brothers. But now there is a wealth of 'styles' or 'fashions' all on the market at the same time. We are, in fact, in the 19th century, and are witnessing the changeover of furniture from a craft dominated by a comparative handful of people (rich noblemen and the craftsmen they patronize) to a craft increasingly dominated by a prosperous bourgeoisie. These middle-class buyers are so numerous, and so unsure of themselves, that they occasion two immense changes in the social scene. First of all, they look to the designer or cabinet-maker for guidance in what they should buy. Secondly, there are so many of them able to buy comparatively expensive furniture that the old-fashioned cabinet-maker now tends to become an industrialist running 'a furniture manufactory'.

The great advantage of the 18th century, for the student of furniture, is that fashions for styles of ornament tended to follow one another in a fairly orderly progression. This is not to say that one does not find provincial makers working in styles sometimes 50 years later than that adopted in the capital. But, in the case of the major London cabinet-makers, a style of ornament can usually give one its date within a decade, even if there is no other information upon which to rely. But, towards the end of

the 18th century and as we enter the period of the
Regency, 'styles' proliferate.

Indeed, there were so many handbooks of furniture
designs published during this period that the architect
Robert Morris even inserted a satirical advertisement in a
newspaper to the effect that:

> There is now in the Press a Treatise on Country Five Barr'd Gates,
> Stiles and Wickets, elegant Pig-styes, beautiful Hen-houses, and
> delightful Cow-cribs, superb Cart-houses, magnificent Barn-doors,
> variegated Barn Racks, and admirable Sheep-folds; according to the
> Turkish and Persian manner. . . .

The belief, sometimes absurdly fostered by those in the
antique trade, that everything in the 18th century was
good, should be dismissed by every student or embryo
collector. The 18th century was full of vulgarity in its
furniture as in much else—but the *best* of it is impec-
cable. Any idea that all 18th-century furniture was in
'the Grand Manner'—which declined during the Regency,
and suddenly went 'bad' in the Victorian era—must be
forgotten. Even a brief study of 18th-century design and
pattern books will reveal the seeds of much that is called
'typically Victorian'. There was, it is true, a general
coarsening of taste during the Regency—but all the signs
of it can be seen, for instance, in a book of designs pub-
lished by Matthew Darly as early as 1750.

One of the most useful books for the beginner in this
difficult subject of furniture design is published by the
Victoria and Albert Museum, *English Furniture Designs
of the Eighteenth Century*. Culled from the many books
published during this period, it gives a better overall
picture of 'Georgian' design than almost anything else—
for here we are confronted with a wide selection of the
artist's or cabinet-maker's original drawings. They show

what he intended, and they show very clearly the ramifications of 18th-century taste.

As the author remarks in the foreword: 'The story of English furniture in Georgian times can be vividly illustrated with a great variety of designs by cabinet-makers, architects and others; and the view we shall thus get of the subject will be different from the usual one, in that the practical and social aspects of furniture, the way it was made, the needs it served in different periods, the woods that were used and other matters of that kind ... will occupy our attention less than questions of style and the purely decorative quality of the furniture represented. As revealed in the designs collected together in this book, *the history of furniture becomes part of the history of ornament in general*'. (My italics.)

It is as part of 'the history of ornament in general' that all furniture should be regarded. Being a social and practical craft, furniture can never be divorced from the social structure of its time and period. A war can prevent the importation of certain woods; a popular monarch or a reigning celebrity can make some particular item or style of furniture fashionable; and a long period of peace can see a gradual increase in comfort. Finally, the influence of fashionable architects and painters upon attendant crafts like furniture must never be discounted.

With the turn of the 18th century we enter upon a period of particular fascination for the student of furniture, because the end of one long period of human craftsmanship is in sight, and the beginning of a new approach to the manufacture of domestic goods is on the horizon. Mechanization or the 'factory system' was not an invention of the 19th century. Even in crafts like that of the furniture maker, or the cabinet-maker, to give him

his grander title, the mass-production of certain items had long been the order of the day. As early as Chippendale we find the sub-contracting process, or 'putting out' of certain types of work, quite general. Similarly, when it came to japanning or lacquering, a piece of furniture would be sent to a craftsman who specialized in this type of work. Inlaying and metal-work had long been specialized subsidiary crafts on their own, while the division of the furniture trade into 'cabinet-makers' (important and fashionable furniture), 'chairmakers', and 'joiners' had been growing more and more marked throughout the 18th century.

One distinctive feature of Regency period furniture is the emphasis on archaeological features, so that it has sometimes been called furniture of 'the archaeological revival'. The most prominent figure connected with this type of furniture was an antiquarian, Thomas Hope. He had spent several years travelling in Greece and the Near East, and had been profoundly inspired by the discoveries of Egyptian art that had taken place under the savants and archaeologists who accompanied Napoleon on his Egyptian expedition. Hope was a collector of antiquities and, in addition, a skilled draughtsman. On his return to England he wanted a suitable house for his collection, and he also wanted furniture which would accord with the antiquities he had bought. Unable to find any furniture on the market which accorded with his ideas of 'archaeological furniture', he set about designing his own. He also published a book of designs in 1807 'Household Furniture and Interior Decoration', which had an influence far beyond its real merits—occasioning Byron's scornful comment 'House-furnisher withal, one Thomas hight'.

The designs in what is often called the 'English Empire' style combined motifs taken from ancient Greece and Rome together with a strong Egyptian influence. In fact, Hope's designs and the pieces made by many other craftsmen in a similar vein owe a great deal to French Empire furniture, and in particular to two French architects, C. Percier and C. Fontaine. Both Percier and Fontaine were architects to Napoleon, and had published a book of designs which clearly gave Thomas Hope many of his motifs and overall conceptions. As he wrote in the foreword to his own book

> I am flattered with hopes of producing in London a work comparable, in point of elegance of designs and of excellence of execution, with that publication which at present appears in Paris, on a similar subject, directed by an artist of my acquaintance, Percier, who having devoted the first portion of his career to the study of Italian antiquities, now devotes his time to the superintendence of modern objects of decoration in France.

As is quite clear from remarks made by the two French architects in their own publication, a predominant influence upon furniture design at this time was the archaeological work taking place in the newly discovered sites of Herculaneum and Pompeii:

> The excavations made in the towns of Herculaneum and Pompeii, by restoring a whole host of objects which at one time formed part of the furniture and fittings of the houses, have vastly increased the current taste for imitating the antique. . . .

They also refer to the Egyptian influence arising from the excavations then being made in the tombs and temples of the Nile basin.

The result of all this archaeological activity was that the Regency period teemed with chairs ornamented with sphinxes; Egyptian masks; wings like those of the Hawk

God Horus; and other motifs like the winged solar disc of ancient Egypt. At the same time the basic design of many of the chairs, couches, sideboards and bureaux made about this time follows a neo-classic style copied from the finds made in Herculaneum and Pompeii. Much of this work is heavy and ostentatious. Indeed, Lord Lonsdale remarked of Thomas Hope's new home, 'Mr. Hope's house resembles a museum'. Some of the Regency pieces made in this fashionable idiom, however, are both graceful and elegant—even though the use of metal mounts is often over-elaborate. Ormolu and brass mounts were also often used in Regency furniture, while the favourite wood was undoubtedly Rosewood.

Anyone interested in the subject of Regency furniture can do no better than visit the Royal Pavilion at Brighton where the furniture, the hangings, and the whole style of interior decoration of this period can be seen at their best. It is, indeed, an opulent and rather vulgar world—but it is not without considerable charm. 'Florid' would perhaps be the best word to describe the Regency style. It is as florid as was the Regent himself, but it must always be conceded that that much-maligned Prince had also a great deal of charm.

EARLY VICTORIAN

One of the reasons why people have tended to be disparaging about furniture made during the Victorian period is not only that much of it is mass-produced, but also that it is extremely difficult to date. It is true that the great majority of pieces made during the 19th century in England were not a product of hand-craftsmanship, as they had been during earlier centuries. In fact, this is almost certainly true for all furniture made as a standard product for the middle and working classes. It was certainly not true of the pieces made for special order, or for exhibition by furniture manufacturers at the countless international exhibitions of the period.

Nearly all Victorian furniture, for whatever level of society (or 'income bracket', to use the modern term) it was made, was soundly and solidly constructed. Because our ancestors had almost a monopoly of African and Far Eastern trade, they had access to the very finest woods available in the world. They had also a large labour-force, much of which was still trained in the craftsmanship standards of the 18th century.

The result of this was that tens of thousands of Victorian chairs still survive, as do tables, chests-of-drawers, bureaux, and bedroom hanging cupboards. The very fact that so much 19th-century furniture is still serving a useful purpose is proof in itself of the standards to which it was constructed. But the other argument, that Victorian styles are a complete muddle, is more difficult to refute.

The fact remains that there is a slim, if somewhat tenuous, thread by means of which one can date the majority of Victorian pieces one is likely to want in one's own home.

J. C. Loudon, in his remarkable work *Cottage, Farm and Villa Arhictecture* (1833) stated that the

> principal styles of design as at present executed in Britain, may be reduced to four; viz., the Grecian or modern style, which is by far the most prevalent; the Gothic or Perpendicular style, which imitates the lines and angles of the Tudor Gothic architecture; the Elizabethan style, which combines the Gothic with the Roman or Italian manner; and the style of the age of Louis XIV, or the florid Italian, which is characterized by curved lines and excess of curvilinear ornaments.

These styles can be found throughout all Victorian furniture, the dominant during the first ten years or so being the Grecian style. At this point I should add that, taking Regency or 'late Georgian' to cover the period from 1790–1840, so, again for convenience sake, the next sixty years, 1840–1900, I call Victorian. But, certainly during the first decade of the Victorian era, the Grecian style (itself a 'hangover' from the Regency), exerted the main influence. Its origins can be traced back to Sheraton, Hepplewhite, and even Thomas Hope.

The curved or sabre leg in dining room chairs is an outstanding feature of this style of design. Basically, ornamentation is slight and the influence of the Neo-Classic is to be seen in the total effect of the piece as a whole. Anyone familiar with the work of Sheraton and particularly the Adam brothers will have little difficulty in recognizing it.

By 1851—that great water-shed of Victorian style in everything from billiard tables to necklaces—the Grecian, or Regency, mode had almost disappeared. In its place

PLATE 4 Bracket clock. Case veneered with king-wood, with pierced brass mounts. Inscribed: *Johannes Fromanteel Londini Fecit* (member of the Clock-makers' Co. 1663–80). About 1670–80. H. 1 ft. 2¾ in., W. 9½ in.

Victoria and Albert Museum. Crown Copyright.

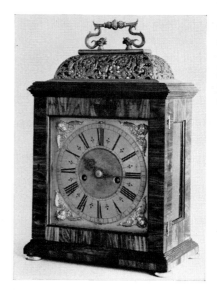

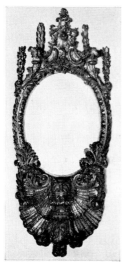

PLATE 5 Mirror. Pinewood frame, carved and gilded. Probably designed by William Kent, for Frederick, Prince of Wales and made by Benjamin Goodison. About 1730–40. H. 5 ft. 10 in., W. 2 ft. 5 in.

Victoria and Albert Museum. Crown Copyright.

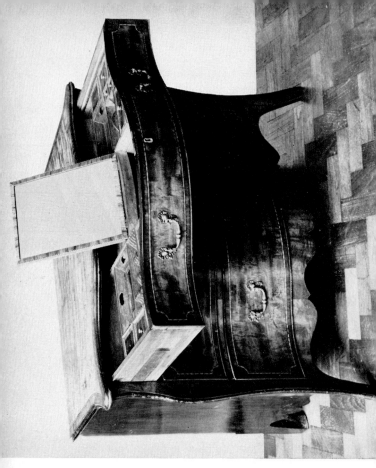

PLATE 6 Dressing table, inlaid with satinwood lines and ebonised wood. c. 1775. H. 2 ft. 9 in., W. 3 ft. 8½ in.
Victoria and Albert Museum.
Crown Copyright.

we find the other three styles mentioned by Loudon. First of all, there is the Gothic, stemming from such incongruous sources as the works of Sir Walter Scott and the achievements of Barry and Pugin in the new House of Commons. From the lodgekeeper's house at Highgate Cemetery, to the remotest seaside boarding house, one can find the Gothic influence on architecture. The furniture, of course, is scattered throughout the world—but anyone familiar with the basis of real Gothic styles will not fail to recognize it, when they see Gothic arch or window-shapes in a chair or bookcase that clearly can have been made only about one hundred years ago.

The Elizabethan style is a typical Victorian hotch-potch of Tudor and Renaissance—but always recognizable by its floridity and by its use of carving, of roundels, of pseudo-Italian heads, *amorini*, and swags of flowers. In silverware, jewellery, and metalwork generally, it was usually referred to as 'In the manner of Cellini'—something that was an excuse for any amount of baroque ornamentation applied regardless of the overall design.

Throughout the whole of the last half of the century the Louis XIV style was fashionable for special pieces made at great expense for international exhibitions, or for the special customers who demanded the very best in Victorian craftsmanship. It is very easy to distinguish, first of all for the distinctive 'Frenchiness' of the decoration and design; secondly, for the general quality of the inlay and marquetry work. The best Victorian cabinet-makers, such as Holland's, Jackson and Graham, Wright and Mansfield, specialized in this manner of work and design. These were firms who exhibited at nearly all the international exhibitions, and it was not uncommon for a special bureau or bookcase made by one of these outstanding

c

cabinet-makers to be sold for as much as one thousand
pounds. (Such has been the depreciation of our currency,
it would be fair to multiply this by five at least.)

The real trouble about dating Victorian furniture is
that none of these styles was automatically succeeded by
another, but that—up to a point—they all coexisted.
Still, it remains true to say that the Grecian died first,
was succeeded by the Gothic and Elizabethan, and then
by the Louis XIV.

These were, indeed, the four basic styles throughout the
whole of the period, but they were also embellished by a
good number of others. After the Queen's Golden
Jubilee (1887) one finds a number of Indian influences
creeping in, while Japanese and Oriental motifs generally
became popular in the last fifteen years of the century.

There is the slight additional complication that, as
always in furniture or the decorative arts and crafts, there
is a time-lapse between the things made for the rich and
those made for the middle class, let alone the poor. For
instance, cheap Gothic, and even cheap Grecian, was still
being made at least thirty years after it had gone out of
fashion among the stylesetters and the better Victorian
craftsmen who worked for the upper echelons of the 19th-
century world.

'Ornament is not a luxury,' wrote R. Wornum (in an
essay which won the international prize on 'The Great
Exhibition as a lesson in Taste'), 'but, in a certain stage
of mind, an absolute necessity'. That 'certain stage of
mind' was something which the Victorians possessed in
full measure. To them, ornament was an indication of
richness and power. Whereas the modern 'status-seeker'
demands the second motorcar, the Victorian business
man demanded a new dining-room suite in a style that

indicated quite clearly to his guests the extent of his bank balance.

The fact that so much of this ornament is mixed up with designs for which it is totally unsuitable does not prevent one from tracing a distinct pattern throughout the history of Victorian furniture. If one bears in mind those four basic patterns which Loudon gives us, there is immediately apparent a distinct skeleton throughout the whole of Victorian furniture and interior decoration. The thing that one has to bear in mind is that it took a good many years before these ideas (as, indeed, is common with all ideas) filtered down to the lower levels of demand, and of the trade which supplied them. A Gothic style chair of really good quality may well be dated somewhere about the middle of the century, but a Gothic style chair of cheap quality is very likely to be ten or even twenty-five years later.

In a trade journal of the mid-century one writer could affirm that:

> Everyone connected with cabinet-making is aware of the difficulty of obtaining good and novel designs of furniture. When, however, such designs are obtained, everyone is equally aware of how comparatively easy it is to adapt them to the kind of work required: they may, in fact, be multiplied indefinitely by engrafting the decorations of one on the forms of the other.

This is perfectly true of much Victorian work, and it is only by knowing which basic designs succeeded one another that any interested student can make the distinction between work dating from the 1850s and the 1880s. At the same time, the very fact that Victorian designers and cabinet-makers were so susceptible to the influences of what nowadays we call 'Fashion', can assist very greatly in placing their furniture within at least ten

years. No one, for instance, would expect to find a Japanese-style china cabinet with bamboo legs in the 1840s, and similarly no one would expect to find a good quality mahogany dining-room chair with sabre legs dating from the 1890s. The dating of Victorian furniture, like that of Victorian architecture, is difficult but it is far from impossible.

MASS-PRODUCTION METHODS

When one considers the immense amount of Victorian furniture still in existence, one is inevitably led to the problem of its production and manufacture. It was during the 19th century that what had formerly been a craft became an industry, using mass-production methods and machinery. To satisfy the ever-increasing demands of a prosperous middle-class (and a rapidly expanding birth-rate) the new steam-driven machinery was brought into play.

Victorian furniture, however, was not only made on one level. When one considers the furniture trade throughout the 19th century, one sees that the pattern was threefold. There was a luxury trade which still carried on the old handcraft methods and made expensive suites and articles of cabinet-work for the rich. There was a middle section which combined a certain amount of handwork with the production of furniture carcases by machine. Finally, there was the lower level which made the cheap articles for the poorer classes.

At this end of the trade one finds what were called the 'garret-masters', individual workmen with a very little capital who lived a hand-to-mouth existence. In that remarkable work 'London Labour and the London Poor' (1851–1864), Henry Mayhew records an interview with a garret-master. The following extract is given at some length because it shows, only too clearly, the conditions under which so much of the cheaper Victorian furniture

was made. It also reveals a sad state of affairs, something
that could never have existed in earlier centuries when the
workman, as well as the quality of his work, was to some
extent protected by the guild and apprenticeship
system.

'I am now 41,' a maker of Loo tables told Mayhew, 'and for the
last ten or twelve years have been working for a linen-draper who
keeps a slaughter-house [a cheap retail shop]. Before that I was in a
good shop, Mr. D-'s, and was a general hand . . . I have often made
my 50s. a week on good work of any kind; now, with three appren-
tices to help me, I make only 25s. Work grew slack; and rather than
be doing nothing, as I'd saved a little money, I made Loo tables,
and sold them to a linen-draper a dozen years back or so, and so
somehow I got into the trade. For tables that, eighteen years ago,
I had in a good shop 30s. for making, now 5s. is paid; but that's
only in a slaughterer's own factory, when he has one. I've been told
often enough by a linen-draper, 'Make an inferior article, so as it's
cheap: if it comes to pieces in a month, what's that to you or me?'
Now, a 4-foot Loo table is an average; and if for profit and labour—
and it's nearly two days work—I put on 7s., I am bid 5s. less . . .
For a 4-foot Loo table I have only £1, though the materials cost
from 11s. to 13s., and it's about two days' work. There's no doubt
about it that the linen-drapers have brought bad work into the
market, and have swamped the good. For work that, ten or twelve
years ago, I have had £3–5s. to £3–10s. from them, I have now 30s.
I know that men like me are cutting one another's throats by com-
petition. Fourteen years ago we ought to have made a stand against
this system; but, then, we must live'.

That is the sad picture of the way the Industrial Revolu-
tion had affected the noble craft of cabinet-making and
joinery at one end of the scale. At the other, however,
things were very different. As J. H. Pollen wrote in an
account of the furniture and woodwork of his day (1877):

The number of hands employed in large cabinet-making and
furnishing establishments is very considerable. Not only are the
workshops provided with joiners, cabinet-makers, and turners, but

also with upholsterers, cutters-out, and workwomen, stuffing, tacking on or sewing on the covers of chairs, sofas etc. Indeed, it is no uncommon occurrence for the entire furniture of royal palaces and yachts to be ordered from one of these firms by the courts of foreign potentates in every corner of the world. Chairs, tables, sideboards, etc., were lately made at Messrs. Holland's for a steam yacht of the Emperor of Austria; while Messrs. Jackson and Graham have been furnishing the palace of the Khedive at Grand Cairo.

In the middle section of the trade, for the homes of the comparatively well-off bourgeoisie, there were innumerable firms such as the well-known Smee & Co., and Story & Co. The quality of wood and workmanship from these firms was sufficient for thousands of their products to have lasted into the second half of the 20th century, but the standard of their designs was often low. Largely copied from pattern books issued by professional designers or by the better-class of cabinet-makers, they were derived from the popular styles which we have considered in the previous chapter.

The really distinguishing feature about Victorian furniture at the middle or lower levels is its florid design, its excess of mechanical carving, and its unrelated use of ornament. A Gothic device, for instance, may well be found incorporated into a piece of furniture whose shape and structure is classical. Any number of books by Victorian designers tell the story very plainly. Here, for instance, is Henry Whitaker in his book of designs (1847) remarking that it 'consists of original designs in the Grecian, Italian, Renaissance, Louis XIV, Gothic, Tudor and Elizabethan styles'. That is exactly why a Victorian bookcase may combine Gothic with Classic, and a sideboard Tudor with Sheraton motifs.

It is worth bearing in mind that the real beginning of the study of English furniture and interior decoration

began during the 19th century—largely undertaken by connoisseurs and men of taste who realized that the new industrialization of the craft was changing its whole pattern for ever. This happened around the 1860s to 1870s, when there was a fashionable vogue for what was then termed the 'Queen Anne' style. This was followed or almost paralleled by the 'Chippendale' style. Plans were published, reproducing designs which were either taken from previous publications (like Chippendale's 'Director'), or were *pastiches* of designs by the better-known craftsmen and designers such as Adam, Sheraton, and Hepplewhite. In the last quarter of the century a great many reproductions or 'variations on the theme' of eighteenth-century masters were made by London and even provincial cabinet-makers.

Along with this revival of interest in English eighteenth-century furniture came the great popularity of French Louis XIV, or Louis XV pieces, examples of which are not uncommon in modern salerooms. Much of this semi-reproduction furniture was of good quality, but it is unlikely that any except the inexperienced would ever be deceived by it. The Victorian furniture manufacturer was not aiming at a careful copy, but merely at something 'in the style of'. The result was that, quite apart from the quality of the carving, there are nearly always a number of features which stamp the work as unmistakably Victorian.

THE GOTHIC REVIVAL

One of the most important of all influences in Victorian decoration, the arts and crafts, and particularly in the craft of furniture, was the Gothic revival. The influence of Augustus Pugin and of Sir Charles Barry, with their designs for the Houses of Parliament, marks a watershed in 19th-century taste. Until then the main style in furniture had derived from what we have seen was the Regency or, as the Victorians themselves usually called it, the 'Grecian'.

A brief glance at the catalogue, or at any of the souvenir volumes surviving from the Great Exhibition of 1851, soon shows that the dominant influence in English furniture design was the Gothic. A great deal of this furniture has survived—partly due to the robustness of its construction. Much of it is totally unsuitable to modern flats and small houses. Much of it, on the other hand, deserves sympathetic consideration.

As is the case with so much Victorian furniture, the wood used was good, and the craftsmanship is quite often comparatively distinguished. The student or collector must first of all learn to distinguish between the harshness and repetitive patterning of mechanical carving, and the sensitive cutting that has been done by a hand-craftsman. It was during the Victorian era that the machine was first introduced on a large scale into the furniture industry. After the middle of the century only the

furniture made by the better quality cabinet-makers retained any of the distinction of its ancestors.

Firms such as Jackson and Graham, Wright and Mansfield, and Gillows, still employed first-class craftsmen right up to the end of the century, when in most other directions the machine had ousted the old-fashioned hand-workman. It is the products of firms of this calibre that are still deserving of the collector's attention. At the present moment, the Gothic is far from fashionable in England—yet another reason why examples of Victorian Gothic can often be bought at comparatively low prices.

If it was the influence of Pugin and Barry which largely served to promote the Gothic style, the work of writers like Sir Walter Scott and Joseph Nash with his book, *The Mansions of England in the Old Time*, created a nostalgia for old oak furniture. One of the distressing factors which one must record is that it was during this period that a great deal of simple oak furniture which had survived from previous centuries was elaborately carved and altered.

In the 19th century, the taste for collecting and preserving old furniture had hardly begun, with the result that few saw any question of vandalism in taking a Tudor coffer and 'improving' it with contemporary carving. Similarly, with his love for the Gothic or Elizabethan styles, the Victorian's outlook was not that of an antiquary. To him the *pastiche* of a Gothic room, with oak panelling, leaded casement windows, carved oak cupboards, tables, and chairs, was a means of escape from his drab industrial environment.

One should not expect then that Victorian Gothic will have any of the simple purity of the original. It is much more ornate and elaborate, and no one with any acquain-

tance of the true Gothic could ever be deceived by a
Victorian piece. Loudon wrote about the Gothic style
that

> To a Briton this style is rich in associations of the most interesting
> description.

It was the 'rich associations', and not a faithful transcript
of the past, that the Victorian wanted from his furniture
and furnishings.

Ornament, as we have seen, was the passion of the
Victorians, and it was because the Gothic style was rich in
ornament that they so happily adopted it. Under a head-
ing, 'Gothic for Drawing Rooms', Loudon shows among
other things an oak chair with elaborate carved Gothic
back, but with spiral twist legs that suggest the period of
Charles II.

Accuracy, then, is not something one should expect in
Victorian Gothic. In another catalogue one finds a chair
described as 'Gothic' which has all the appearance of a
Charles II cane chair. At the same time—and this is
especially true of the better London cabinet-makers and
individual designers—there was some remarkably fine
furniture made in an almost pure Gothic idiom.

Oak, of course, is the wood which predominates in all
this type of furniture—and the oak used by Victorian
craftsmen was a great deal better than the oak obtainable
today. Much of it, of course, was imported, but a great
deal of it came from the remnants of the great oak forests
which had once been England's glory. It was good oak,
and it was well-seasoned before reaching the furniture
maker's workshop.

This is one reason why, although it may have gone out
of fashion, Victorian Gothic furniture repays a little
attention. A small 'refectory' type table, made by the

firm of Smee & Co., sometime in the late 19th century, can have as fine a grain and quality of oak as can be found anywhere else. Oak furniture need not be heavy and 'depressing', as it is sometimes called, provided that the walls and the rest of the interior decoration around it are kept light and simple.

A curious feature of certain Gothic-type furniture made in the mid-19th century was the use of bog-oak. This is a very hard and dark type of oak, coming from Ireland. It would seem to have gained its first popularity during the Great Exhibition of 1851, when a number of pieces were exhibited in this material. The elaboration of the carving may offend the modern feeling for simplicity, but again, if the pieces are set against simple backgrounds, this elaboration is a large part of their charm.

Elaborate turning, barley-sugar effects, carved figures of cupids and monsters, gargoyles, masks, all these were the hallmarks of Victorian Gothic. A great deal of it deserves to stay where it is most often found—in remote small hotels and boarding houses. This was the mass-produced Gothic dating from the latter part of the century. Nevertheless there were at the same time a number of designers and cabinet-makers producing pieces which combined dignity with serviceability.

THE 19TH CENTURY HOME

The Victorian age has already receded so far from us that its social life and customs call for some explanation before one can fully understand the furnishings of the Victorian home. A man makes his home, furnishes it and lives in it, but the way in which he lives, the clothes he wears, and the food he eats, all have their bearing on the furniture with which he surrounds himself.

In the 18th century, for instance, the popularity of the new custom of tea drinking—and its association with China—had introduced the vogue for *Chinoiserie* in ornament. The association of books with monasteries and ancient seats of learning, and thus with the Gothic style, also led many noblemen to furnish their libraries in revived Gothic. In the same way, to take one instance, in Victorian days the growth of the Tobacco habit and its associations with Turkey led to a Moorish vogue in smoking rooms and studies, as well as in gentlemen's smoking costumes. The increasing importance of India as 'The Brightest Jewel in the Imperial Crown' led to the importation of much Indian brasswork, and to the copying of oriental and Indian designs on metalwork, hangings, and fabrics.

Like any other room in the house the hall showed the social pretensions, and something of the income group, of the householder. In the more formal social conditions obtaining during the Victorian period the hall possessed an importance which it has entirely lost today. For it was

here that the visitor waited until such time as the master or mistress of the house had been acquainted of his presence by a servant, and was ready to receive him.

The hat-coat-and-umbrella stand was an essential piece of furniture in the middle-class home. Like so many 'Victorian' designs it would have appeared to have originated during the Regency period. There is an illustration of such a stand in Ackerman's 'Repository of the Arts' as early as 1812. The earliest stands were of a central pillar type, with pegs for hanging coats and cloaks at the top, and a pierced circular platform half way down to support umbrellas and sticks. Although the umbrella is still with us, the stick has virtually disappeared, and it is worth remembering that it was almost a *sine qua non* of the Victorian gentleman's wardrobe. Later Victorian hall stands, which were made in considerable numbers in every style from Gothic to Balmoral Scottish, were designed to stand like dressers with their backs to the wall. The central panel of the stand normally incorporated a looking-glass.

The next most important piece of furniture in the hall was a table, usually of mahogany or oak, upon which was placed a salver or bowl for the reception of visiting cards. Again, the greater formality of the Victorian world is brought home to us. An examination of any of the 19th-century books on etiquette will show the importance of the custom of 'calling and leaving a card'. Cassell's *Household Guide* contains the whole elaborate etiquette on the subject.

A lady should always be prepared to receive visitors, if at home, between the hours of three and five o'clock ... When making a ceremonious morning call a gentleman should take his hat with him into the drawing room, and when there should hold it in his hand

in an easy manner. It is not now necessary for a gentleman to take off his gloves, if they be particularly well-fitting and of light colour.

In case the gentleman might be requested to wait, there was either a hall seat, or a hall chair, to accommodate him. The hall seat, which dates back to the 18th century, had one distinguishing feature which did not make for the comfort of the visitor—it was of hard wood, not upholstered. It is possible that this traditional type of seat was not upholstered on the grounds that the gentleman might still be wearing his wet overcoat. The typical Victorian hall chair had a wooden back, often carved and sometimes containing a central panel in which a coat of arms could be cut. This style, too, dated back to the 18th century when a nobleman would have his arms or crest incised or painted on the panel. It is an interesting illustration of the social snobbishness of the Victorian period that this type of chair—having its origins in the habits and usages of the 18th century aristocracy—should have been adopted by tens of thousands of bourgeois householders. Even if they had no crest to engrave, the manufacturers of such chairs made them with standardized lions and heraldic figures and animals to convey the right feeling of 'Baronial nobility'.

An important position in the hall was occupied by the long case or 'grandfather' clock. Most of the standard clocks of this type made during the 19th century were cased in mahogany and had a seven-day movement. Cheaper varieties which required rewinding every twenty four hours were also made in considerable numbers. Companion to the clock was that essential to the English climate—the barometer. The earlier versions were of the mercurial type in slender stick-cases. But, after the

invention of the aneroid barometer, the familiar banjo-shaped case made its appearance in most Victorian halls.

Almost invariably, hall furniture was of oak or mahogany. If it was of oak, the style of design was likely to be either Gothic, or 'Elizabethan' as it was known. If mahogany, 'Grecian' was the prevailing style for this type of furniture, with turned legs to the table, and rococo scrollwork decorating the backs of the chairs.

To the Victorians the hall was a place of some importance, for it was here that the visitor received his first impressions of the wealth, social status, and nature of the family upon whom he was paying his call. E. Knight in *Taste and Economy in Decoration and Furniture* (1893) stated that

> It tends to be an index to the whole house. Articles should be there displayed to invite inspection and to convey generally an air of welcome . . . Too much attention cannot be paid to apparently trifling details—such as lighting up a dark corner with, for instance, a bust, a figure, or a light porcelain vase, or the judicious prominence being given to some particular piece of furniture, or the placing of a picture on an easel in front of some piece of drapery.

In town houses the hall was lit by gas, but in the country districts, where this was not available, suspended paraffin lamps of various elaborate designs were used. In the early part of Victoria's reign the colza oil lamp was used for house lighting, but it soon gave place to paraffin, and then to gas.

One of the great difficulties of dating correctly any pieces of Victorian furniture, lies, as has been emphasized, in the fact that so many different styles were extant at the same time. Even a Victorian hall chair provides us with this problem as much as a drawing-room chair or an elaborate escritoire. The dating of 18th-century furniture

in comparison is simple, because there exist definite signposts which indicate at what decades each of the various styles flourished.

Particularly favoured for hall furniture was what J. C. Loudon termed the 'Elizabethan' style, which was at its most popular during the first half of Queen Victoria's reign. It combined motifs ranging from Elizabethan to Carolean, and has been aptly termed by modern historians 'Jacobethan'.

> 'We may observe,' [Loudon wrote], 'that there is no end to the variety of form and combination which might be introduced into Gothic chairs.'

Victorian furniture, in fact, had little or no real distinctive style of its own. It was indeed a rag-bag of every kind of ornament, derived from every country and every age, and clapped on to whatever basic form took the designer's fancy. This still does not mean to say that some of it cannot be quite pleasant—nor does it in any way mean that the work and the woods used in the construction were not good—or even excellent.

The complete misunderstanding of the true use of ornament in furniture design—or in the design of the other crafts—was the Victorian manufacturer's real error. His idea was that the more the decoration and 'the richness' (a favourite expression of the time), the better an article would be. Machinery had made carving on woods like mahogany no longer a specialized job, costing the labour of an expensive craftsman. Elaborately-carved furniture was now within the reach of nearly everyone who could afford a house.

THE VICTORIAN DINING ROOM

In London and the other cities of Britain the rapid increase in building, and the annual erection of mile upon mile of similar streets of small family houses, rapidly transformed 18th-century cities into the vast urban areas which we know today. The growth of the population during the 19th century resulted not only in this immense building activity, but in the production of millions of pieces of furniture for the Victorian families. This is the reason, quite apart from any other, why for every 18th-century chair there are a hundred Victorian ones. At the turn of the century the population was approximately 9,000,000, but in the census of 1831 the total population of the United Kingdom had already risen to 24,000,000.

Among the many pieces of Victorian furniture which are common on the market today are dining-room tables, chairs, and sideboards. Some, though far from all, of these articles are of good quality and material, and can look pleasant in a modern house. Today the dining room counts for less than it did in the 19th century, but it is the very fact that in those days no town house, however small, could be without its separate dining room which accounts for the number of suites of chairs, tables and other dining-room items still in existence. The greater size of the average Victorian family and the greater quantity of the meals meant inevitably that the dining room was of much greater importance than it is today.

In the average middle-class town house the dining room almost invariably opened off the hall. The size of the meals, even in a moderately prosperous home, would amaze the Victorians' grand-children. Mrs Beeton's *Household Guide*, and numerous other publications dealing with the conduct of the Victorian home, all reveal to us a world where eating and drinking played a far greater part than they do today. Thomas Carlyle describes life as it was lived in a large country house as

life occupied altogether in getting itself lived; troops of flunkeys, and bustling and becking at all times, the meat-jack creaking and playing all day . . .

Even when describing the meals of the poor, Charles Dickens can amaze us with the sheer quantity of food which our ancestors ate. There were not many perhaps who could rival the appetite of Lord Palmerston who is described at the age of eighty as taking for dinner:

Two plates of turtle soup, a plate of cod and oyster sauce; he then took a pâté; afterwards he was helped to two very greasy-looking entrées; he then despatched a plate of roast mutton; there then appeared before him the largest, and to my mind, the hardest slice of ham that ever figured on the table of a nobleman, yet it disappeared, just in time to answer the inquiry of his butler, 'Snipe, my Lord, or pheasant?' He instantly replied 'Pheasant', thus completing his ninth dish of meat at that meal.

The dining table was inevitably the principal piece of furniture in the room. It was wide, and upheld on four stout, turned legs. The typical Victorian dining table was capable of being extended by the addition of extra leaves to accommodate guests for a dinner party. The four legs were of sufficient massiveness to be able to support the table even when it was extended.

A table of this type was known as a 'Telescopic Table' and Sir Charles Eastlake in his book *Household Taste*

(1875) had some very pertinent comments to make about the subject of its design:

> Among the dining room appointments the table is an article which stands greatly in need of reform. It is generally made of polished oak and mahogany laid upon an insecure framework of the same material, and supported upon four gouty legs, ornamented by the turner with mouldings, which look like inverted cups and saucers piled upon an attic baluster . . . When it is extended, it looks weak and untidy at the sides; when it is reduced to its shortest length, the legs appear heavy and ill-proportioned. It is always liable to get out of order, and from the very nature of its construction must be an inartistic object.

One thing, however, which Eastlake forgot to mention was the fact that, even if it was ugly, the Victorian dining table was comfortable to sit at. Except at the extreme corners where no one sat, there were no legs to get in one's way. Furthermore, when in use, its ugly and heavy legs were hidden by a table cloth, and at other times by a baize or linen cover. At a Victorian dinner party it was no longer the custom as it had been in the 18th century to remove the cloth for dessert. This is confirmed by *Cassell's Household Guide*:

> 'The table-cloth is now almost invariably left on the table for dessert. This plan saves a great deal of trouble and on that account is to be commended.'

The 18th-century dining table, on the other hand, was an elegant piece of furniture—whether it was supported upon several legs or upon a central column with a tripod foot. The Victorian successor was ugly, but the ingenious ease with which it could be extended, to some extent compensated for this.

The large size of the typical Victorian family, as well as the social custom of entertaining large dinner parties, meant that the table must be massive and that a long set

of chairs, as well as a sideboard of monumental propor-
tions, must be provided. The sideboard was, without
doubt, one of the most important pieces of furniture in
the Victorian home. It was very much an index to the
wealth and social pretensions of the householder. It is not
surprising therefore that we find so many of the *pièces de
resistance* made by furniture firms for the various Inter-
national Exhibitions consisted of ornamental side-
boards. What the elaborate family bed had been to earlier
generations, the sideboard became for the Victorians.

Usually the Victorian sideboard was of the pedestal
type. The top, which was fitted with drawers, spanned
twin pedestals and in the open space beneath the arch
there was room to stand a cellarette. This type of side-
board dates back to the beginning of the 19th century,
and even earlier. By Sheraton's time the sideboard had
already become an object for the display of silver plate,
and not only for serving the dinner. By Victorian times
the sideboard's original function had yielded place to its
function as a display object: the carving and serving of the
meals usually being carried out by the master at the head
of the table, the vegetables and other dishes being handed
round by the servants—and the sideboard glowing with
silver, fruit, and wine. The Sheraton type of sideboard
from which the Victorian had evolved had a back con-
sisting of brass rails, upon which silver salvers rested.
These rails evolved into a low back made of wood. From
the Regency onwards this back continued to grow in size
until by the mid-Victorian period it had swollen to a
height of several feet—often with a looking-glass panel
inserted in it.

Elaborate and massive sideboards of this type were
among the *chefs d'oeuvre* for important cabinet-making

firms like Holland and Son, and Jackson and Graham. Like all articles of furniture which outgrow their natural function, the massive sideboard suffered from a sharp decline in favour. By the last quarter of the century more elegant pieces, once again in the manner of Sheraton, began to take its place.

The set of chairs for the dining room often numbered twelve, and two of these were 'armchair type' or 'carvers' as they were called. These 'carvers' were for the master and mistress of the house and were placed at each end of the long table. The design of dining-room chairs was extremely varied. Like the rest of Victorian furniture the styles ranged from Elizabethan, Gothic, and 'Queen Anne' to reproduction Chippendale. For a long time the 'Grecian' style which had become popular during the Regency persisted in fashion. These were, perhaps, the best and most comfortable of Victorian dining-room chairs, with their balloon-shaped backs which supported the diner, and their elegant sabre, or upright turned legs. The Gothic Revival brought into existence a great number of dining-room suites in the heavy 19th-century Gothic style. These were often made of oak, but throughout the century most dining-room chairs were mahogany. Wire springing for the seats of chairs had been invented before the close of the 18th century, but these springs did not become commercially available on a large scale until the Victorian period. Most Victorian dining-room chairs will be found to have such sprung seats.

The majority of dining rooms were lit by a large central gas chandelier (in the cities at any rate), with candles on the table and sideboard as secondary lighting. The large plaster roses which decorate the ceilings of so many Victorian houses were designed to take such central

chandeliers, and the rose was pierced to allow the heat from the gas jets to escape.

A grating should be concealed in the central flower, and a pipe, not less than two inches in bore, carried from it to an airbrick in the wall or chimney. This pipe will convey away not only the air destroyed by the gas, but a current will be created which will carry off all the foul air produced by the breathing of the inmates of the room.

The Victorians did not sit so long over their wine as had their Regency fathers, and we learn again from Cassell's Home Guide:

Sufficient time for the enjoyment of wine having been allowed, a servant, by preconcerted arrangement, brings in the coffee. Within about half an hour from having served coffee, tea is generally taken in the drawing room in the same fashion; and in most houses notice of the fact is given to the master of the house, if still in the dining room. This is a sign that those gentlemen who please are at liberty to join the ladies.

THE VICTORIAN BACKGROUND
AND THE DRAWING ROOM

In attempting to evoke the typical furnishings of the Victorian home one has always to keep a picture in one's mind of the whole social and architectural background. What we, perhaps, tend to dismiss as the 'stuffiness' of the Victorian room was reflected to no small extent by the surrounding world of the new industrial city. The thing which would most have struck the modern observer was the dense smoke-pall from the millions of private houses as well as factory chimneys—that blanket of smoke which made London fogs world-famous, and which still seems to linger in the great literature of the period; so that it is impossible to open the works of Dickens without seeing the city as it then was—wreathed in yellow smoke and lit by the flare of gas-jets. For gas had come in as early as 1807, and the Gas, Light and Coke Company had been incorporated in London by 1812.

The sound of Victorian London was very different from its sound today. Now it is a hum, or a mechanical murmur, but then it was a great clattering, resounding roar from the millions of horses' hooves and iron-bound wheels as they passed over streets that were still largely cobbled. G. M. Trevelyan, in his *British History in the Nineteenth Century*, gives us the following picture:

Night and day hundreds of horses in relays were coming up at trot and gallop from the South Coast and even from the Berwick and Solway salmon fisheries, bringing fresh to Billingsgate the best fish

of every port. A hundred thousand head of cattle and three-quarters of a million sheep yearly walked up to Smithfield for the slaughter, many of them from Scotland or from the borders of Wales. But strangest of all to the modern eye would be the droves of geese and turkeys, two or three thousand at a time, waddling slowly and loquaciously along all the roads to London for a hundred miles round, between August and October, feeding on the stubble of the fields through which they passed.

All this may seem a long way away from the Victorian drawing room and its furnishings, but the truth is that one cannot dissociate man's home and his furniture from the background of his time. If one has a mental picture of Victorian London one is in a better position to understand and evaluate the furnishing of the homes. In a typical middle-class Victorian house the drawing room would be on the first floor. It was the seat of entertainment, and the room which, above all others, belonged to the mistress of the house.

In terrace houses, such as the many built in London and the provinces, the first-floor drawing room was sometimes divided at the far end by sliding doors from a smaller room, used either as a study or as the mistress's work room. H. C. Davidson, in his *Book of the Home* (1900), defines precisely the place of the drawing room in the Victorian scheme of things.

A drawing room should especially give the idea of rest and comfort. Here the family gathers for recreation after the duties of the day, and here visitors are received.

On the subject of folding or sliding doors, dividing the drawing room proper from the study or work room, we see how Mr. Pooter in *The Diary of a Nobody* managed to conceal the fact from his guests that they were being entertained in what were normally two rooms, and not one large drawing room as it appeared:

> The arrangement of the drawing room was excellent. Carrie had hung muslin curtains over the folding doors . . .

In the Victorian drawing room the focal point was often a piano. In a society where amateur music played so important a part, it was not surprising that a great deal of care and attention should have been lavished upon the piano. Mahogany cases inlaid with satinwood were fashionable, and the front panels often had designs inlaid in ivory and mother-of-pearl. The long unbroken lines of the upright piano were usually softened by hanging draperies, and by ornaments and candlesticks.

Over the elaborate mantelpiece—a feature of both the drawing room and the dining room—it was usual to find a large mirror in an elaborate frame. These deep expanses of looking glass became a feature of the Victorian home—something which they could not have been in the 18th century when the expense of making such large areas of glass would have made them prohibitive except for the wealthy. At the other end of the room from the mantelpiece there would sometimes be another large mirror in a tall gilt frame, sited immediately above a gilt console table. To add to the richness and elaboration of the room, low cabinets or chiffoniers with display shelves for china and other valuables were favoured by Victorian ladies.

The habit of china collecting increased throughout the century, and it was not only the rich dilettante or amateur of the arts who fancied that no room was complete without its china. The habit spread among bourgeois Victorians and brought in its wake many pieces of furniture which now seem to us redundant, like the whatnot and the china cabinet. To accommodate china over the doors of the rooms, a kind of shelf known as a Japanese over-door was introduced in the '80s. The

method of constructing these is explained in an issue of the 'Illustrated Carpenter and Builder' (1883).

Judged by 20th-century standards, the room was vastly over-crowded. The Victorian writer Robert Kerr in *The Gentleman's House* enumerates the many objects which the fashionable drawing room should contain. They include:

'—couches, chairs, ottomans, chiffoniers, what-nots, occasional tables, and cabinets.'

The central ottoman in a large drawing room provided the focal point of the seating arrangements. Other ottomans were sited against the side walls, and pouffes were often arranged around the fireside. Upholstered chairs and couches were also thought essential, and when one considers that a number of guests—as well as the family—had to be accommodated during an evening's entertainment the profusion of Victorian chairs and seats becomes more explicable. There was little or no outside entertainment in those days and people made their own amusements. Quite apart from the large size of the Victorian family, this meant that an entertaining room like the drawing room had to be furnished to seat a considerable number of guests.

The coal fire being the only source of heat in the room, it was not surprising that a great deal of attention should have been paid to the mantel- and chimney-piece. Often of white marble, the Victorian chimney-piece was hardly complete without its clocks in an ormolu and marble case. It also served as a repository for metal candelabra, vases, silver-mounted miniatures, as well as pastille boxes and other minuterie.

The circular table on a pedestal, or the Loo table (so called after a popular card game of the century), often stood in the bay-window. Made *en suite* with the chiffoniers

and cabinets, it often had a finely inlaid and decorated top, and was largely a display object—unlike the Loo table of the parlour, which was primarily utilitarian.

The bay window itself was a curious feature of the Victorian home, but it was so popular that practically no new building was complete without one. Indeed, many old buildings had a 'face lift' to accommodate one. It was a builder's device rather than an architect's and—though it could rarely be called beautiful—was practical in that it let in more light, and provided a useful extension to house the desk, writing table, or Loo table.

The importance of furniture to the Victorian home is often misunderstood by people today. Their houses were full of furniture and furnishings, for the very reason that the home was in itself all-important. With little incentive to go out for their amusements, and with the background of their large families and comfortable houses, the Victorians were home-loving people. As the Grossmith brothers put it in the mouth of Mr. Pooter:

> After my work in the city, I like to be home. What's the good of a home if you are never in it? 'Home, Sweet Home,' that's my motto. I am always in of an evening.

PARLOURS AND BEDROOMS

Servants were the foundation upon which the whole social and economic edifice of the Victorian home was raised. Without a proliferation of servants, there could have been no cluttered drawing rooms, no coal fires to every bedroom, and no streets of mile-upon-mile of three, four, and even five storey houses—each with its basement, as often as not. The passing of the domestic servant has changed the whole surface and appearance of English social life (and therefore of furniture and furnishings) more than anything else in the past five hundred years.

An important room in the Victorian home, and above all the 'Family Room', was the Parlour. It fulfilled a number of uses, the family often taking their breakfast there, as well as afternoon tea. In addition, it was to some extent the children's room, and used by them for games and indoor amusements. This was particularly the case in the middle-class home. In the houses of the rich, the children had their own separate day nursery.

The main piece of furniture in the parlour was the Loo table. It was usually kept covered to protect its surface, although the Loo table to be found in the parlour was a less ornate piece of furniture than the one in the drawing room. Supported on a central pillar, Loo tables were made in a wide variety of woods, the tops often being inlaid. Veneering, inlaying, and fretwork were increasingly used in standard items of furniture like the Loo table as the

century advanced, and mechanical fret- and veneer-cutting machinery became generally used in the trade.

A sofa or ottoman and a suite of chairs were the other principal articles in the room. They followed the prevailing fashions of the time, but would tend to be less ornate than the 'display' ones in the drawing room. Another feature to be found in the parlour—and indeed in most rooms in the house—was the firescreen. This essentially English object was mounted on a pole, with a circular or tripod foot. Its panel was often of wool, sometimes of needlework, and quite commonly papier mâché or inlay. Its purpose was not only to conceal the fireplace when the fire was not in use, but also to prevent the direct heat of the fire scorching the faces of people sitting around or in front of it. It was fairly uncommon on the Continent, where the enclosed stove took the place of the English open fire. In those days of cheap coal the Victorian householder could afford to be wasteful with his fires, whereas on the Continent, where coal was more expensive, the more efficient and economical closed stove was in general use. In the Victorian dining room, too, the firescreen prevented the diners who had their backs to the fire from getting over-warm during the meal.

When one considers the number of rooms in even a comparatively small Victorian house, and the amount of furniture required to fill them, it is important to bear in mind the relative purchasing power of the pound sterling at that time. A contemporary article on the subject of furnishing a house, for instance, tells us that:

> A snug little villa occupied by a couple with an income of £200 a year may be neatly and prettily furnished for £100.

In an advertisement in 1855 a firm of cabinet-makers, Messrs. Leverton, estimated the cost of furnishing a six-

room house at £67-17-6, £4-16-0 of which was scheduled for the outlay on a servant's bedroom.

A great change took place in the English bedroom during the 19th century. A writer in Cassell's Guide informs us:

> Medical men consider it the more healthy plan to sleep on beds with as few draperies as possible. With a view to promote healthy slumbers, and yet have ornamental surroundings, furniture-makers have again brought into use the Arabian bedstead, in wood, iron, and brass, which they term Half-Tester.

The disappearance of the four-poster bed from the English home is one of the notable features of the Victorian era. Until the 19th century it had always been considered that the night air was bad for the health. The wise, therefore, slept in a four-poster, enclosed from air and draughts by heavy curtains. Perhaps due to the spread of medical knowledge, or perhaps to a new regard for open air and exercise which characterized the last quarter of the century, the Victorians dispensed with the hangings—except in so far as they were ornamental round the head of the half-tester.

Along with the disappearance of the four-poster, the framework of the bed also changed, and wood was very largely replaced by brass or iron. From the point of view of health and hygiene (especially in poor areas where the ubiquitous bed-bug had always been a curse), this was a notable advance. So was the appearance of the sprung mattress in place of the old feather or flock mattress. Victorian bedsteads of brass ranged in price from £4-15-0 to £20 for a full-size half-tester. Iron bedsteads, such as were used in servants' rooms, were considerably cheaper. By the latter part of the century the brass or iron bedstead had almost completely ousted the old wooden type.

It is, perhaps, a curious fact that there is little to be found in contemporary letters or books as to the reasons for this notable social change, from the four-poster to the half-tester or the plain brass bedstead. When Pepys, for instance, found himself in a bed without curtains, it was sufficiently strange for him to record in his diary that he had slept in 'a naked bed'.

Throughout the Victorian period the family bed was the large full-size 'double bed'. Although Sheraton in his drawing book had been so advanced as to show the design of a bed with two separate mattresses (with a passage down the middle), which he called a 'Summer Bed', the idea of twin beds was a 20th-century innovation.

The dressing-table and the wash-hand stand were the two other main pieces of furniture in the Victorian bedroom. The surface of the latter was usually of marble, and the splash-back of marble or tiles. The dressing-table differed from the 18th-century type in that the looking-glass was now a fixture, and part of the table itself. Previously the looking-glass had been portable: an independent object in its own right.

Other pieces of furniture to be found in the Victorian bedroom were the chest-of-drawers, the night commode, and the wardrobe. Chest-of-drawers and wardrobe were usually made of mahogany if of best quality, or of mahogany veneer on an oak carcase. They were solid and heavy objects, but—as the purchaser of one will often find—almost invariably with well-fitting drawers. The wardrobe itself was usually large, and of the 'wing' type. Sometimes the central panel would be fitted with a looking-glass. Machine-carving of swags of fruit and flowers often decorated the side-panels or wings. Mahogany veneers, machine-cut, were laid on a carcase of oak in

most cases. Veneer-cutting by machinery now meant that almost every middle-class family could afford pieces of furniture which, to the casual glance at any rate, looked as if they were made of solid mahogany. But even cheap articles made by mass-production firms such as Smee & Co., and Storey & Co., were of heavier and better wood than most of their modern equivalents.

Whatever Victorian furniture might lack in design, it often made up for it in terms of good wood and solid workmanship. Thousands of Victorian Loo tables, chests of drawers, beds, chairs and wardrobes are still giving good service. One wonders if the same will be true of our own mass-production furniture in one hundred years' time?

PAPIER MÂCHÉ FURNITURE

One distinctive feature to be found in many Victorian articles, furniture included, is the use of papier mâché. Not so very long ago, tables, chairs, fire-screens, boxes and even beds made of papier mâché were being thrown out of attics and spare rooms as no more than rubbish. That was in the 1930s, when a revulsion against the Victorian period gripped many a householder. It was a very great pity, for many of these pieces were worthy of preservation. Nowadays, when papier mâché is collected almost as if it was fine gold, the owners of these discarded pieces could have made themselves a handsome profit.

Before considering the type of articles that were made in papier mâché, or considering styles and techniques, it is important to ask—what exactly is it?

'Pulped paper' is the answer, and it was in France—or more specifically Paris—that papier mâché originated. In the 18th century, due to the Parisian habit of pasting up advertising bills over night (and renewing them every twenty-four hours), there was an enormous wastage of paper. Then an astute manufacturer came along, and discovered that this waste paper could be processed so as to make a surface that was almost as durable as wood, and considerably lighter. As in the case of so many Western 'inventions', papier mâché had been anticipated centuries before in China. The intelligent and inventive Chinese had used it for everything from decorative box-ware to military helmets.

The early French papier mâché, which was soon copied by manufacturers in England, differed from the Victorian articles with which most people are familiar. It was made from a high-grade paper pulp, which was then poured into a mould and allowed to harden. Very little quality 18th-century papier mâché is to be found today, and its price makes it almost on a level with other 18th-century pieces of craftsmanship. It is 19th-century papier mâché that, scarce though it has become, can still be found in the shops of second-hand furniture and antique dealers.

This later type of papier mâché was made of sheets of special paper, known as 'making paper'. The best quality was made of rag pulp, and each sheet was a little thicker than a sheet of modern blotting paper. These sheets were laid one upon another, glued so that they adhered together, trimmed to shape, and then prepared for varnishing by 'stoving', or drying in slow ovens. The finished article was then 'japanned' or lacquered. The usual basic background was black, but upon this were painted elaborate floral decorations, pastoral scenes, or imaginary Oriental designs.

Almost every type of article was once available in papier mâché. Here is an extract from a manufacturer's catalogue at the end of the 18th century:

> High varnished panels or roofs for coaches, all sorts of wheeled carriages, and sedan chairs, panels for rooms, doors and cabins of ships, cabinets, bookcases, screens, chimney-pieces, tables, tea-trays, and waiters.

Over the years, of course, nearly all the big pieces have disappeared. It is only the small domestic items that remain to interest the modern collector. Trays, boxes, fire screens, letter racks, these have survived because they

have been carefully looked after in private homes. The most familiar object of all is the papier mâché tray, easily distinguishable from a similar article in wood by its lacquered surface and its lightness.

It is the quality of the decoration which decides the quality of the papier mâché. Quite early in the 19th century, some of the finest craftsmen and decorators in England turned their ability to painting on papier mâché. They used yellow and green-bronze shades, made out of metallic powder. Much of this early work consists of flower paintings. One of the major discoveries during this period was the use of bronze powder to get light and colour into simple country and pastoral scenes.

Bronze, copper, zinc, silver, and gold powders were widely used in the decoration of papier mâché during the first half of the 19th century. If one is ever lucky enough to come across a tray, firescreen, box, or piece of desk furniture, with a rustic scene painted on it in these metallic colours, it is always worth buying—unless the price is exorbitant. Military and naval processions, pageants, and pictures copied from the works of popular artists like George Morland, were widely used themes.

Few of these early pieces, however, are on the market, for their decorative value has long been appreciated by collectors. There is one style which is still sometimes to be found on trays and boxes. This is a little more elaborate and detailed, executed with metallic powders standing in relief above the surface of the lacquer. Cathedral scenes and country landscapes were popular in this so-called 'Wolverhampton' style. A typical example would be a lacquered papier mâché tray on which is depicted the interior of a cathedral, with shafts of sunlight falling through the windows.

The one type of papier mâché with which most people come in contact at one time or another is that in which mother-of-pearl or shell inlay is used, and sometimes also glass or 'paste' stones inset. Most of this dates from the second half of the 19th century, and a great deal of it is coarse, second-rate work. Japanese or Oriental themes were popular, and the shell was sometimes used for sky backgrounds, being overlaid with transparent paint. Although boxes, trays and screens made in this style now command pounds rather than shillings, most of this papier mâché is of little real value.

From the point of view of furniture, it must not be forgotten that the Victorians, particularly in the mid-19th century, used papier mâché for practically every type of article—tables, chairs, and even beds. Very few of these large pieces have survived, for the reason that their construction was often a little weak. Even though the papier mâché was usually wrapped around an iron frame, it inevitably had to be coarsened to take the stresses and strains involved.

It is still sometimes possible to find a papier mâché table. They are usually modelled on the familiar Loo table, the central column and foot being cast-iron disguised by wrap-around papier-mâché. An idea of the extent to which papier mâché manufacturers went in their use of the material can be gauged from some illustrations in a magazine published in 1853. These show a whole life-size model village being exported to Australia. There were ten cottages, and even a ten-room villa, all made in papier mâché, together with their furniture and fittings. It would be interesting to know whether anything of it still remains.

Dating furniture and other articles made in papier

mâché is largely a question of eye, combined with a knowledge of techniques. Anyone familiar with the varying styles and shapes of Victorian furniture will not have too much difficulty, for the manufacturers followed whatever style was in vogue in household decoration. For instance, after the building of Sir Charles Barry's new Houses of Parliament between 1840 and 1860, the country was swept by a passion for Gothic. So the makers of papier mâché trays, for instance, developed a Gothic style of rim. It was rather similar to what a silversmith would call a 'gadrooned rim'—an ornamental edge formed by a series of convex curves. Another type of rim found in papier mâché was the 'Windsor', an architectural style where the edges sloped away from each other at about 45 degrees. Most common of all was the Sandwich rim. This had a straight edge, which was turned upwards all round, and then flattened horizontally.

A firescreen or chairback or other papier mâché article containing a moonlight scene—the sea at night, ruins under a full moon, or a silvery countryside—was almost certainly made after 1864. This was the date when the famous papier mâché firm of Jennens and Bettridge introduced powdered aluminium as a decorative device. Moonlight on Gothic abbeys, moonlit country with a castle in the background—such subjects appealed to the romantic streak in the Victorian temperament.

Very few pieces of papier mâché are marked, although Jennens and Bettridge did stamp some of their best quality work with the initials J & B. Any papier mâché article that is either marked by the manufacturer, or signed by the painter, is almost certainly of the best quality. Marked or signed articles are rare, and fetch high prices with collectors.

THE ARTS AND CRAFTS MOVEMENT

Quite apart from the main range of Victorian furniture—articles made for middle-class and upper-class homes—that still survives, there is one small separate field which must be taken on its own. This is the area dominated by the specialist individual hand-craftsmen.

In a reaction against the mass-production of furniture, furnishings, and fabrics, a group of artists and craftsmen determined to restore the ancient traditions of good design and hand-craftsmanship. The principal, and best-known figure in this movement was the redoubtable William Morris—poet, painter, printer, designer, and all-round 'Renaissance man'. The *Catalogue of Victorian and Edwardian Decorative Arts* (Victoria and Albert Museum, 1952) is invaluable for students of this period, and of the individual artists and craftsmen associated with the movement. It has the following comment on William Morris and his associates:

> The influence of William Morris on the decorative arts in this country, and ultimately abroad also, was so profound and far-reaching that there is hardly a single late-19th century designer who owed nothing to it. . . . Morris's whole life was a crusade against the debased standards of mid-Victorian mass-production which he traced to the influence of machine-manufacture and the disappearance of honest and satisfying hand-craftsmanship. His own particular contribution to design was in the field of flat pattern-making in which his fertility was prodigious and his genius unsurpassed. This he applied successively to embroideries, wallpapers, printed textiles, woven textiles, carpets, and tapestries, in each case basing his designs on a thorough understanding of the processes of production gained by intensive personal research and experimentation.

With the exception of a few very early pieces for his own use, he appears never to have designed furniture (despite frequent statements to the contrary), or any other three-dimensional objects in pottery or metal.

Morris, like Philip Webb and several other designers who contributed to the movement, had been trained as an architect. It was this architectural conception of furniture—as opposed to the niggling decorator's outlook of professional furniture designers—that set the furniture made by these artists and craftsmen quite apart from the run-of-the-mill articles being produced at the same time.

Another architect, William Burges, designer of Cork cathedral among others, turned to furniture since he was appalled by the lack of taste in the standard articles. It is not surprising to find that an architect whose main work was influenced greatly by the French Gothic, should have imported something of the same style into his furniture designs. His contemporary, another architect, Thomas Jekyll, turned to the Orient for his main inspiration. The influence of Japan upon the arts and crafts in this country was enormous in the closing years of the 19th century. It was not only the painters and draughtsmen like Whistler and Aubrey Beardsley who absorbed the rhythms and elegances of Japanese prints and designs. Men like Thomas Jekyll, too, were inspired by the Oriental use of bamboo and of furniture made light and elegant—in contrast to the heavy, over-stuffed feeling of most late Victorian articles.

Most of the furniture made at the Morris workshops was, in fact, to the designs of an American, George Jack, who yet again had been trained as an architect. Jack worked first of all with Philip Webb, and then in 1890 became chief furniture designer for Morris and Co.

At the other end of Britain, in Glasgow, there was a remarkable Renaissance in the last decade of the century. The celebrated Glasgow School owed much of its drive and vitality to Francis Newbery who was principal of the School of Art from 1885. Among the distinguished designers of furniture who came from Glasgow was the well-known architect, Charles Rennie Mackintosh.

Among other distinguished figures who did so much to improve the standards of furniture design in the latter part of the Victorian era mention must be made of C. F. A. Voysey. He joined the Art Workers' Guild in 1884 and, during a busy life as a practising architect, also found time to design a considerable amount of furniture—some of it for the houses which he had himself planned. As with so many members of the Arts and Crafts movement, Voysey preferred oak to other woods. There was a deliberate trend away from veneers and inlay work among these artist-craftsmen. They felt that the whole craft of veneering and inlaying had been debased by the cheapness and mass-production techniques used in so much of the poorer quality Victorian work.

William Lethaby, Ernest Gimson, and Sidney Barnsley were among a distinguished group who formed what was later known as 'The Cotswold School'—from the fact that their principal centre of activity was Daneway House, Sapperton.

Turned ash chairs were made by Gimson, while a number of craftsmen worked for many years under the direction of Peter Waals at Chalford making good simple furniture of unostentatious design. As the late Peter Floud wrote:

Gimson and the Barnsleys were united in believing that furniture design must arise out of an intimate knowledge of the processes of

production and a respect for materials used. Gimson interpreted this by designing in conjunction with his craftsmen, often making modifications as the work progressed. Sidney Barnsley, on the other hand, preferred to carry out his designs unaided.

The whole of the Arts and Crafts movement in the last quarter of the 19th century must be seen very largely as a 'protest movement'. These men of talent and taste were in revolt against the debased standards, both of design and craftsmanship. that had become only too general as the century advanced. Although most of the furniture that they made was far too expensive for any other than the discriminating and wealthy client, its influence was far greater than the comparatively small amount of furniture that was actually made.

Not only in Britain, but on the Continent, the revived conception of a designer being both an artist and a craftsman (as in the 18th century) did much to promote the revival of good furniture design in the 20th century. It was, however, something of an irony that the work of a socialist like William Morris (who hoped that his designs would enter the homes of working men) was almost invariably not only 'above their heads', but beyond their pockets.

It was not until the second half of the 20th century that mass-production realized the lessons that Morris and his followers had taught. The old 'hack designer' who had worked his way up from a bench in the firm, and who borrowed his ideas from all and every source, was ultimately replaced by the skilled architect-trained designer who also had a close familiarity with the techniques of the craft.

CONTINENTAL INFLUENCES ON ENGLISH FURNITURE

No history of English furniture would be in any way complete without some indication of the immense debt that it has owed over the centuries to the Continent. It has been indicated how, at one time or another, the influx of Dutch or French refugees stimulated native design and craftsmanship. The Dutch influence upon English furniture was indeed considerable, and particularly so at the time of the restoration of Charles II. In the Victorian period, on the other hand, the paramount new influence was often German. Berlin woolwork springs immediately to mind as an example of the flow of Germanic influence into England. Similarly certain aspects of German, Swiss, and Austrian carving—particularly in oak—are to be found in Victorian furniture. The Prince Consort, with his love of his native German art, undoubtedly did much to stimulate the interest at the 'top' end of the scale. Italy had influenced our native carvers, architects, and craftsmen immensely during the reigns of Henry VIII and his daughter, Elizabeth I. But the impact of the Renaissance came to this country largely through the medium of France. Indeed, it was from France above all that British craftsmen and designers in all the domestic arts and crafts took most of their inspiration from the 16th to the 19th century. Even in the late 19th century, most of the high quality pieces made for special orders, or for international exhibitions, tended to be 'in the French manner'.

The first furniture style to come from France and exert an important influence upon English furniture makers was that of the Henri Quatre period (roughly contemporary with Tudor and Elizabethan). This could not by any means be called a distinctively French style, for it was in the main a copy of Italian work. It did, however, introduce motifs and designs which were a French adaptation of the Italian. Thus, although satyrs, caryatids, and the other figures and emblems so typical of the Renaissance were used in French work, they tended to be more formal and less 'warm' than the Italian originals. Oak, as in England, was the favourite wood, and elaborate armoires (cupboards or wardrobes) in oak were important items of the period. The oak was not only elaborately carved, but quite often painted as well.

In summarizing the effect of French furniture of this period upon British furniture craftsmen, one might say that it was from France—only slightly transmuted—that the Italian Renaissance reached England. The French themselves had added a feeling for slightly more severity in design, and when this reached England it was changed fractionally yet again by a certain native heaviness, and a fondness for traditional patterns (such as linen-fold).

One of the best ways of comparing the furniture of different countries and the influence that one has exerted upon another is to visit the furniture galleries of the Victoria and Albert Museum. Here one can—within the space of a few minutes—examine an Italian 16th-century cupboard, a Henri Quatre armoire, and lastly a Tudor or Elizabethan oak buffet. The line of ancestry is quite apparent, so too the minute but important differences imparted to each by the different temperaments and techniques of the craftsmen. There can be little or no

doubt that at this period the English craftsman was a great deal less sophisticated than his continental rivals.

Contemporary with the English Early Stuart and Jacobean periods one finds the Louis Treize style in France. Again, this is not distinctively French, but has a lot in common with furniture at that time being made in Holland and Germany. One might say that, on both sides of the Channel, the Dutch influence was strong at this time. Carving was still widely used, but turning had become very fashionable (as it had, too, in England). Again as in England, furniture was becoming much more comfortable, with considerable use of leather or other materials on the chairs. Unlike England, however, a French taste—which later was to become very important —was the use of bronze mounts on furniture.

This is the first sign of what will later become a very distinctive feature of all French work: the ornamentation of wood with bronze, ormolu, and (in cheaper work) brass. From early days there was always a tendency among French craftsmen to work in collaboration with the metalworker, and indeed to treat fine articles of furniture much as if they were no more than large pieces of jewellery. In this case there can be seen something of the Latin temperament—and a tendency towards what the English would often think of as ostentation. At its best, however, no furniture in the world has ever equalled the choice and rich work of the finest French cabinet-makers. (*Ébéniste*, incidentally, is the French equivalent to a high-class cabinet-maker.) At a later date, their guild was to become one of the most exclusive in France, and the great *ébénistes* who worked for the French monarchs held a position and importance that was hardly equalled even by men like Chippendale.

The Louis Quatorze style was contemporary with
Jacobean, William and Mary, and Queen Anne. Var-
nishing, gilding and painting of furniture was on the in-
crease over this period, while the size of the furniture
considerably increased. The greatest improvement in
French furniture took place at this time, with the
establishment of the *Manufacture Royale des Meubles de la
Couronne* in 1663. From now on the royal patronage of
the Gobelin factory was to result in the production of
some of those magnificent specimens of French fur-
niture that can truly be called works of art.

The skill and artistry lavished upon these exceptional
pieces made for the king and the court was never quite to
be equalled in England. It was not only the work of the
ébénistes that became technically perfect, but this was
matched by the *ciseleurs* (engravers and chasers of metal),
sculptors, and artists who worked on and designed the
best furniture of the time.

To gain some appreciation of French furniture at its
best, the student should go to the Wallace Collection in
London. Here he will find what is probably the finest
collection of French furniture in the world. For those
unfamiliar with the splendours of French craftsman-
ship at its best, the Wallace Collection will prove a
revelation.

During the reign of Louis XIV, André Charles Boulle
perfected that type of inlay work which has ever since
borne his name. Boulle work is the process whereby a
furniture carcase (of oak or ebony) is decorated with tor-
toiseshell, which in its turn is inlaid with brass or silver.
At its best it has a splendour unrivalled in any other type
of furniture. The wood beneath the tortoiseshell is
sometimes artificially coloured, so as to produce a rich

series of tones. In Boulle-work, furniture comes as close to jewellery as it has ever done.

Although it is right that Boulle should·have the credit for this elaborate and delicate work, it is important to note that it was in effect no more than an elaboration of Italian marquetry. Indeed, it bore some relation to Italian pieces inlaid with *pietre dure* (hard stones). Table-tops and panels of cabinets were still being enriched with *pietre dure* in France, although less commonly in England. The Louis Quatorze period will always be remembered for the beauty of its marquetry work. It was from the success of marquetry in France that its influence spread to England—where it was widely copied, although never to quite the same degree of delicacy and elaboration.

Contemporary with late Queen Anne and much of the Georgian period is that of Louis Quinze. Although this begins in much the same manner as its predecessor, the craft of the furniture maker tends to suffer a decadence as the era progresses. This is a decadence not of technique (for indeed this was often improved) but of taste and design. The elaborate French rococo style, which naturally has its admirers and defenders on the continent, has never really appealed to English taste. It is felt that it is too elaborate, too 'sweet', and generally too contrived.

At the same time, the age was marked by the work of such great *ébénistes* as David Roentgen and Jean François Riesener. In their delicacy of execution it is doubtful whether furniture has ever been made to such almost 'watch-like' precision. In the last stages of rococo hardly a straight line is to be found anywhere in the designs, and the effect tends to be somewhat restless and irritating. However, at its best, rococo is the most feminine

furniture ever made. It perfectly accords with the world contrived by painters such as Watteau and Boucher.

The influence of rococo was considerable in England, as can be seen in innumerable Chippendale designs— particularly in mirrors and overmantels. However, a certain native dourness prevented English rococo from ever becoming as saccharine as in France and on the Continent. Marquetry work, of course, was ideal for this feminine style, and the marquetry of this period is marked by its extensive use of many woods—sycamore, tulip, rosewood, laburnum and many others. Where the variety of woods available would not yield quite the effect required, it was common to stain the wood with vegetable and other dyes. In many of the elaborate desks, armoires, and other pieces of furniture produced at this time one can find the nearest thing to a fusion between the arts and crafts of the painter, the cabinet-maker, the jeweller, the metal-worker, and the engraver.

The great looms of Aubusson, Beauvais, and Gobelin contributed to the decoration of the French apartments, and the furniture itself was often elaborate with the finest needlework and tapestry-style work. Ormolu continued in favour, and some of the most exquisite ormolu and bronze mounts were made. At the same time the tortoiseshell inlay of Boulle remained in fashion, although as the period advanced it became less popular. (Even this was felt to be a trifle too heavy.) Grace, elegance, lightness, and in the final analysis, frivolity distinguish this remarkable period of French furniture. It left its impression upon England, but in this country it was absorbed and 'masculinized' by the prevailing feeling for classical restraint and dignity.

Contemporary with the English mid- and late Georgian

is the furniture that derives from the reign of Louis Seize. This made a considerable use of lacquer and japanning (which had indeed become fashionable in the previous period). In contrast to the Louis Quinze style, however, there was a reaction against the almost 'art nouveau' curvaceousness of rococo. The straight line tends to dominate most pieces, and it is against this architectural background that the feminine decoration and restrained curves of chair backs etc. show to great advantage. The 'Chinoiserie' style was also popular, but again it was used with more discrimination than in the previous age. In the furniture called after Louis Seize one finds some of the most elegant and agreeable pieces ever made. In England, Hepplewhite and Sheraton reflect something of this mood. It is feminine and elegant, but it is not too 'soft' and sugary.

Because it became fashionable to have one's furniture painted, the pieces made in France during this era are sometimes catalogued as belonging to 'the decorated style'. Similarly, in England, the furniture of Adam, of Sheraton, and of Hepplewhite, quite often employed painted motifs—although to a much lesser extent than in France. Among famous French painters who worked in conjunction with cabinet-makers must be numbered Boucher, Fragonard, Lancret, and Watteau.

Inlay work continued to be popular, and the marquetry of this period is unsurpassed. Extremely elaborate scenes were worked out on panels and table tops—flowers, and fruit, and even pictorial themes like the chase. Even more woods were used in this type of work than ever before. Among them were holly, laburnum, maple, rosewood, sycamore, and tulipwood.

With the Empire or Directoire style, which parallels

that of the Regency in England, one finds that French influence is as great, if not greater than ever before upon design and techniques on this side of the Channel. It must always be borne in mind that, even at the height of the Napoleonic wars, the fashionable in England tended to look towards Paris for everything that was best and most elegant, whether in clothes, interior decoration, or furniture. Indeed, the moment that there was a temporary cessation of the war, fashionable England streamed across to the capital of their enemies to buy what they could, and to absorb whatever new ideas were in the air.

It was in this way that, as we have seen, the influence of Napoleon's architects, Percier and Fontaine, had such an effect upon furniture designers like Thomas Hope. The use of gilded and painted wood in furniture, and the copying of classical motifs, busts, heads, and medallions— both of these things (so common in English Regency furniture) stemmed from the French Empire.

A certain severity, a heaviness even, now prevailed throughout all aspects of design. One notes at once the influence exerted by the Napoleonic court upon the arts and crafts of the country. Gone is the feminine and somewhat degenerate mood of the later Louis. In its place there comes, indeed, a feeling of 'Empire', and of gravity.

The furniture, generally speaking, tends to be somewhat heavy, even massive, and the Roman mood has entirely supplanted the graces and winged *amorini* of Fragonard and Boucher. Classical motifs are used as lavishly as they had been during the Renaissance, but with the difference that they are now interpreted as reflecting French taste. There is no slavish copying, even of the figures and designs so recently unearthed at Herculaneum and Pompeii. With the close of the Empire

period, the influence of France upon the furniture makers of England largely ceases to exist. It would not have anything further important to bring to bear upon the subject until the advent of 'Art Nouveau' in the early years of the 20th century.

WOODS AND WOODWORK

It is not enough for an understanding of furniture to have no more than a knowledge of styles and periods. Furniture, as we understand it in Western Europe, is after all basically no more than wood converted into objects designed for the comfort of man. Some knowledge, then, of the principal woods to be found in furniture is essential. As has already been suggested, it is a very good practice to make the acquaintance of someone in the joinery, repairing, or cabinet making business, so as to be able to watch just how joints are made, how dowelling is done, and to see the other basic practices of the craft.

Wood, however, remains the basic ingredient of our craft and it is hoped that the following brief outlines of woods to be found in furniture making will assist the student. In order to gain an appreciation of woods and to be able to recognize them, the best practice is to visit some of our great national collections. The Wallace Collection in London probably has more different types of wood under one roof than almost anywhere else.

ACACIA, which is of a yellow colour with brown veins leafing through it, was used a great deal in marquetry work. Fashionable in the 18th century, it was often used by cabinet-makers of that period, often for the reason that it was cheaper and nearly as decorative as tulip wood.

ALDER, native to England, has never been a first quality wood but has been used throughout the centuries,

principally in chair-making. A stain derived from the bark
was used as a dye, and the matured alder is a not un-
attractive dark yellow colour.

AMARANTH, often known as PURPLE HEART, is a close-
grained hardwood coming from British Guiana. One will
not find it, therefore, used in any early work, but prin-
cipally for veneers and decoration from the 18th century
onwards. It is a very dark brown to a darkish violet in
colour, and has a distinct wavy grain and markings.

AMBOYNA is another decorative wood which was used
mostly for furniture panelling in the 18th century. It
comes from the East Indies and was popular in mar-
quetry and veneering for its handsome brown colour and,
in certain instances, for its 'bird's eye' patterning.

APPLE, another native wood, used a great deal in pro-
vincial and country furniture from the 17th century on-
wards. Being readily available to the local craftsman and
to the carpenter and joiner on country estates, it will be
found in simple kinds of work, but not in furniture
emanating from the workshops of the London cabinet-
makers.

ASH, with its silvery grey bark, produces a hard white
wood. Like apple, it was used to a certain degree in
country furniture but the fact that its long and fibrous
grain made it liable to split militated against much use
being made of it in furniture. Used, however, in certain
items of farm equipment since it is almost as hard as oak.

BEECH has long been used by country craftsmen in chair
making. It is technically a hardwood, but not so hard as,
for instance, oak. Its particular qualities make it suitable
for turning—one main reason why it has endeared itself
to chair makers. Quite a large number of the chairs to

Adam, Sheraton, and Hepplewhite designs in the late 18th century (which required to be painted, gilded and decorated), were made of beech.

BIRCH is another wood that was popular with many of the great 18th-century craftsmen, though for different reasons than beech. The attraction about birch is its fine close grain which enables it to be used as a substitute for the rare, and more expensive, satinwood. Similarly it takes a fine polish, and good quality birch is among the most attractive of our native woods.

BLACK BEAN is hardly to be found during the great years of furniture design and interior decoration, being a product of Australia. It is a hardwood with a fine golden colour, finely figured, and is very largely to be found in panelling and other joinery work from the early 19th century onwards.

BLACK WOOD, a term often to be found in diaries, cabinet-makers' account books and so on, is no more than a generic name given to a considerable number of hardwoods which emanated during the 18th century from both the East and the West Indies, and South America. The distinguishing factor of all these woods is, of course, their dark colour, which ranges from a chocolate or mahogany brown to a deep port wine colour. They are to be found used in all kinds of inlay, intarsia, and decorative work.

BOG OAK is, as its name suggests, oak that has been removed from bogs and swamps where, by the action of the damp and natural ageing, it has become almost as black as coal and very hard. In the early days of the furniture craft, particularly in Tudor times, it was mainly used for decorative inlay work. It will, however, be found

in a great many 19th-century pieces, not only as decoration but as a main constructional wood. I have seen, for instance, a study chair completely made out of elaborately carved bog oak. Its use stemmed mainly from the Gothic Revival, and from the feeling that it gave a dark 'romantic' quality to furniture. The Catalogue of the Great Exhibition of 1851 shows a number of special exhibition pieces entirely made out of 'Irish Bog Oak'. At the same time a number of pieces of Treen (small articles such as boxes made out of wood) were also made in bog oak. To modern taste it is, perhaps, a little heavy and gloomy, but properly used bog oak is an excellent decorative wood.

Box WOOD, coming from the shrub, has a very small fine and regular grain which makes it particularly suitable for carving small objects. For this reason it has often been used in marquetry work. Again, it has been very popular with craftsmen in treen and small woodwork generally. It has a pleasant yellow colour.

BRAZIL WOOD comes of course from South America, and is a hard red wood somewhat akin to mahogany. Dyes can be extracted from the wood, but in the furniture craft it has been mainly used as an inlay. It will be found used in this way in quite a lot of 19th-century work.

BURL, technically, is no more than a knot in any kind of wood. However, in furniture it is usually applied to the figuring of wood where circles and convolutions in the grain produce interesting patterns. As a noun it is also sometimes applied straightforwardly to a type of walnut thus marked. Burl walnut, to give it its full name, is carefully selected walnut which has been chosen from knotted roots of the wood where a concentric grain and an interesting pattern is to be found. For certain types of

display cabinet work burl walnut has long been a favourite with the craftsman.

CALAMANDER is hazel-brown in colour with darker streaks of brown enlivening the surface. A hardwood coming from the East Indies, it was used largely for small decorative objects.

CAMPHOR WOOD, which comes mainly from Borneo and Kenya, is very similar to mahogany in colour and texture. Its principal use from the late 18th century onwards was for drawers, chests of drawers, and linen presses. Apart from being an attractive-looking hardwood, the odour of the camphor made it unattractive to moths—thus serving a practical purpose.

CANARY WOOD, which is a kind of mahogany, but light yellow in colour, was used from the 18th century onwards for veneers and in marquetry work.

CEDAR, famous from remotest antiquity ('The Cedars of Lebanon'), has been used for furniture and decoration particularly because of its delicate scent. Being a light and rather soft wood, its principal use in European furniture has been as a lining for drawers, cabinets, and presses.

CHERRY, mainly used for small articles such as treen, takes a very good polish and is an attractive reddish colour. Found in a lot of country work, and used by city cabinet makers for decoration.

CHESTNUT, which ages well and has some of the same qualities as oak in this respect, is a hard white wood. When polished, it looks not unlike satinwood, and indeed in the 18th century was quite often used as a substitute for the latter. The chair maker often used it for rails and supports.

CIRCASSIAN WALNUT is a particular kind of figured walnut which is used for veneers.

COROMANDEL, a type of calamander, comes from the East Indies. Used principally for small articles, treen etc., it is light brown in colour interlaced with darker brown streaks.

CYPRESS is another long-lasting wood with a very fine grain and a reddish colour. Prior to the introduction of cedar and camphor wood, cypress was often used as a lining for chests and drawers.

DEAL, another name for the timber of fir or pine, has been used by joiners and furniture makers since the Tudor period. Technically, deal should be a plank of fir or pine wood between 7 to 9 inches broad, not over 3 inches thick, and 6 foot long. It has a straight grain and is easy to work.

DEGAME WOOD is yet another of the many West Indian hardwoods used for veneers and decoration. It is yellow in colour.

EBONY, a close-grained black hardwood, has long been used for veneering fine quality furniture. It is extremely heavy and will sink in water. Its overall black colour is often enlivened by stripes of dark brown and even green. During the 18th century it was so highly regarded in France that the French word for a cabinet maker was an *Ébéniste*, a worker in ebony. Ebony continued to be used to a considerable degree throughout the 19th century, in England as well as in France.

ELM, a native hardwood with a distinct marked grain, was largely used in chair making. It was never a quality wood but, being long-lasting and good for turning, it has

always been a favourite with country and provincial chair makers.

GUM WOOD, not found in use before the 19th century, is an Australian hardwood from the gum tree. It is rather similar in appearance to mahogany.

HAREWOOD, which is also found written as hair-wood, is a sycamore veneer that has been stained green or yellow. It became extremely fashionable in marquetry work, particularly during the latter part of the 18th century. Favoured by designers such as Sheraton and Hepplewhite.

HICKORY, a North American wood allied to walnut. Tough and heavy, it was however little used for furniture as it is particularly susceptible to wood worm and tends to warp with temperature changes. As a hardwood, however, and because of its enduring toughness, it was greatly used for gun stocks, shafts, handles, and farm equipment.

HOLLY has long been a favourite with the marquetry worker. Much used in veneer work, it is a white wood with a spotted grain. It was sometimes dyed to different colours, especially when used in Tunbridge Ware, which was a veneer cut from the ends of small rods of different coloured woods.

KAURI WOOD did not come into use until the 19th century. It comes from New Zealand, and is light yellow in colour. Because of its regular straight grain it was particularly used in bent-wood work such as bent-wood chairs.

KINGWOOD, which is similar to rosewood, comes from Brazil. As a banding on satinwood veneers, the dark brown of kingwood was a favourite with inlayers.

LABURNUM, either dark brown or dark green, is a fine-grained hardwood. For inlay and veneering it was fashionable with the cabinet makers of the late 17th century.

LARCH is another tough native wood with a straight grain. The bark is used in tanning. Larch is resistant to decay and singularly free from knots.

LIGNUM VITAE, the wood of life, is a West Indian hardwood of a dark greenish-brown. Extremely hard and durable, it was popular with veneer cutters in the 17th century and was later used mainly for small articles where durability was important.

LIME is a white wood with a good grain. Its attractive appearance, coupled with the fact that it is durable as well as easy to cut, has long made it popular with wood-carvers. Lime was often used by the great Grinling Gibbons, some fine specimens of whose work can be seen in the Victoria and Albert Museum.

MAHOGANY, the king of woods in the English 18th century, was first imported about 1710. Its familiar reddish colour often goes almost black after polishing; but it may range in colour from a light to a very dark red. It comes from the West Indies and the Central Americas. A type of hard mahogany much used in the 18th century was sometimes called Spanish mahogany, most of it originating from Cuba. The 'Age of Mahogany' is usually taken to cover the period from 1710 to 1810.

MAPLE, much favoured for inlay and marquetry work, is a fine-grained white wood. Bird's-eye maple, on the other hand, is obtained from the sugar maple tree. The unusual and attractive figuring of Bird's-eye maple has long made it popular with inlayers and frame-makers.

OAK, most famous of all English native woods, has been in use since the beginning of joinery and furniture making. Extremely durable, it is suitable for every type of joinery work, and was—until the Jacobean period—the prime furniture wood in the British Isles. 'The Age of Oak' is usually taken to cover the period from about the mid-15th century to the late 17th century. Oak can range in colour from light to very dark brown, almost black. For certain types of furniture it has never been superseded and it is still widely used today. Mellowing with age, oak at its best reaches a rich dark brown through polishing. Swamp oak is another name for Bog oak, already described, and became popular during the mid-Victorian period.

OLIVE WOOD, originating in the Mediterranean area, is a greenish-yellow in colour. Used very largely for small articles such as salad bowls, salad knives and forks, it is also found in veneering and marquetry work. Both in the Mediterranean and England it has also been used by the carver and the maker of treen.

PADOUK is another Australian hardwood, little found in English furniture. Its qualities are rather similar to rosewood, but in colour it is somewhat lighter or greyer.

PALISANDER is another name for amaranth, already described, and is the same as Purple heart.

PARTRIDGE WOOD is another hardwood coming from Brazil and found in marquetry work. In colour it is a reddish-brown somewhat similar to mahogany.

PEAR WOOD, used a great deal in marquetry and inlay work, has a very fine hard grain. In colour it is reddish. Pear wood was popular with makers of treen and boxware for its fine grain, and it was also used for small pieces of furniture.

PINE, which was introduced in the 17th century, was used in cheap furniture as a substitute for the native oak. It is not found in quality furniture. Pitch pine, an importation from North America, has been extensively used by the joiner for all sorts of inexpensive work.

PLANE was often used in the 18th century as a substitute for beech by the chair maker. It is a close-grained white wood. Late 18th-century chairs which were painted or gilded were often made of plane, and it will be found in many of these articles made to the design of Sheraton and Hepplewhite.

PLUM, found in old country-made furniture (but more often in treen) is a dark yellow in colour. It has a good grain and is very hard, two qualities which caused it to be used by the inlay worker.

POLLARD OAK is the wood from an oak that has been pollarded, i.e. cut short at the top in order to keep the strength in the main trunk and to give a bushier head. The action of pollarding causes an alteration in the grain of trees. Not only oak used for furniture but also walnut sometimes came from pollarded trees.

POPLAR is a yellowish-grey wood. During the 18th century it was sometimes used in marquetry work.

PURPLE HEART is yet another name for amaranth or palisander.

ROSEWOOD, which became extremely popular during the 19th century, comes from India. In colour, texture and appearance it is somewhat similar to mahogany, but because of its brittleness and hardness (particularly its brittleness) it is extremely difficult to carve and cannot therefore compare with mahogany. At the same time it

has a rather delicate fragrance which gives it an attraction rather akin to camphor or cedar wood.

SANDALWOOD comes from Malabar and is usually yellow, although it also occurs as white and even red. It is another fragrant wood and, like cedar and camphor, acts as a deterrent to insects such as the clothes moth. During the 19th century a great deal of boxware was imported because of the popularity of sandalwood with the Victorians. Boxware in sandalwood was also made in Britain.

SATIN WALNUT is not found in antique furniture. It is a light brownish colour, sometimes patterned with dark markings. It originates in North America.

SATINWOOD is a delicate yellow-coloured wood with a fine close grain. Extremely decorative, it was fashionable in the late 18th century, particularly with such designers as Sheraton and Robert Adam. It originates in Africa and the West Indies.

SNAKE WOOD comes from either Brazil or British Guiana. It is rather rare, but found in some high-quality inlay work, particularly during the 19th century. Reddish-brown in colour, it is patterned like a snakeskin and is very heavy, like ebony.

SYCAMORE is a large timber-tree akin to maple and produces wood of a light yellow colour that often has a fine 'fiddleback' grain. Mainly used for veneering, sycamore is sometimes dyed to a greyish colour. The wood is hard and has a very even grain.

TEAK is a heavy durable wood that neither warps nor shrinks, and has the additional virtue that it does not corrode any iron fastenings used in it. Hardly a furniture wood in the normal sense, it has been principally used in

boat-building, but it has also been used since the 19th century for garden furniture. Originally dark brown in colour, exposure to salt water or wind and weather turns it a fine silvery grey.

THUYA WOOD is another rather rare wood to be found in inlay work. Its basic colour is a golden-brown, but it is figured with small 'bird's-eye' patterns, usually in a circle.

TULIP WOOD is yet another of the West Indian hardwoods that was used by the marquetry worker. It is attractive in appearance, being of a light yellow colour with pink stripes laid irregularly throughout the surface.

WALNUT, the third of the great furniture woods, is fine-grained, the figured grain being particularly attractive. English walnut tends to be lighter in colour than continental walnut. It was first used on a large scale for furniture during the Cromwellian period. But it was not until the reign of Queen Anne that walnut really came into its own. 'The Age of Walnut' lasted roughly 100 years, and from about 1730 onwards its use was on the decline. One of the things that militated against it in comparison with the hard mahogany was that walnut was subject to worm. The development of the craft of the cabinet maker coincided with the Age of Walnut. Veneering, inlay work and marquetry also evolved into skilled crafts at the same time. American or blade walnut is inferior to European.

YEW is principally found in country furniture such as Windsor chairs. Hard, pliable (and therefore suitable for chair spokes), yew is red brown in colour. It is also sometimes used in veneering.

ZEBRA WOOD comes from British Guiana and was used during the 18th century in marquetry. It has dark striped markings on a light brown surface, hence its name.

There are, of course, a number of other comparatively rare woods found in inlay and marquetry work which have not been included in the above list. In France particularly, where the craft of the ébéniste became almost as delicate and elaborate as that of the jeweller, innumerable exotics were pressed into service. Both in French and Italian work from the Renaissance onwards, metals, bone, ivory, and polished hard stones (*pietre dure*) were used to embellish furniture.

The English cabinet-maker and craftsman tended to concentrate almost entirely on the plain beauty of finely figured and polished wood. He did, of course, embellish his pieces with fairly elaborate mounts, plates, handles, and so on, of brass. In the main, however, English furniture is distinguished by its masculine severity and restraint. Even the work of late 18th-century designers such as Hepplewhite is considerably more restrained than contemporary Continental work.

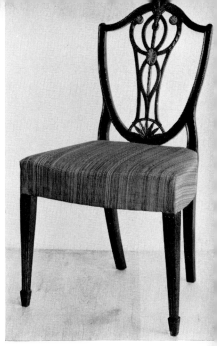

PLATE 7 Chair. Mahogany, inlaid with boxwood *paterae*. The splat closely resembles a design in Hepplewhite's *Guide* (1st edition, 1788), pl. IV. H. 3 ft., W. 1 ft.

Victoria and Albert Museum. Crown Copyright.

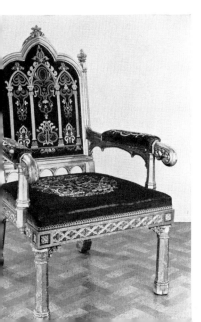

PLATE 8 Armchair of carved and gilded wood with velvet upholstery, about 1830. Its Gothic style, based on Elizabethan shape, was typical of much furniture from this time onward and Victoria Gothic became the dominant influence in design.

Victoria and Albert Museum. Crown Copyright.

PLATE 9 Table of mahogany with a glazed top inset with metal plaques by William Hiam of London, on a blue velvet ground, about 1850. Although the decoration of its top is unusual, this table is a good example of the type known as 'Loo Tables' (from the card game of that name), and follows the standard pattern of three legs supporting a turned and carved column.

Victoria and Albert Museum.
Crown Copyright.

PLATE 10 Pedestal table of papier mâché by Jennens and Bettridge, about 1850. This combines two popular Victorian tastes: the use of papier mâché in furniture and the 'Grecian' shape much favoured in the first half of the 19th century.

Victoria and Albert Museum.
Crown Copyright.

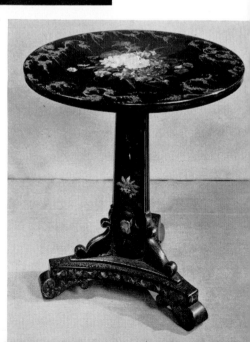

CHAIRS

The chair may possibly be considered the prime and essential article of furniture. A society can hardly exist in the real sense of the term without the chair. Yet, despite this fact, the native Britons seem to have managed without this graceful and useful article for a number of centuries after the departure of the Romans. One may conclude from this, therefore, that society did indeed revert to a very rude and primitive state.

The chair emerges, as do so many articles of furniture, out of the simple chest—that one indispensable piece of furniture (if such it can really be called) which has survived all wars, disasters and upheavals. The chest, into which the family belongings and valuables could be stowed when once again a move had to be made, has fathered not only the chair, but the stool, the settle, and the settee. Since the chair occupies so important a place in the history of furniture I cannot do better than to quote David Reeves in his *Furniture: An explanatory history* (1947):

> One of the most difficult pieces of furniture to make—both from the point of view of structure and of decoration—is the chair. The chair gets more hard use than any other piece of furniture. It must be comparatively small, to suit the sitting position for which it is intended, and yet of great strength—strong enough to take the weight of a person, which can be more than the entire contents of a cupboard, and stable enough to support him when he does not sit still and his weight is thus unevenly distributed. A chair must also be fairly light, so that it can be moved about easily. Moreover, because in being used it will be seen from all sides; and even from

above, its design must be complete and pleasant in every respect. Cupboards are generally placed against walls, and can be designed to be seen from the front only; tables are looked at more from above than in all-round perspective; and this reduces the demands on the designer for elegance of detail. Further, chairs occupy an intimate place in a household and must minister not only to the physical comfort of people but also to their sense of domestic happiness and dignity. The chair designer must solve problems of temperament, as well as problems of structure and appearance: plan chairs that will make people feel as natural and self-respecting in them as in the clothes they wear. A chair that seems structurally adequate and of inoffensive appearance may make the person who sits down in it look and feel awkward and ridiculous: the chair designer must foresee the position which people will adopt in using the chair, and allow also for its use by persons of different size and bearing. Chairs can be so expressive of the people who use them that, examining the chairs used in a certain place, one often gets a fairly definite impression of the average look of the people who live there. . . .

Evolving from a box that gradually became improved by arms and a back, the chair was, as it were, 'rediscovered' in Britain and Europe during mediaeval times. For the chair, such as we know it in the best 18th-century examples, had been perfectly familiar to citizens of the Roman empire. Indeed, magnificent examples of chairs and stools have been found in the tomb furniture of the ancient Egyptians.

In Britain, among the earliest examples of chairs which are still in existence are ecclesiastical thrones—not surprising at a time when the church was all-powerful. 15th- and 16th-century chairs of this type naturally drew their inspiration from the architecture of the church in which they were placed. One might say, then, that the first native furniture style in Britain is the Gothic. Oak was of course the wood used in these early joiner-made pieces. The construction was heavy, wooden dowels being used to

peg the framework together. Later on, the main part of the chair—the box-like seat—was made in framed panels, a technique learned from Continental craftsmen. Decoration where it existed was, as might be expected, a combination of those conventional grotesques (beloved of the church craftsman) and naturalistic details of foliage.

The X-shaped frame, one of the earliest of man's discoveries in furniture (found in ancient Egypt), came to the fore once more during the Renaissance. The design is a good one for distributing the weight, while at the same time it can be aesthetically attractive. Seat and back were often covered with stretched leather held in place by brass studs, while the comfort of the sitter was attended to by a stuffed cushion. The X-chair has proved basically so good a design that it is still being made today, although modern tubular constructions seem a far cry from these early Tudor ancestors. During the 19th century there was again a revival of this early style, just as there was of the Gothic. Not only chairs, but stools on the X plan, were made for the study, where the 'Tudor' or 'Gothic' mood was much cherished.

From the period of Queen Elizabeth onwards one finds the craft of the turner lavishly applied to the legs of chairs and stools. The bobbin pattern is predominant, and it is not until the last quarter of the 17th century that one finds the advent of spiral turning being applied. From this period date the many examples of domestic furniture with the distinctive 'barley sugar' twists.

In all the examples of the chair stemming from this period one will find that the frame is held together for security by an underframing. This applies equally to stools. Seeing how sturdy in their native oak are the specimens that remain to us one may be tempted to

wonder why the joiner or chair-maker did not trust his judgement of stresses and strains sufficiently to eliminate the underframing. But one must realize that this frame was not only a security measure: it also gave the sitter a place to put his feet above the somewhat squalid floors, and out of the draughts with which most houses were afflicted. As comfort increased, as carpets became an accepted necessity and no longer a luxury, so the underframing of the chair became less of a practical object and more of a decoration. In Carolean chairs it will be found that this framing is now a place where the carver exercises his craft. As walnut became the fashionable wood (the tree had been brought to Britain originally by the Romans), so the chair became not solely a practical piece of furniture, but an elaborate and often beautiful object.

Backs of these chairs are almost invariably high, with a richly decorated cresting piece between the two uprights. Seats are usually of cane, while as often as not there is a cane panel in the chair back. An elaborate front rail reflects the design and carving of the cresting piece, while the legs may be either carved or turned. Where the chair has arms, these too will reflect the carver's craft.

An S-shaped scroll from the late 17th century onwards became fashionable as a shape for the front legs. The back legs were still straight. This S-shape was also often repeated in the shape of the arms and in the frame of the centre splat. This elegant shape was later to evolve into the cabriole leg, one of the most attractive of the chair-maker's devices. Even here, however, it must not be thought that the cabriole leg was a new discovery or invention. It was, like so many things, no more than a re-discovery of a form that had been popular in the ancient world. Roman craftsmen had used a leg based on that of

the goat for many pieces of furniture, ranging from chairs and tables to vase stands.

In the William and Mary period the influence of Dutch craftsmen (which had become evident since the Restoration) was even further established. Huguenot refugees contributed to the spread of Dutch styles and of Dutch techniques, one of the most famous of these being Daniel Marot, a distinguished cabinet maker and designer. Chairs now became thoroughly attractive pieces of furniture, the scroll leg being refined and elaborated, while the ball foot made its appearance. Apart from the scroll leg, an elegant turned leg with a tapered round section (another importation from the Continent) is often found combined with the ball foot.

The cabriole leg proper is found from the Queen Anne period onwards. It is not until the Georgian period, however, that the pure cabriole leg with no underframing appears on the scene. Other features of Queen Anne chairs are the use of a vase-shaped splat between the cresting rail and the seat, and the habit of repeating the curve of the leg in the cresting rail and in the uprights at the back of the seat. Walnut veneers as well a complete walnut frame are distinguishing features of these chairs, which are as attractive as any in the history of furniture. It stands to reason that a good walnut chair of the Queen Anne period is today an extremely expensive article. There are some fine examples to be seen in the Victoria and Albert museum.

With the Georgian period one reaches the highest level of chair design that has ever been seen in this country. The chairs are both comfortable and elegant, and the genius of a number of master designers was applied to the problem of solving this equation. During this age when English domestic architecture achieved its peak, the craft

of the cabinet-maker and the chair-maker also managed to produce some of the finest looking as well as most practical furniture in Europe. France may indeed have achieved higher levels of sheer technical virtuosity, but the prize for combining aesthetic appeal with practicality must certainly be handed to the craftsmen on this side of the Channel.

The claw-and-ball foot, an elaboration of the simple ball, distinguishes a number of chairs of the High Georgian period. A further elaboration upon the claw, found also in Georgian chairs, is the lion's paw clasping a ball. The knees of chairs are quite often elaborately carved with masks and escutcheons. It is interesting to note that as early as 1911, Edwin Foley, writing of *Decorative Furniture*, could remark that:

> Expert and popular judgement of Chippendale's pre-eminence as a chair designer is endorsed by auction-room prices, as much as 1700 guineas having been paid for a suite of his frames comprising five chairs and three settees, and 1000 guineas for two ribbon-back chairs . . .

These prices have, of course, increased considerably since that time.

Foley has the following comment on Chippendale's work as a chair designer:

> By the variety of his patterns and his excellent work he advanced the art more than any man whose name is writ in British furniture annals. The sizes of his chairs have not been approved by later generations, but chair sizes and fashions are particularly attendant upon dress fashions: the broad seats for the full-skirted Chippendale Georgian period being as necessary as the narrower seats of the swallowtail coat era.

This point—the effect of clothing fashion upon furniture design—is something that must always be borne in mind by the student.

With the advent of hard mahogany (as well as improved tools that could carve it crisply) the chair designer had a perfect material to hand. No longer was it necessary to tie together the legs of chairs, while a comparatively narrow surface could be decorated with carving without greatly weakening the structure. Similarly, while the legs could be refined, the vase-shaped splat at the back could now be pierced with carving or made in delicate ribbons, thus giving rise to the term 'ribbon-back'. Of these chairs, Chippendale himself remarked:

The best I have seen (or perhaps have ever been made).

The three main types of chairs to be found in this great designer's repertoire are: splat backs; ribbon backs; and 'all-over' backs.

The perforated splat at the back of the chair had been used since the period of James II, but it was not until the introduction of mahogany (and particularly the hard 'Spanish' mahogany) that the full development of the splat could take place. Chippendale also experimented a great deal with the top or cresting rail of the chair, and this too became refined and elaborated. The splats became more and more pierced, at the same time as the cabriole legs usually remained fairly restrained. Some heavy and slightly over-elaborate legs are, indeed, to be found on chairs of this period. It is a matter of taste. A good example of the heavy 'Chippendale' style is to be seen in the study at the Soane Museum in Lincoln's Inn Fields. Generally speaking, the junctions of the back posts with the top rail were now scrolled upwards somewhat into the shape of ears.

The ribbon or ribband back chairs possibly owed their origin to French designers. Certainly this delicate and

feminine style is found in the work of the French designer
Jean Berain, and it is quite possible that Chippendale
found a source for some of his motifs and designs from a
design book published in Paris in the late 17th century.
Certainly ribbon back chairs are quite common in French
work during the Louis XV period.

What have been termed 'all-over' backs is where the
central panel between the uprights forms a complicated
pattern 'all over' the area concerned. These are invariably
either in the Gothic or in the Chinese style. Chippendale's
taste was again accurate in that he used stretchers under
these chairs—stretchers that, as it were, repeated the com-
plicated patterning of the backs. When it came to his
cabriole legged chairs, or those which followed the delicate
French style, he wisely dispensed with stretchers. On his
chairs 'in the Chinese taste' he also used square-shaped,
strong and solid legs, reckoning perhaps that the elabora-
tion of the back needed to be counterbalanced by sim-
plicity and strength in the legs. So strong has been his
influence that it is almost impossible to imagine a
Chinese-style chair with a cabriole leg. Yet it must
always be remembered that great though the name of
Chippendale is in the world of antique furniture today, he
was not in his own time considered to be anything more
than just another one of several good furniture craftsmen
whose workshops were in London. Less well known to the
general public, but a greater figure in his own day, was
William Vile (d. 1768) who worked in collaboration with
John Cobb (d. 1778). Both were appointed cabinet
makers to George III, and were considered in their own
day to be the supreme furniture craftsmen.

Another type of chair popular in this period, and again
often associated with the name of Chippendale, is the

ladder-back. This is a sophisticated London version of the ladder-back which had long been made by country and provincial chair-makers. Again, as in the Gothic and Chinese style, the legs are of square proportion, while the backs are set with horizontal rails which are curved to fit the sitter's back and are also often pierced. A good example of an 18th-century ladder-back is among the finest—if apparently simplest—examples of English furniture.

In a separate class to these masterpieces of the wood-carver's and chair-maker's craft are the 'stuffed chairs' which were ultimately to become the principal type of chair throughout the world. There can be no doubt in this case that to France must go the credit of evolving a padded chair designed principally for comfort rather than for show; not that stuffed chairs cannot be both well-designed and aesthetically satisfying, but their principal function is to minister to the comfort of the sitter. These upholstered chairs had been known and indeed described since the reign of Charles II as 'French Chairs'. In fact by the reign of Queen Anne a distinctive and attractive version of the upholstered chair had appeared in the form of what is now generally called a 'wing chair'. The side pieces protected the sitter from those ubiquitous draughts which must have been endemic in the English home and which are still not entirely eradicated in the second half of the 20th century. The Bergère is a distinctive form of this upholstered type of chair. A wide-seated armchair originating in France during the reign of Louis XV, it is the ancestor of all modern lounge chairs.

To the modern taste, perhaps the most attractive of all the chairs dating from this great period of English domestic art and architecture are those originating from

designs by Robert Adam, George Hepplewhite or Thomas
Sheraton. Here one finds elegance and grace combined
(none of the heaviness which afflicts quite a lot of even
the best of Chippendale's designs), together with comfort
and practicality.

The shield-shaped back is a distinctive characteristic of
Hepplewhite's style (see his *Cabinet-maker and Upholsterer's
Guide*). So also are the equally attractive chairs with their
backs formed in an oval or heart-shaped design. The legs
are usually straight, tapered, and of either square or round
section. Often the front rail of the seat is in a serpentine
form while the whole frame is femininely shaped. Hepple-
white was deeply indebted to French designers for his
whole approach to the styling of chairs, but at the same
time he added his own contribution—a certain masculinity
or 'English reserve'. Robert Adam, who has been discussed
in an earlier chapter, was notable also for combining
lightness and grace with a classical sense of style. Again,
like Hepplewhite, he was fond of the oval back for his
chairs, but had a great preference for painted satinwood as
a basic material.

In 1794 there appeared a volume which was to have an
immense effect upon English furniture design—but par-
ticularly chair-making. This was *The Cabinet-Maker's and
Upholsterer's Drawing Book* (1794) by Thomas Sheraton.
Attractive slats, set either vertically or diagonally, tend to
fill the open square of the back, while legs are tapered
either as squares or cylinders.

Sheraton, it has been said, foreshadows the Regency
period—and so indeed he does in some respects, par-
ticularly in his later work. I have already dealt with the
Regency itself, and with the influence of Percier and
Fontaine upon designers such as Thomas Hope. From this

point on we are approaching the mixed, but not entirely total, confusion of styles in chairs (and in all else) which characterizes the Victorian period. It must be stressed, however, that English chair-makers did not fail entirely to live up to their old and noble traditions during the 19th century. There are many excellent, strong, well-designed and aesthetically attractive chairs still in current service which emanated from the mass-production lines of the middling Victorian furniture makers. It will be noticed, though, that from the mid-Victorian period right up to the present day it is the 'stuffed chair' which has triumphed, while the decorative (but not so comfortable) wooden chair has tended to be relegated to the hall, the kitchen, or the dining room.

STOOLS, SETTEES, AND SOFAS

The stool, as has already been pointed out, is another article of furniture deriving from the simple wooden chest. Although at no time can it be said to have achieved the dignity or aesthetic interest of the chair, yet the stool must be accounted one of the most permanent items in furniture history. It was being made in mediaeval and Tudor times, and it is still with us.

As with chairs, so the earliest stools were principally made of oak. It must not be assumed, however, that the joiner was for any reason restricted to oak, and indeed other native woods such as ash, beech, and elm were constantly used. Oak, however, was good and strong for an article like a stool, and permitted a certain amount of simple Gothic carving. The joint stool, as it is often called, was of course a joiner-made piece. The legs of such stools were usually splayed to make the article more stable. The seat was simple and solid and a framework below joined the four legs. At the bottom the legs were tied together by simple and unadorned stretchers.

A term also often used to describe these early stools is the 'coffin stool'—based on the fact that two of such simple pieces were indeed used to rest the coffin prior to its journey to the graveyard. At the same time it must be borne in mind that in many rural areas the coffin-maker, employed by the church, was possibly the only trained joiner in the district.

By the 17th century the stool, although still a rather

humble piece of furniture, had come up in the world enough for stools to be made in the fashionable walnut.

In its early history the simplicity of the stool, the fact that it needed only a plain wooden top, and that it was structurally easy to make, naturally endeared it to the joiner. It is of course essentially a joiner's piece, but it was natural that with the increase in comfortable furniture the later types of stools should have recessed tops to take a small stuffed cushion. From this point it is no far remove to the padded or upholstered stool. Throughout the 19th century stools still continued to be made in great numbers—stools for the nursery, stools for resting the master's feet while he sat at his study desk, piano stools, and so on. Throughout its history the stool has remained a tough and comparatively undecorated piece of furniture, although there are a few of the more important examples extant which have such refinements as 'barley sugar' legs and carved rails. The Victorians also revived the 'Gothic' stool in oak, and even in bog oak. Most examples to be found at sales or in antique shops today are more likely to date from the 19th century than from the Renaissance, let alone from earlier periods.

Towards the close of the 18th century, and particularly during the Regency period, the stool suddenly remembered its ancient classical past. X-shaped stools, reminiscent of Greece or Rome, were made to the designs of craftsmen influenced by the French Empire style. One design by Thomas Hope shows an X-shape with rams' heads at the top, an Egyptian lotus motif at the junction of the seat and the supports, and rams' feet. It does not look comfortable.

The settee, unlike the stool, does not seem to have been a native form. It is true that before the advent of the

settee in the last quarter of the 17th century there had
existed that unusual article the day-bed. This, indeed, had
certainly been made in England since the Jacobean period.
It was not particularly comfortable in its earliest form,
being little more than a hard bench with a head rest. It
was after the introduction of cane-seating that the day-
bed proper made its appearance. It is therefore to be con-
nected with the Restoration period, and is part of that
civilizing influence upon our native furniture which began
with the return of Charles II and with the importation of
Continental craftsmen. The day-bed, designed for an
afternoon nap or for the daytime repose of an invalid in
the downstairs rooms of a house, was a distinct article on
its own. It did not father the settee.

The settee, in fact, would seem to have been another
Continental importation—but arising from the desire to
combine together two chairs, and not to make a 'day-bed'
for reclining upon. Throughout its history the settee has
been basically a double chair. It is a piece of upholstered
furniture, and in its first forms can be seen to resemble
closely two wing-back armchairs of the type which first
became familiar in England after the Restoration. Carving
is restricted to the legs and the stretchers between them.
Some of these pieces are very handsome and still com-
fortable, but they are certainly not to be found upon the
'ordinary' market.

At a later date when the influence of France was
dominant, the settee in the hands of masters like Sheraton
became a particularly elegant and attractive piece of fur-
niture—though not, one might say, as comfortable as the
upholstered settees of an earlier period. Sheraton settees,
for instance, tend to be cane-seated with legs very
similar to those found in his chairs. Sometimes they have

dual medallion-shaped ornamentation in the backs of each respective side. Legs and arms echo each other in a light-hearted version of the classical style. Another Empire-type settee that made its appearance has no back to it, but instead has two back-rests at each end. It fore-shadowed the 'confidante' of the 19th century, designed for elegant (though possibly not very comfortable) con-versation between two people.

A painted caned satinwood settee from the late 18th century, the property of Lady Wernher, was described in the following accurate terms by Edwin Foley at the beginning of the century:

> There is little in common between the sturdy simple chest, to which in early oaken days a back was added as a concession to comfort, and this delicate, dainty, and altogether sophisticated survival of the
>
> > Teacup times of hood and hoop,
> > Or when the patch was worn.
>
> Neither, indeed, could lay claim to much comfort in its present-day upholstered conception. One suspects that not only would the stalwart men of Tudor and Stuart days have felt as ill at ease upon Lady Wernher's lightly built double seat, as would the ladies of the third George's Court have been upon the solid settle; but that both, when weary, would gladly have deserted their contemporary couches had they been given the opportunity of reclining upon a modern settee of the Chesterfield type.

There can be little doubt that caned settees like this par-ticular example with its attractive painted decorations on the frame, as well as on two small medallions set in the back caning, represent the most graceful form that the settee ever reached. At the same time, from the point of pure comfort and practicality, there is something in the comment that they were neither very restful, nor very comfortable.

The stuffed sofa, incorporating the spiral spring (which

was not made in large quantities until the Victorian period), marked the beginning of real comfort in a piece of furniture that was to supplant both the day-bed and the settee. The eastern divan which began to exert its influence early in the 19th century can be seen, for instance, in David's famous picture in the Louvre of Madame Récamier. As the century advanced, the ottoman, mentioned by Byron among others, ousted the sofa pure and simple. Deriving its name from the Ottoman Empire where such type of upholstered furniture had long been popular, the ottoman was also promoted by the Victorian vogue for finding romance in the East. By the latter half of the century, when gentlemen had their own 'smoking rooms', smoking jackets and caps, the ottoman had become a familiar piece of furniture.

TABLES

Although the 'pleasures of the table' were much enjoyed even by the unsophisticated from earliest times, the table was still a fairly basic item of furniture. It was above all 'a board', that board indeed from which we get the expression in the Tudor 'Boke of Curtasye':

> Whereso, thou sit at mete in borde (i.e. table)
> Avoide the catte at on bare worde
> For yf thou stroke catte other dogge
> Thou art lyke an ape teyyed with a clogge.

The reference here is to the numbers of animals which tended to infest the great hall and make their dwelling under the table waiting for the scraps that either fell, or were thrown in their direction. Life was still dirty and primitive in many great houses as late as the reign of Henry VIII, as we can learn from one chronicler:

The bones from many a dinner lay rotting in the dirty straw which strewed the floor. The smoke curled about the rafters and the wind whistled through the unglazed windows.

It was for the diners at this type of table that the 'Boke of Curtasye' reminded them to 'loke thy naylys ben clene in blythe'.

The long board supported on trestles was soon to give way to the framed table, where four or more legs supported the table top, themselves being strengthened and tied together by stretcher rails. The basic styles of Elizabethan furniture have been discussed in an earlier chapter, but it is worth noting that in the table—as much,

or more, than anywhere else—one can see the distinctive 'plum pudding' flavour of the period most clearly exemplified. A heavy top, often decorated around the sides, is supported upon four bulbous legs of the distinctive acorn style. These large turnings are also often referred to as 'cup and cover', since it is very probable that they were a deliberate attempt to reflect the covered cup of the time (which would also have been prominent at the meal).

These tables, solid and well-constructed, have survived in many instances, and few important museums of furniture or old country houses cannot show one or more examples. They were to be followed by the draw-leaf table, a simple and ingenious arrangement (still used today) whereby the table can be extended by sliding out graduated 'leaves' from under its main surface. The great advantage of this was that the body of the table no longer needed to take up so much space in the room. As dining rooms took over from the old-fashioned great hall, so the need for a table which would not inconvenience people, when it was not required to its full extent, was quickly felt.

Before leaving the tables of the early period, some further comment upon the manners and social customs of our ancestors may help to place the table in its setting: 'Forks are said to have been little used before the sixteenth century [Forks originated in Italy, along with other improvements in table-ware and social behaviour], guests using their fingers to help others as well as themselves: a quite sufficing reason for washing both before and after a meal. That no plates for holding food are shown in early MS. illustrations is incidental endorsement of the old writers' frequent mention of the practice of flinging

refuse food and bones upon the floor for the dogs. When the "trencher" came into use, it was either a thick slice of bread, used by the wealthy as a plate to place the meat upon and given to the poor afterwards, or a wooden platter possessing no pretensions to decoration. . . .'

It is worth remarking, incidentally, that even as late as 1663 one finds Pepys complaining about the coarse simplicity of a banquet table. This was on no less an occasion than the Lord Mayor's Banquet, where Pepys found it

> was very unpleasing that we had no napkins nor change of trenchers and drank out of earthen pitchers, and wooden dishes.

Pepys was sitting on this occasion at the Merchant Strangers' table.

Interesting and attractive tables were being made for the home throughout the 17th century. The gateleg table emerges during this period, another attempt to solve the problem of how to produce a table that will accommodate a number of guests when required to do so, but will not take up all the space in the room at other times. The gateleg like the draw-leaf is another successful design which is still with us. The central part is supported upon four legs tied together with stretchers at the bottom. At either, or more often than not, at both ends, a gateleg table swings out to support a flap. In its most usual form the table, when completely erected, will form an attractive oval, while when its legs are closed it is a simple rectangle that will stand easily against a wall. The legs of many of the 17th-century examples are decorated like the chairs with bobbin-turning. Most of these tables are in oak although there are some walnut pieces in existence. It must be pointed out that the gateleg table, with hardly any change in its styling, has been made continuously in

England for the past three centuries. Early examples are rare and comparatively hard to come by. The majority that appear at country or provincial auctions will not be later than the 19th century.

With the increase in social comfort from the Queen Anne period onwards the forms and shapes of tables multiply. Walnut writing-tables, often delicate small pieces, with a recessed kneehole for the writer's legs and drawers on either side, appear upon the scene. Few and far between nowadays, they are among the most expensive pieces of furniture on the modern market, for in the small house or flat they are ideal. *Caveat emptor*—they have been widely copied, originals heavily restored, and fakes are not as uncommon as one would wish.

Sidetables or carving tables are an 18th-century elegance, Chippendale leaving some designs for them. At this period the sideboard proper (introduced by Hepplewhite) was not known, and the carving table was the 'work table' of the dining room. Many of these carving tables had *scagliola* tops. This was an Italian composition, stained to look like marble, and was widely used throughout the 18th century in England. Where the owner could afford it, and marble was available, this of course was used on the tops of carving tables.

Card tables were another distinctive 18th-century development. With their claw and ball feet, and with their recesses for candlesticks and money (guinea wells), they evolved from their William and Mary ancestors into extremely graceful and attractive objects. In an age when gambling for high stakes was common the card table was an important item of furniture. 'Gambling and drinking,' it has been said, 'were the nation's chief amusements.' Sir Robert Walpole, the Prime Minister, for instance,

staked and lost the magnificent marble staircases which led up to his home at Houghton. Others, like the fabulous Squire Mytton, gambled and drank away the whole of a massive family fortune in only a few years.

An extremely attractive folding-leaf table appeared in the mid-18th century. This was the Pembroke, reputedly named after the lady who first proposed the design to Sheraton. It is an elegant and feminine descendant of the folding-leaf dining table, the flaps in this case being supported on small brackets which either slide out, or hinge out, from the frame. This was essentially a table for the lady's room, to serve the new social habit of tea-drinking, or the taking of light snacks. Many of them are of mahogany, although later in the century they are also found in satinwood.

Of about the same period are the many examples of pedestal tables which can still be found at not too great a cost. Of course, perfect examples, particularly those with such refinements as pie-crust edges, are expensive. Hinged to a block in the centre of the underneath of the table top, the top tips up so that the table, when not in use, can be pushed back against the wall. Supported on a central column with usually three legs splayed out to balance and take the weight, these tip-up pedestal tables are among the most pleasant of the small Georgian pieces of furniture in the ordinary home. Again they are usually of mahogany, although they are still sometimes made in walnut, and country pieces even in oak. I have in my own possession a pleasant provincial or country pedestal table with an oak top and a walnut inlay surround. Essentially these attractive tables were for light meals such as breakfast, for tea or coffee, and for general purpose use in the living rooms of the house. They were

made in great numbers from the second half of the 18th century through to the end of the Regency period.

A close relative of these tip-up, all-purpose tables, is the small tip-up table designed expressly for the tea and coffee equipage. These are a good deal smaller than their ancestors and are often extremely delicately made. Fretted galleries, elaborately carved centre pedestals (with Grecian style fluting) and vase-shaped stems above the point where the three legs splay out, are characteristic. The legs themselves are of cabriole shape and end either in pad feet or claw-and-ball. One great weakness of all such tables is at the 'ankle' just above the foot. Very often these were carved a little too fine, with the result that the ankles tended to snap. Examination of a number of such tables will often show that one or more of the ankles has been repaired.

Closely allied to these tip-up tables in that it is supported on two pillars, each with its three cabriole legs, etc., is the dining table with a central leaf, each end of the table being in the shape of a 'D'. Good examples are extremely attractive (and expensive) but it must be borne in mind that most of those on the market today are Victorian, or even reproduction.

The large circular top table supported upon a heavy central pillar with four supporting claws was a French importation. There is a legend that it owed its invention to Cardinal Mazarin who was in the habit of dining alone at such a table while his guests were served separately at another. It has also been suggested that in revolutionary France it owed its popularity (like the Round Table of King Arthur) to the fact that, since no one could sit above another, it made all the citizens equal. In fact, it is more than likely that it was just a development by the furniture

craftsman of the many small round tables that were already in existence. It lingered on well into the 19th century, although the Victorians, as has been said, finally decided that they preferred the long table with the master at one end, and the mistress of the house at the other. These typical long Victorian tables with their telescopic expanding leaves (operated by a screw and worm system) are often made of excellent mahogany but tend to be too large for most modern houses.

Work tables, which in this country seem to owe their origin to Sheraton, with their sliding trays and drawers and silken pouches to contain fabrics and thread, were made from the late 18th century right through the 19th. Similarly, screen tables or fire screens, made in every variety of material from mahogany to rosewood, and later in the Victorian period with Berlin wool-work tops, are first found in any number in the late 18th century. They protected one from the direct heat of the 'sea-coal' fires in the drawing room, or shielded the backs of the diners in the dining room.

Variants upon the basic four-legged table are innumerable. There are the decorative lyre-ended tables—where each end of the rectangular table top is supported upon a lyre-shape. There are innumerable dressing tables ranging from beautiful examples dating from the late 18th century (and sometimes decorated by painters like Angelica Kauffmann or Cipriani), to countless Victorian dressing tables of every quality. The Victorian loo table has already been discussed at some length. It is worth adding, however, that good examples still make most useful tables, being strong, decorative, and in every sense good 'working tables'.

A GLOSSARY OF FURNITURE TERMS

Both in this book, and in others that the furniture student will read, it is inevitable that certain terms are used which are not immediately familiar. The craft of furniture, like any other, has evolved descriptive and technical terms to define certain types of work, decoration, and aesthetic styles and motifs. The following glossary is not intended in any way to be definitive (specialist glossaries and dictionaries of furniture terms are in existence), but only to give a number of the terms with which the student of the subject may not be familiar. Many of the terms, it will be seen, came into the craftsman's language from Italy or France, or have classical origins. This in itself should serve as a reminder that in furniture, as in most of the arts and crafts, the influence of our Latin neighbours in Europe has been extremely important ever since the Italian Renaissance.

ACANTHUS, which is a plant whose leafage formed the carved ornament on columns of the Corinthian order, was also a popular motif with wood-carvers. Ever since the Renaissance it has been widely used in carved and inlaid decoration. It was a particular favourite form of ornamentation with carvers during the 18th century when it was often used to decorate the edges of chair seats. Acanathus swags, small rosettes embodying acanthus leaves, were an elaboration often used by the Adam brothers and by Thomas Sheraton.

ACORN-TURNING, mainly found in the Stuart period but also in Jacobean work, were knobs or pendants resembling acorns. They were often used as finials (*q.v.*) on chair-backs.

ALMERY is another form of the word ambry (*q.v.*) and is also found written as aumbry and aumerie.

AMBRY was a small cupboard used in mediaeval churches for the receipt of alms prior to their distribution to the poor. The term is also applied to a similar small cupboard in which ecclesiastical utensils such as the communion chalice were stored. As an extension of this, in church architecture the term is sometimes applied to a recess in the wall which is closed off by a door with a lock.

AMORINI, Italian for cupids or cherubs, have been popular in decorative work since the Renaissance. From the 17th century onwards they have been extensively used by English woodcarvers on pieces of furniture styled in the Baroque manner.

ANTHEMION is the conventionalized Greek honeysuckle used in decoration. Popular with the carver and the inlayer, it is occasionally used by Chippendale. Its main use in England stems from its adoption by the Adam brothers, as well as Sheraton, after which it was extensively used by furniture craftsmen well into the 19th century.

APPLIED MOULDINGS was a form of moulding resembling panelling 'applied' to furniture. Found mainly in 17th-century work, they are also sometimes called Jacobean mouldings.

APPLIQUÉ or applied designs are sections of wood which have been fret-cut, and then glued or tacked to the main body of the piece of furniture.

APRON is the supporting timber beneath the edge of a table or between the seat framing of a chair, also used to describe the base timber between the feet of a cabinet or similar article. Although in many cases the apron is structural, it is also used in some pieces to do no more than *conceal* the construction and is merely a decorative masking piece.

ARABESQUE, meaning 'in the Arabian style', is a term usually applied to designs formed of floriated scrolls. It was adopted during the 15th century by Continental artists from Oriental craftsmen, and was introduced into England in the Tudor period. Arabesques in furniture work and wood carving are usually in low relief. It was a very fashionable detail throughout the Stuart period and up to the end of Queen Anne, and was later revived by the Adam brothers.

ARCHITRAVE, an architectural term, which in woodwork denotes the outer mouldings of windows and doors.

An ARK is a chest or box, usually set upon small legs, and having a lid of arched shape. It was often used much like a modern safe for money and valuables, as is borne out by a 15th-century will:

> To ye ordre of Cisteaus he gaf two thousand mark . . . to lay up in ark.

ARMOIRE, French for cupboard, was originally any large receptacle designed to hold valuables. Later it came specifically to mean a large cupboard or wardrobe of continental origin. On the Continent itself the term in early days was applied to the ambry. French armoires are often lavishly decorated with inlay work or elaborate carved panels.

ARRIS is a woodworker's term for the sharp edge at the junction of two plane or curved surfaces of wood.

ASTRAGAL was originally applied to a small bead moulding on classic columns. In woodwork it came to mean the beading placed on the extreme edge of one of a pair of doors in order to exclude the dust from the interior of a cabinet or book-case. In the latter half of the 18th century it is also sometimes used to mean the glazing bars on a glass-fronted book-case or cabinet.

BAIL HANDLES are small drop handles suspended from knobs on back plates of drawers, etc. The earliest bail handles are made of cast iron, but later examples are made of brass and are often quite elaborate.

BALL FOOT, which became popular in England in the Carolean period, has been popular with chair and cabinet makers ever since, even though during the 18th century— except for chairs—it was to some extent superseded by the bracket foot (q.v.). The well-known claw-and-ball foot to be found on so many 18th-century chairs was most probably a Dutch importation.

The BALUSTER (also found as 'ballister' and 'banister') is a small column of turned wood to be found often in chair backs, particularly during the Jacobean period. As a support to the front of architectural cupboards it is more decorative than structural.

BAROQUE is the elaborate style deriving largely from Italy and Spain which later came to influence English furniture craftsmen, especially during the Carolean period. It is sometimes confused with the French Rococo style, which is in fact considerably lighter and more delicate. Baroque in furniture coincides with Wren's St. Paul's, which is itself the peak of architectural baroque.

BAS-RELIEF is a carving where the figures or motifs stand out from the background, but only slightly: i.e. low relief, as opposed to High Relief or Alto-Relievo.

BEAUFAIT (French) is the equivalent to the modern buffet (*q.v.*). Originally this was a simple wooden stand for food, which later came to incorporate a cupboard for the storage of food and utensils.

BERGÈRE is an upholstered, broad-seated chair of French origin. Found in the Louis XV period, the *bergère* often has cane panels. It is the ancestor of the modern lounge chair.

BERLIN WOOLWORK, which became popular during the Victorian period, was very widely used for covering chairs, firescreens, stools and so on. Printed and coloured patterns on ruled paper were copied out in needlepoint.

BEVEL in cabinetwork is the sloping of the edges of a panel or glass so as to diminish the apparent size of the surface and to provide a play of light and shade.

The BIBLE BOX, sometimes referred to as a Desk-box, is a lidded box used, as its name suggests, for holding the family Bible, and also writing materials and documents. The sides of the box are often decorated, but the top is usually left plain so that it can be used as a writing surface. Examples are found from the 17th century onwards.

BIEDERMEIR is the name for a German type of furniture made during the 19th century, usually in inexpensive country woods such as apple. Cast metal mouldings were often used to decorate the chairs and sofas made in the style, which were horsehair upholstered with springing.

A BLOCK FOOT is a cube or rectangular foot on a piece of

furniture. This is the simple basic form. A more elaborate and elegant version is tapered, and was a favourite with late 18th-century craftsmen and designers.

BLOCK FRONT is that section of a piece of furniture, such as in a wardrobe, which projects beyond the main body of the piece. Again, it is used to denote a rectangular shape in distinction to the swelled shape of *bombé* (*q.v.*).

BOLECTION, sometimes written balection, is an ornamental moulding which projects above the surface of the framework to which it is applied.

BOMBÉ is the French term for a piece of furniture which is swollen at the front or the sides. It is often applied to this type of Continental commode. A characteristic of furniture of the Louis XV period, it is also found in Dutch work and became fashionable in England during the William and Mary period.

BONHEUR-DU-JOUR, another French importation, is an elegant writing table having a drawer with an adjustable slope for writing. At the back there is a shelf with a place for books and papers. Hepplewhite copied the style from France and made a number of elegant designs embodying a small cupboard and three full-length drawers beneath the writing top.

BOULLE WORK, also found as 'Buhl', is a method of ornamentation originating in Italy but brought to its greatest perfection by André Charles Boulle who was the officially-appointed cabinet-maker of Louis XIV. Basically it consists of covering the carcase of a piece of furniture with a tortoiseshell veneer, which in its turn is inlaid with designs in metal. Some magnificent examples of Boulle work are to be seen in the Wallace Collection, London.

This type of furniture is perhaps the most extravagant and elaborate of any in the history of the craft.

The Bow FRONT, found in a lot of fine 18th-century English pieces, is where the front of a chest-of-drawers or other similar article is gently curved outwards. It is distinct from the *bombé* front in that it is a regular curve and not in any way protuberant. Somewhat similar is the Bow top in chair making, where the top rail at the back of the chair is shaped in a pleasant and gently upward-rising curve.

Box SETTLE is the term used for an early box seat where the hinged lid itself serves as a small bench. Mediaeval and Tudor examples usually have plain wood tops, but later pieces have a padded surface.

The BRACKET FOOT is, as its name suggests, a foot extending in two directions similar to a wall bracket, etc. Widely used on chests and wardrobes in the 18th century, it became fashionable as early as the Queen Anne period when it largely ousted the plain bun or ball foot.

BRASSES is a generic name given to all the decorative items of brass work which have been used over the centuries to embellish pieces of furniture. Brass founding began in England in the reign of Queen Elizabeth I, when the alloying of copper and zinc with tin was first brought over by Continental craftsmen. During the 18th century the designs for furniture brasses became extremely elaborate and decorative, Chippendale and many other furniture designers having left their own patterns for brasses. To a great extent a piece of furniture can be dated by its brasses, although it must be remembered that early patterns have been copied subsequently and are still being made today. During the Victorian period, unfortunately, many early pieces were disfigured by being mounted with

heavy and ostentatious brasses quite unsuitable to the furniture in question. It is perfectly justifiable to remove these and replace them with modern brasses made to 18th-century patterns of a suitable styling.

BREAKFRONT, deriving from the furniture term 'break' for a projection or recession in the plan of a cornice or plinth, etc., is used to denote pieces of furniture such as bookcases or desks in which a vertical part projects from the main structure. This technique for enlivening the appearance of a large piece of furniture became extremely popular in the 18th century.

The BROKEN ARCH or PEDIMENT is again a popular 18th-century device for giving lightness and grace to the top of a piece of furniture, particularly such things as bookcases. The break or gap occurs, of course, at the apex of the arch or pediment, and it was often enriched by a wooden urn or other decorative detail sited in the centre of the break.

The BUFFET (see BEAUFAIT) was essentially a piece of furniture used for display purposes. Whether it was a cupboard, sideboard or sidetable, its function was to display the plate or china of the household. Originally it was no more than a simple sideboard, but after the Renaissance it became increasingly elaborate. The term is also sometimes applied to those elegant 18th-century cupboards built into the sides of a room and serving a similar purpose.

BULBOUS, or bulb-like, refers to that style of design so common in Elizabethan furniture where the leg of, say, a table swells out into a bulb shape. Apart from early furniture it is comparatively little found until the Victorians brought it back in their Gothic Revival pieces.

The BUREAU is another French importation and is described in an advertisement of 1727 as being

> a cabinet or chest of drawers or scrutoir papers or accounts.

It is primarily an enclosed writing cabinet, and the finer 18th-century examples have elaborate nests of drawers, fall fronts, pigeon holes inside for keeping writing equipment, and so on. French cabinet makers of the calibre of Riesener made the bureau into one of the most decorative items of furniture. In England the first bureaux were made under Continental influence in the William and Mary period. A later development was the bureau bookcase in which notable English craftsmen achieved some particularly fine results.

The BUTTER CUPBOARD denotes an early English food cupboard, which, as its name denotes, was used for cool storage. The sides and the front are perforated, the holes being arranged in simple patterns. A number of Jacobean examples are in existence.

The BUTTERFLY TABLE is a variant on the traditional gate-leg table, the main difference being that the supporters for the flap top are pieces of wood which resemble a butterfly's wing. A considerable number were made during the Victorian period.

The CABINET-MAKER, as distinct from the joiner, is a term that first came into use in the 17th century when the craft of making elegant furniture became too specialized for the old style joiner, and the London craftsman felt that his work was deserving of a special title. The same process took place in France, where the word *ébéniste* (*q.v.*) carried the same definition as 'cabinet-maker'. The cabinet itself, that evolution from the simple cupboard, which became such a prominent display item in the living rooms

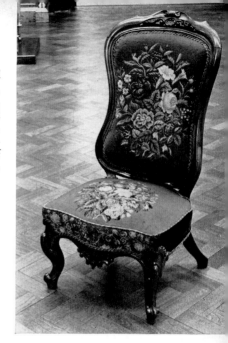

PLATE 11 Chair of carved wood with Berlin wool-work upholstery, about 1845. Chairs like this one, with curvilinear outlines and 'Louis XIV' decorative detail, were produced in immense quantity and variety and form one of the basic types of the 'naturalistic' style.

Victoria and Albert Museum.
Crown Copyright.

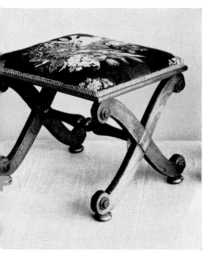

PLATE 12 Stool of mahogany upholstered in Berlin wool-work, about 1850. This small piece shows a restraint and elegance not infrequent in mid-Victorian furniture of the less pretentious type.

Victoria and
Albert Museum.
Crown Copyright.

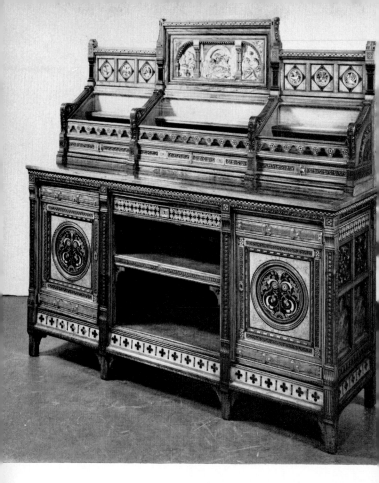

PLATE 13 Cabinet of walnut, carved and inlaid with various woods, with enamel plaques of birds, and metal reliefs of the 'Sleeping Beauty', designed by B. J. Talbert (1838–81), and made by Holland & Sons, 1867.

Victoria and Albert Museum. Crown Copyright

of the well-to-do, was the most elaborate piece of furniture at the time, so it was natural that the superior furniture craftsman should announce his ability to 'make cabinets'.

CABOCHON MOULDING denotes a plain space of convex section (similar to a cabochon-cut gemstone). The rounded surface is usually, though not invariably, surrounded with some type of ornament. A very popular variant to be found in the 18th century both in furniture and interior decoration is the cabochon moulding with a leaf or foliage surround.

CABRIOLE, literally French for a leap or a goat's leap, indicates that kind of leg so fashionable in the 18th century which was copied from a goat's leg. The knees or upper parts are convex, while the ankles or lower parts curve inward. It was introduced into England as early as the William and Mary period but became increasingly elaborate at a later date. Chippendale used it, as did other outstanding designers and cabinet-makers.

CACQUETEUSE is the French word for a gossip. In furniture it is used to denote a narrow high-backed French chair which is also sometimes called a Chaise de Femme, and is usually applied to the 16th-century type which has a triangular seat, a tall narrow back and spread arms. Some of the later types had a seat shaped rather like a saddle which allowed the men to spread their long coat tails on either side of the seat.

A CANOPY CHAIR is a 15th- or 16th-century formal or State chair, similar to a throne, with a canopy over the head. Another word for it is a DOSSIER, although this should strictly be applied to a mediaeval high-backed bench for three or even more persons.

F

C<small>ANT</small> is a bevelled or inclined surface. The term 'canted' is used to indicate any part of a piece of furniture which has an inclination off the level.

A C<small>ANTERBURY</small> was originally an 18th-century supper tray which had separate compartments for cutlery, plate, glasses, etc. In the late 18th century and the 19th century the term was extended to cover the small stands which were divided into compartments to hold sheet music for the piano.

A C<small>APITAL</small> is the curved or moulded member forming the head of a column or pilaster. This top of the column is distinguished by its Order of Architecture, of which the five classical orders are: Tuscan, Doric, Ionic, Corinthian, and Composite. From the somewhat squat Tuscan Order the tendency is for the others to increase in height, the elaboration of the Capital, and in delicacy.

The C<small>ARCASE</small> is the body or enclosed part of a box-like piece of woodwork. The main body of a piece of furniture is called the carcase, and in England seasoned oak has been mainly used for this purpose.

C<small>ARD-CUT</small> is the term applied to flat-relief (basso relievo) wooden ornamentation which is applied to the surface of a piece of furniture. Good examples of card-cut ornament are to be seen on the Chinese-style pieces of Chippendale and others of this period.

C<small>ARD-TABLES</small>, which were introduced during the Carolean period, reached their peak of elegance during the 18th century when card-playing and gambling became so fashionable. Early examples were made in walnut, but in the 18th century, as one would expect, most examples were made in mahogany. The shape that finally became established was the familiar square card-table with

'dishes' for money and counters and drawers to keep the cards. Some have tapered legs, but the cabriole leg was generally preferred.

The CARLTON HOUSE writing table is a type which was made fashionable by Thomas Sheraton. Usually set on tapered legs, this type of writing table has an elevated back containing small drawers (often semi-circular) and wing-like elevations on each side of the main top which also contain drawers. It is not only a workmanlike writing table but also an extremely elegant one. They continued to be made throughout the 19th century.

The CARTONNIER is a small bureau or cabinet. It is usually fitted with a lot of small drawers, and some elaborate examples have secret drawers released by spring mechanisms where money, private papers or other valuables could be concealed.

The CARTOUCHE is a decorative device originally based upon an unrolled scroll. Later the term comes to cover shield motifs found on chairs and other pieces of furniture as well as almost any scroll or carving used ornamentally.

The CARVER CHAIR, as its name indicates, usually denotes the armed dining chair, or the two armed dining chairs, set at the ends of the dining table. In America the term is used to denote a chair decorated with turning and having a rush seat. Reputedly called after Governor Carver who was a Governor of Plymouth Colony. An original in Pilgrim Hall, Plymouth, New England, is said to have been owned by Governor Carver.

The craft of CARVING has naturally played an important part in the history of furniture. Implying any decoration of wood made by a knife or chisel, carving began to

become mechanized in the late 18th century, and during the 19th century only a relatively few high-quality pieces were entirely hand-carved. Most Victorian pieces were machine-carved and, if they were of any quality, were then finished off by hand. Cheap articles were entirely machine-carved.

A CARYATID, plural CARYATIDES, is a carved female figure used as a decorative supporting post or pilaster. Legend attributes the classical Greek Caryatides to the period when Carya was captured by the Greeks and its enslaved women became models for these supports. During the Tudor and Stuart periods they became fashionable in English decorative furniture, being copied from the French or Italian models. Throughout the 17th and 18th centuries the caryatid remained a popular decorative device. It was revived again during the 19th century. A variant on the caryatid is the Atlas (plural Atlantes), a male supporter called after the legendary strong man who upheld the world.

CASSONE, the Italian word for a chest or a coffer, is usually understood to be a marriage coffer of elaborate and decorative design. Very ornate examples were made during the Renaissance period. Later the term was extended to cover any decorative chest used for valuables.

The CAUSEUSE, also called a sofa chair, is a double chair on which two people can sit and, as its name implies, have a conversation. Originating in France during the 18th century, it continued to be made in both France and England throughout the Victorian period.

The CELLARET is another name for the wine-cooler which was extensively made throughout the 18th century. The main body was generally of mahogany, but the interior

was zinc-lined to keep the wine bottles cool and, if ice was used, to contain the water. In the late 18th century, with the evolution of the sideboard with its built-in wine containers, the cellaret gradually went out of fashion.

CERTOSINA, named after the Certosa del Pavia where the monks were famous for the skill in the art, is a type of inlay using small hard stones or very small pieces of wood or bone in strictly geometrical patterns. It is a variety of TARSIA decoration and in much of the work, bone or ivory are used in contrast against walnut or ebony.

CHAISE LONGUE is a kind of French day-bed which originated during the Empire period. A typical example is portrayed in the famous portrait of Madame Récamier so that this type of single-ended couch without a back to it is also sometimes called after Madame Récamier.

To CHAMFER is to remove an edge by a bevel, or a groove cut in a wooden surface by a bevel.

A CHESTERFIELD is a type of fairly large upholstered settee which is supposed to derive its name from the 19th Earl of Chesterfield.

The CHEST-ON-CHEST is an early form of highboy (q.v.). As the name indicates, it is basically no more than two chests on top of one another.

The CHEVAL GLASS, from the French 'cheval', a horse, is a large swing mirror mounted on a frame designed to present the viewer with a full-length reflection. A larger version of the familiar dressing table swing mirror.

A CHIFFONIER in its basic form is a movable low cupboard with a sideboard top. Originating in France, the chiffonier later became elaborated into a very decorative piece of

furniture with drawers and cupboards, and often also incorporated a mirror.

CHIP CARVING is a type of carving practised in the 16th and 17th centuries where a pattern is formed in wood by a gouge or chisel. Extensively used in some old oak furniture, cupboards and the like.

CLOSE CANING is used on chairs and the backs of chairs and settees, and is a later descendant of the Carolean open or coarse caning. In close caning, as the name implies, no openings are left in the cane work.

CLUB FOOT, or Colt's foot, is a simple foot on a piece of furniture, somewhat resembling an animal's hoof. The style reached England from the Continent early in the 18th century and has been in use ever since.

COCK-BEADING is a form of decoration which became very fashionable in the 18th century. It consists of a narrow beading which projects above the main surface of a piece of furniture and is most commonly found around the edges of drawers.

COFFEE FORT, French for strong box, is another name for the elaborate Renaissance style coffer.

The COMMODE, which became one of the most elaborate forms of French furniture, is an ornamental chest-of-drawers with a *Bombé* shape. Although a number of English cabinet-makers made commodes they were hardly ever as elaborate as their French ancestors with their elaborate mounts and delicate marquetry work.

CONFIDENTE, French, is a type of settee, which, apart from the main seat area, has two further small seats set outside the arms of the main body.

The CONSOLE TABLE, similar to the console mirror, is a table supported at the back by a bracket projecting from the wall. The Adam brothers made them very fashionable and in the late 18th century they usually had marble or *scagliola* tops.

The CONVERSATION COQUETOIRE is another name for the *cacqueteuse* (*q.v.*).

COQUILLAGE, French for 'shell fish', is a type of ornament embodying patterns derived from the shapes of shells. Very popular in the 18th century.

CORBEIL, another French word which means a basket, is a form of ornament embodying a basket or flowers, fruit, etc. Like COQUILLAGE, much favoured in the 18th century.

CORBEL is an architectural term for a projection of stone or timber. In furniture it is a bracket or projection used for ornament.

A CORNER CHAIR, as its name implies, is similar to a corner cupboard in that it is designed to go in the corner of a room, the seat being fixed diagonally.

A CORNICE, another architectural term, is in furniture the horizontal and moulded projection at the top of, say, a bookcase, wardrobe etc.

The CORNUCOPIA, the classical Horn of Plenty, has long been a favourite ornamental motif with furniture designers and decorators. It is shown as a goat's horn overflowing with flowers, fruit, and corn, and was very popular during the late 18th century.

A COURT CUPBOARD, literally a short cupboard, has its upper storey set back from the lower and is the ancestor

of the sideboard. Found from Tudor times onwards, usually in oak.

The CREDENCE is another forerunner of the sideboard, which started as a small table used in churches for Communion. Later it became a chest upon legs to which a shelf was attached, and used for the display of plate, etc. during Tudor and Jacobean times.

CRENATION is a form of decoration on the edge of woodwork, having a notched or toothed edge.

CRESTING is the term used to denote the ornamental carving at the top of a chair back. Elaborate in the Carolean period, cresting in the hands of designers like Chippendale was often refined and delicate.

A CRICKET STOOL is a Scottish or North Country term for any small stool. Similarly, a Cricket table is a small table with a round or triangular top supported on three legs.

CROSS BANDING is where a banding of veneer is placed so that its grain 'crosses' or runs opposite to that of the background wood.

The CROSS RAIL, is the horizontal rail that connects the uprights of a chair back.

CUP TURNING, which was introduced into England from the Continent in the 17th century, denotes the cup-like bulging ornamentation often found on chair legs, etc. The leg itself tapers. Cup turning has been a popular form of decoration right up to the present century.

The CURULE CHAIR, which derives from ancient Roman chairs, is basically like a camp stool. In antiquity it was inlaid with ivory. In Roman times only a curule magistrate was entitled to such a chair.

A CYLINDER-FALL is the curved sliding top found on writing tables. The original cylinder-falls were made from a single piece of wood, but in the 19th century they were often constructed on the Venetian-blind principle.

The CYMA CURVE, deriving from the Greek word for 'a wave', is the ogee moulding of a cornice. Hence it is used to denote anything showing a curved shape or surface.

DARBY AND JOAN settees, also known as Love-seats, are small settees or seats for two people. The backs are usually similar to two connected chair-backs.

A DAVENPORT DESK, which is reputed to derive from the first maker's name, is a small writing desk with a sloping top and drawers underneath. Usually the drawers are fitted on one side only, with complementary 'blind' drawers on the other side. A great many Davenports were made in the 19th century.

DAYBEDS are Late Tudor, Stuart, and early 18th-century ancestors of the couch or sofa. Caned at first, they were later upholstered, and finally supplanted by the upholstered settee.

DENTILS, from the Latin Dens, a tooth, are a tooth-shaped type of ornament. Usually upon cornices, they are rectangular blocks with spaces between.

DESK-BOX is another name for a Bible-box, and the term is normally used to denote a 17th-century box for holding writing materials and books.

DIAPER WORK, which derives from a linen fabric with a small diamond pattern, is used in woodwork terms to describe geometrical or natural shape patterns which are repeated in a reticulated pattern. Most commonly found as an ornament on panels, particularly oak.

A DISHED CORNER is a depression on a card table or a writing table to hold either counters, coins, or a candlestick.

A DISH TOP is a type of table, usually circular, popular in the 18th century which has a raised rim or edge all around it.

The DOLE CUPBOARD, similar to the almery, is an early cupboard with pierced or fretted holes in it, and used for storing food.

The DOVETAIL is a constructional detail owing its name to its resemblance to the tail of a dove; a wedged-shape in the wood fitting into a similar wedged-shape opening.

The DOWEL, a method of construction largely supplanted by dove-tailing, is a wooden pin or 'nail' used to fasten timbers together. This was the method used by the joiner. Dowels are circular, square or polygonal.

The DOWER CHEST, which held the bride's dowry of clothes, jewellery, etc., is a large chest usually made of oak and often elaborately decorated.

A DRAUGHT CHAIR, as its name suggests, is a winged chair designed to keep the draughts off the sitter.

A DRAW or DRAWING TABLE is an early form of extension table where the size of the top is extended by drawing out flaps supported upon runners.

The DRESSER, French DRESSOIR, is a piece of furniture upon which pieces of plate, etc. were *dressé*, i.e. displayed. A relation of the cupboard, the dresser is commonly designated as a kitchen, rather than a dining-room, piece of furniture.

The DRESSING TABLE, a descendant of the lowboy (*q.v.*), became an integral part of the bedroom furniture in the

18th century. Sheraton, among others, designed some very elegant dressing tables.

The DROP-FRONT is a type of desk-lid which, when opened, is supported upon slides and forms the writing surface.

DROP HANDLES date from the latter part of the 17th century and are the familiar pear-shaped hanging handles found on so many pieces of furniture. Sometimes of iron, although in quality work invariably made of brass.

The DRUNKARD'S CHAIR as it is sometimes erroneously called, is no more than a large 18th-century elbow chair.

The DUCHESSE settee is the English equivalent of the chaise longue. The term 'Duchesse' is also sometimes applied to a dressing table with a swing looking-glass.

DUGOUT is a term applied to some very early forms of coffers which, like dugout canoes, were hollowed out of a solid log.

A DUMB WAITER is a term nowadays sometimes applied to a movable table for carrying food and drink, etc. In the 18th century it usually indicated a pillar table with two or three circular tops set one above the other on which food could be displayed.

The DUTCH FOOT, which is closely related to the ball foot, terminates in a ball shape, but the leg of the piece of furniture swells out at the ankle before joining the foot.

ÉBÉNISTE, the French equivalent to a cabinet-maker, means literally a worker in ebony.

EBONY, the close-grained and very hard black wood which was so widely used in 18th-century France for veneering high-quality furniture. The green or darkish brown stripes in the surface of the ebony give it an interesting

texture. In combination with the elaborate mounts favoured by the French designers and cabinet-makers, ebony has contrived to produce some of the most decorative and luxurious pieces of furniture in the history of the craft. Throughout the 19th century also, both French and English cabinet-makers made very high quality pieces with ebony veneers.

ECHINUS (Latin) is the name often used for the Egg-and-Dart or Egg-and-Tongue decorative enrichment of mouldings which consists of egg-shapes alternated with darts or tongues.

ENDIVE was a fashionable decorative device during the 18th century, resembling an endive leaf. The term is also applied to a kind of marquetry with intertwined stalks which seems to have originated in Holland and been brought to England during the reign of William and Mary.

ESCALLOP (Scallop) SHELL motif was much used as a furniture ornamentation from the 17th century onwards.

ESCRITOIRE, French for writing desk, is normally used to designate a type of elegant writing table or desk distinctive of the 18th century. They were elaborately appointed with drawers and pigeon holes and places for writing equipment.

ESCUTCHEON in heraldry is a shield 'charged' or decorated with armorial and other devices. In furniture terms it can mean any shield-shaped ornamentation. Similarly, keyhole plates, because of their shape, are often called 'escutcheons'.

ETAGÈRE, yet another of the many French terms to be found in English furniture nomenclature, is essentially a series of open shelves or brackets fastened to the wall and

used for the display of porcelain and other decorative objects. The word is also applied to delicate tables with several tiers, which were similarly intended for a display of valuable small possessions.

FALDSTOOL, from the mediaeval word for a folding stool, was originally applied to the X-type folding stool used by a Bishop. Later it also came to mean a movable desk from which the litany was said.

FAN BACK is an elaborate type of Windsor chair, having a back spread like a fan.

A FARTHINGALE CHAIR is an early upholstered chair, often Jacobean or early Stuart period, and designed for the days when women wore large farthingales or hooped petticoats. The chair had no arms (in order to accommodate the farthingales) and tall, narrow backs.

FAUTEUIL is the French word for a type of armchair which, unlike the *Bergère* (*q.v.*), was open under the arms. The back and the seat were usually upholstered.

FEATHER BANDING is a very decorative type of veneering popular in the 18th century, where the veneers are carefully selected in order to make a pattern like birds' feathers.

FESTOON is a wreath or garland, designed to hang in a curve, and much used as an interior decorator's device or as an ornament on furniture in the latter part of the 18th century.

A FIDDLEBACK chair is one in which the central splat (*q.v.*) is shaped like a violin or fiddle. The term 'fiddle-back' is also used to describe the grain of maple and sycamore woods.

FIGURING means the markings in wood used for furniture.

Carefully selected woods used in high-class cabinet work were distinguished for the figuring which marked them.

A FILLET is a narrow flat band used in mouldings, whether in interior decoration or wooden flat mouldings on furniture.

FINIAL is the bulb or turned, or carved, knob crowning the cornices and the tops of pieces of furniture. It can also be applied to any ornament—carved bird, vase, etc.—which crowns the top of pieces of decorative furniture.

FLAMBEAU, French for a torch, is a motif that has long been popular with the designer and furniture craftsman. Used as a finial on furniture and as a painted decoration on pieces of the Adam or Sheraton style.

FLAT CARVING is commonly found in early carved furniture of Jacobean or Stuart periods, usually on chests or other pieces that afford a fairly large area. The design is in relief but left as a flat surface, with no attempt at carving in relief or undercutting—techniques that would develop later.

FLEMISH SCROLL is an 'S'-shaped scroll often found on legs and arms of furniture in the William and Mary period. It is allied to the Flemish foot, a style found in the Jacobean period where the foot of a piece of furniture is made in an 'S' shape.

FLUTING, or flutes, is a form of decoration where parallel grooves are cut in columns or pilasters. Based upon the classic technique of fluting the marble columns of buildings, this style of decoration was later adapted by the furniture maker who used it extensively on the legs of chairs, cabinets, etc., as well as in upright rows on friezes, drawers, and other horizontal spaces. The late

18th century saw an extensive use of fluting in the graceful pieces of designers such as Sheraton.

A FOIL is the Gothic term for the intersecting points at the junction of circular arcs. Derived from this are the trefoil (3 foil), the quatrefoil (4 foil) and the cinquefoil (5 foil).

A FRENCH FOOT is a concave bracket foot (*q.v.*) where the length of the foot is wider than the face.

FRENCH POLISH, which mainly consists of shellac rendered soluble in methylated spirit and given a colour by the use of varying dyes, was not used for furniture until the 19th century. It took the place of the earlier oil finish (*q.v.*) and is considerably harder. Early pieces of furniture should never be French-polished without consulting an expert as, more often than not, the true patina of an old piece of furniture will be lost by the application of French polish.

FRET or FRETWORK is a method of ornament where a pattern is formed by cutting through thin strips of wood with a very fine saw. Open carving in wood, and seen at its most elegant in some of the Chinoiserie style furniture of the 18th century. Fretwork is also found in applied decorations to woodwork.

FRITHSTOOL is an old Anglo-Saxon word for a simple round stool.

FUMING is the technique of artificially darkening wood, particularly oak, by exposing it to the fumes of ammonia.

GADROON is a carved moulding mainly composed of beadings, cabling, or a series of convex curves. In furniture it is mostly found in chair edges and table tops.

The GALLERY is a raised edge on a piece of furniture,

such as the gallery around a desk or a table designed to prevent things from falling off.

A GAMES TABLE, which first became fashionable in the 18th century, but which continued to be made throughout the Victorian period, usually has an inlaid chess and draughts board on one side and a backgammon underneath. The two sides are reversible.

GARDE DU VIN is the French word for a wine-cooler or cellaret.

GARDE-ROBE, similarly, is the French word for a wardrobe.

The GARLAND, one of the decorator's favourite motifs throughout nearly all periods of furniture history, derives from the victor's garland used as an ornament in antiquity. Very widely used during the 18th century as a decoration on all kinds of furniture and interior decoration.

GILDING is the technique of ornamentation by applying fine strips of gold leaf to wood or other substances. In the 18th century it was widely used on many articles of furniture, especially mirror frames. Either a prepared chalk composition was laid upon a carved wood frame, or the surface of the wood was varnished and sized before the leaf was laid upon it. Gilding should not be confused with cheap modern methods of spraying wood surfaces, picture frames, etc., with metallic gold paint; it was a highly skilled craft and good gilding lasts for centuries.

The GIRANDOLE, a French word originally applied to revolving fireworks like a Catherine Wheel, is in furniture taken to mean a branched candle bracket or candlestick. It is usually, but not inevitably, attached to a wall mirror—so that the light of the candles is intensified.

The GLASTONBURY CHAIR is an ecclesiastical X-framed seat of Gothic style, with a sloping panelled back. The most characteristic feature of this type of chair is its arms, which fall away to the front in a sloping sweep so that the priest's vestments can hang easily. The name, reputedly, comes from Glastonbury Abbey where such chairs are said to have originated.

A GOUT STOOL is a stool with an adjustable top to accommodate the foot at various heights. It is probable that they were no more than an intelligent and comfortable adaptation of the ordinary foot-stool, but their origin has been attributed to the 18th century predisposition to gout, due to heavy port-drinking.

The GRANDFATHER CHAIR is a colloquial term for the winged upholstered chair that became popular during the Queen Anne period. Similarly, the term 'Grandfather Clock' is applied to the English long-case clock which was introduced in the late 17th century (mainly to house the long pendulum then used as the regulator). See LONG-CASE CLOCK.

GREEK FRET is the name for a style of ornamentation which became fashionable during the late 18th century under the influence of the Neo-Classic Revival and designers such as the Adam Brothers. It resembles the well-known Greek 'Key Pattern' but only in its continuity for Greek fret is essentially a repetitive design like a twisted ribbon or fillet.

A GROTESQUE in furniture and woodwork terms means a head or even a complete figure where an element of caricature or exaggeration is introduced.

GUERIDON, or *torchère* (*q.v.*), is the French word for an elaborate carved and gilt pedestal, originally designed

to carry candlestands. Later they might be the repository of anything from a bust to a vase of flowers. During the late 18th century, and particularly under the influence of Robert Adam, they became very popular in houses where the interior decoration followed the Neo-Classic style.

A GUILLOCHE is a type of ornament designed to look like a series of braided ribbons, and is quite often used—particularly on chair sections—in the 18th century. Usually a *guilloche* surrounds a *patera* (*q.v.*) or similar ornament.

HANDLES (see BAIL and DROP) are usually in England made of brass if the furniture is of any quality. Prior to the William and Mary period they were often of iron or wood. Nearly all the major cabinet makers who published books of designs included in them designs for the handles and backplates to go with their furniture.

The HARLEQUIN TABLE is an expression usually applied to a Sheraton design which is a combination of dressing and writing table. There is a 'blind' or dummy drawer-front; the top part of the table folds down to make a place for writing; a small nest of pigeon holes is so arranged to raise or lower itself from the table.

HERRINGBONE which, as its name indicates, follows the pattern of a herring's backbone as an inlay ornamentation which became very popular during the 18th century.

The HIGH BOY, from the French HAUTBOIS, is a tall chest-of-drawers or, generally, a chest of drawers set upon another chest of drawers. The term is often confused, for this definition of a high boy is strictly American, and in England a chest of drawers set upon a dressing table is often called a high boy.

HOCK LEG is a type of cabriole leg which, as the name

suggests, has the same shape as a horse's hock. Basically, a hock leg has a broken curve on the inner side of the 'knee'.

The HOOF FOOT, which is found in ancient Roman furniture, looks like an animal's hoof—very often a goat's. It is natural then that one should often find it in association with the cabriole leg.

The HUCHE (French) or HUTCH is a simple form of chest. Dating from mediaeval times, it is akin to the dole cupboard or ambry (*q.v.*). The word is also applied to early forms of chests in which clothes were stored.

HUCHIER (French), the hutch-maker, is synonymous with the English joiner. In the mediaeval period he made chests and simple stools, etc., but at a later date the term was extended to cover the skilled joiner and furniture maker.

HUSKS are a decorative detail which derive their name from a nut, particularly a hazel-nut, when the husk has burst open. This motif seems to have originated in France, where it was particularly popular in the reign of Louis XVI. Copied by English furniture designers, it was widely used in the Adam style.

INCISING is to decorate by means of sunk ornamental lines. In early furniture this was a common form of ornamentation, but at a later period (particularly when fine woods like walnut and mahogany were used) it yielded place to carving.

INLAY or INTARSIA (from the Italian word 'To insert') is wood inserted into another wood in order to produce a pattern. One of the oldest forms of decorative device in the craft of furniture, it is distinct from marquetry (*q.v.*)

in that the design is sunk into the solid panel or basic ground of the piece of furniture. Different coloured woods were used to produce patterns and designs as well as other materials such as ivory, silver, shells, etc.

JAPANNING is the method of painting cabinet-work in imitation of the lacquer work of Japan and China. Originally, in the Far East, the wood thus decorated was sun-dried, but when the technique was copied in Europe it was necessary for the wood to be stoved. Lacquer (*q.v.*) became extremely popular in England from the reign of Queen Anne onwards, and some of the most elaborate 18th-century furniture is lacquered. Reds, golds, blues, and black predominate.

The JOINER was, until the Stuart period, the equivalent of the later cabinet-maker. Basically the term meant that he made 'joined' furniture, i.e. furniture held together by dowels, or mortise and tenon. Glues and inlays and similar sophistications were the innovations of the cabinet-maker.

KETTLE FRONT is a simple English equivalent term to bombé or swelled front furniture.

KEY-CORNERED, as applied to rectangular panels, means that the corners are broken into squares. This contrasts to what are known as 'segmental-cornered' panels, where the corners are broken off by curves or semi-circles.

The KIDNEY TABLE, a Sheraton design, is shaped—as its name suggests—like a kidney. Graceful and elegant, it has a kneehole and a drawer or drawers, often with a shelf between the legs for stowing papers, etc.

KNIFE URNS, designed to hold knives, and similar to knife boxes, are made in an urn shape. They belong to the

latter part of the 18th century, and particularly to the Neo-Classical style made so fashionable by the Adam brothers.

LACQUER (see also JAPANNING) is a resinous substance found in the Orient and used originally in China and Japan in conjunction with colours and metallic substances to decorate objects of wood and other materials such as papier mâché. The lacquer was coloured black, vermilion, green, gold, etc., as well as being decorated with precious materials like jade. When the first lacquered objects reached Europe they created a sensation and there was an immediate attempt to copy them. In England the term lacquering usually means the varnishing of mounts and other brasswork with a mixture of methylated spirits and shellac in order to give the metal a greater resemblance to gold. In terms of furniture, most lacquered pieces were made during the William and Mary, and Queen Anne periods, although lacquering continued to be used right through the 18th century and into the Victorian era.

A LADDER-BACK chair is one in which the cross rails at the back are set in regular rungs like a ladder.

LAMBREQUIN is the French term for a hanging drapery round the top of a bed.

LANCASHIRE CHAIRS fall into two categories: early Cromwellian period, made of oak with a tall panelled back and a carved cresting rail; and an 18-thcentury type, also known as a spindle back, where the back is formed of vertical spindles.

LAURELS have been a popular decorative motif in furniture and interior decoration since classical times. From the 17th century onwards the laurel or crown of bay leaves has been extensively used by carvers.

LINENFOLD is a carved pattern resembling folded linen which is said to derive from the folds of the cloth placed over the consecrated bread at communion or the veils covering the chalice. Certainly the pattern is ecclesiastical in origin and belongs to the late Gothic period. It seems to have come to England from Flanders in the last quarter of the 15th century and was extensively used for panelling and on movable furniture throughout the 15th century.

A LINEN PRESS is a large chest used for storing linen or, at a later date, is applied to a cupboard used for the same purpose.

The LION MASK was a popular decorative device on furniture throughout the 18th century and well into the 19th. As well as being used for brass mounts, it was also a carver's motif and is found, among other things, on the knees of cabriole legs.

LIVERY CUPBOARDS, from the French *livrer*, to deliver, were fixed on movable cupboards used for storing food and wine. Found in England from the Tudor period to the end of the Jacobean.

LONG-CASE CLOCKS (See also GRANDFATHER) were introduced in the last quarter of the 17th century. In the earliest examples there is only an hour hand, and the cases are of oak or walnut. During the 18th century they became an object on which the master cabinet makers lavished their skill and attention, turning them into magnificent pieces of furniture. Thomas Tompion, among others, is a name that will always be associated with these clocks, which are not only fine precision instruments but also minor works of art. Most long-case clocks on the market today are country or provincial pieces dating from the late 18th or 19th century. Fine 18th-century long-

case clocks are among the most expensive items at auctions. A small and delicate type of long-case is commonly termed a Grandmother clock.

The LOO TABLE derives its name from the round card-game, Loo, popular in the 18th and 19th centuries. It is a circular table, sometimes with a tip-up top, mounted on a central pillar. The base may be a tripod foot but is more often circular. Considerable numbers were made during the 19th century.

LOPERS are the slides which pull out to support the drop-fronts of bureaux and writing desks.

LOVE-SEATS are the same as Darby and Joan settees, being small upholstered settees designed for two people.

LOW BOYS are small dressing tables fitted with drawers but without swing mirrors as distinct from high boys (*q.v.*). They date from the William and Mary period.

The LOZENGE PATTERN is an Elizabethan and Jacobean motif popular with wood-carvers and formed by a succession of diamond shapes.

The LYRE BACK is a type of chair popularized by Thomas Sheraton where the chair-back incorporates the shape of a lyre. Very decorative and elegant, these late 18th-century chairs were also copied in the Victorian era.

MARQUETRY (See also INLAY) is the craft of making a design by inserting different coloured pieces of wood into a thin wood panel or veneer which is then glued to a piece of furniture. First fashionable during the William and Mary period, marquetry work in England never quite attained the richness and complexity that it did on the Continent (where it originated).

MEDALLIONS as motifs for furniture designers were

extremely popular during the late 18th century. Either carved or made of composition and applied, medallions were mainly oval or circular.

MENUISIER is the French word for a joiner or cabinet-maker.

A MITRE is the line of junction at the intersection of mouldings usually, but not necessarily, at an angle of forty-five degrees. First used during the Elizabethan period, mitred mouldings in geometrical patterns were popular on chests and cupboards in the late 17th century. A mitre is also the standard joint in picture frames and rectangular mirrors.

MORTISE AND TENON is the strongest method of joining two pieces of wood. On one piece a square hole, the mortise, is cut and into this the tenon, a projection on the other piece, fits exactly.

MOULDINGS are varieties of contour or outline worked upon the edges or other parts of woodwork in order to decorate or mollify the severity of shape. Carved enrichment of mouldings has been employed in architecture since classical times.

MOUNT is the term used in furniture to define the metalwork enrichments such as handles, back plates, etc. Mounts can be extremely elaborate and decorative, particularly ormolu (*q.v.*) mounts.

A MUNTIN is the upright section of wood between two panels.

MURREY is an old-fashioned term used to define a purple-red or mulberry coloured wood.

NONSUCH CHESTS are chests which are ornamented with inlaid representations of Henry the Eighth's Palace of

Nonsuch at Cheam. Later the term was extended to cover any chest ornamented with a similar architectural or topographical scene.

NULLING is a decoration found in woodwork particularly during the Elizabethan and Jacobean periods, and consists of a series of beads or small bosses.

NURSING CHAIR, a term which is generally applied to any low-seated chair, usually with a high back. Early nursing chairs have caning in the back and seat.

OCCASIONAL TABLE is a term loosely used to cover any of the light portable tables which first came into general use in the 18th century.

OGEE mouldings are found in architecture and furniture, and consist of a double continuous curve. Also known as the CYMA (q.v.) REVERSA.

OIL FINISH is a method of hand-polishing furniture with boiled linseed oil, followed by an application of beeswax mixed with turpentine. All quality early furniture was oil-polished, but the technique was largely superseded by French polish (q.v.) in the 19th century.

ONION FOOT, resembling an onion shape, is a style found on pieces of furniture from the William and Mary period.

ORMOLU, a French invention, is a combination of metals designed to imitate gold. More expensive than brass, it is an alloy formed out of approximately 75 per cent copper and 25 per cent zinc. In English, but particularly French work, ormolu was used for mounts and ornamentation.

OVIFORM decoration means decoration in an egg shape. Other terms used to describe the same motif are ovate

and ovoid. Egg-shaped decorations are found in every type of cabinet work from the late 17th century onwards.

OYSTER SHELL veneering seems to have originated in Holland and became fashionable in England during the William and Mary period. Designed to resemble an oyster shell, this type of veneer is constructed out of numerous cross-sections of finely-grained woods.

A PAD FOOT is a simple type of foot found from the 17th century onwards which rests upon an animal pad shape.

The PAGODA TOP, as its name suggests, derives from the Orient and is applied to elaborate types of finials (*q.v.*) which resemble the Oriental pagoda in shape. Typical pagoda tops can be found in some of Chippendale's 'Chinoiserie' designs, as well as in those of other designers and cabinet-makers who followed this style of decoration.

A PANEL, a term found in the earliest English woodwork, is no more basically than a wood moulding contained by a surrounding wooden frame. In interior decoration, panelling was very widely used during the Elizabethan and Jacobean periods. At the same time, the technique of panelling was copied by the joiner and furniture craftsman so that many chests, cupboards and other pieces are constructed out of panels. During the 18th century, although panelling was not generally so widely used, a sophisticated type of panelled furniture was made, often decorated with painting.

A PAPER SCROLL, also known as an 'S' scroll or volute, is a scroll shape often found on the top back rails of chairs. It was a fashionable device in the late 18th century.

PAPIER MÂCHÉ, French for pulped paper, was a composi-

tion first developed in France and used for small decorative objects such as boxware. Later in England, where it became very popular, the technique was extended in the 18th century so that large objects such as the panels for sedan chairs were made out of papier mâché. Even tables and chairs, supported by internal iron frames, were made out of it and attractively decorated. Schools of artists evolved different decorative techniques with the use of metallic powders, etc. Eighteenth-century papier mâché is deservedly a collector's item, but the craft declined in the 19th century when articles in papier mâché were mass-produced.

PARQUETRY resembles marquetry in being a flat inlaid decoration, but differs in that the same kind of wood is used throughout. Designs are usually geometrical. In England the term parquet is usually restricted to the mosaic pattern of wooden floors.

A PATERA was originally a plate-like vessel used in Roman religious ceremonies. In ornament, the term is reserved for ovals or circles, carved or painted, and used on decorative furniture. The use of them is particularly associated with the work of the Adam brothers and with the Neo-Classic style.

PATINA is literally the 'bloom' found on the surface of old furniture, also on bronze-work due to the process of oxidization. This thin cuticle on the surface of woodwork is one of the guides to the age of a piece. Unfortunately, during the 19th century, many old pieces were French-polished thus destroying their patina.

A PEDESTAL SIDEBOARD is one where the top or main working surface is supported at each end by fitted cup-boards or pedestals.

PEDIMENT is the term applied to a moulded or ornamented structure placed above a cornice. The earliest classic shape is a simple triangle, but it was later elaborated into many ingenious forms such as segmental and broken-arch pediments, and the graceful swan-neck broken arch.

A PEMBROKE TABLE is a table with two hinged flaps supported on four legs. When the flaps are raised the table makes a graceful oval. It contains one drawer and was widely used as a breakfast table in the 18th century.

A PIE-CRUST TABLE is one which has its edge carved in a scallop pattern. One of the most attractive of 18th-century occasional tables, it was refined by Chippendale so that the circular top was slightly depressed, leaving the pie-crust edge standing proud above the surface.

PIETRA DURA, literally Italian for 'hard stone', is an inlay of pebbles, jasper, lapis lazuli, and other semi-precious or decorative stones. It was developed in Florence and was often used for table tops as well as applied to decorative furniture, usually of ebony.

PIGEON HOLES are the small recesses in fitted desks designed for storing letters and writing materials. Nests of elaborate pigeon holes are typical of many later 18th-century desks.

A PILASTER is a flat column, almost invariably less thick than wide, which is attached to the face of a plain surface. It is mainly found as an ornamental support to an arch or other superstructure.

A PLAQUE is an ornamental tablet or medallion applied as a decoration to woodwork. Plaques were made of metal (brass and ormolu), pottery and porcelain. They

were widely used in England in the latter part of the 18th century. Plaques for furniture were among the many things produced by the firm of Wedgwood.

The PLATEAU is the centre part of an expanding dining table.

A POLE SCREEN is a small screen mounted on a tall pole stand and adjusted for height. They were made in the 18th century and also in the 19th, and were principally used for deflecting the direct heat of the fire from the face. Many have panels of needlework, although both wood panels and panels of papier mâché were used from the late 18th century onwards.

A POUCH TABLE is a work-table having a fabric pouch for containing silks and wools, etc., when the lady of the house was doing her embroidery. Sheraton designed pouch tables and they were widely made in the 19th century.

A POUFFE, literally French for a high roll of hair, is a large, usually round, cushion designed for placing on the floor either as a foot-rest or to sit upon. It is in origin an Ottoman piece of furniture, but became extremely popular in England during the 19th century.

A PRESS BED was an early ancestor of the 20th-century bed which disappears into a cupboard or wardrobe.

A PRIE-DIEU CHAIR is a type of high-backed chair capped by a narrow shelf, rail or pad on which the user can rest his arms whilst kneeling for devotions. The seat is low to the ground to make it easy to kneel upon. They were commonly used for family prayers in the 19th century and a number of Victorian examples have survived.

THE PRINCE OF WALES FEATHERS was an extremely popular motif with furniture designers during the late

18th century and Regency period. The three ostrich feathers surmounting a crown made an attractive design for wood carvers.

QUARRELS are panes of glass in windows or doors, usually diamond or rhomboid in shape. The term is also applied to any small openings in doors, cabinets, bookcases, etc. It derives from an old French word for a crossbow bolt, and was originally applied in architecture to the openings in the face of buildings through which crossbows could be fired.

QUARTETTE tables are nests of four small tables fitting one within the other. The design was made fashionable by Sheraton and has been widely imitated ever since.

A RABBET is a constructional detail consisting of a groove formed on the edge of a piece of framing designed to receive another piece of wood. It is also spelled as 'rebate'.

RAINÇEAU is the French term for an ornamental device consisting of interlacing stalks of acanthus or other leafage. It was a form of decoration much used by the Adam brothers.

The RAKE is the angle of a chair back, while any piece of furniture designed to be inclined from the perpendicular is described as raked.

REEDED decoration is composed of parallel lines of raised wood placed in rows upon legs of chairs and other furniture. It is the reverse of fluting, with which it is sometimes used in conjunction.

A REFECTORY TABLE was originally a long narrow table used in the refectory of monasteries for the monks to take their meals. It has later come to be applied to any large simple table of oak. A number of refectory-style tables

were made in the Tudor and Jacobean periods. These have a number of legs to support the long oak table top and they are connected by heavy stretchers set on or close to the ground.

RESTORATION CHAIR is a term loosely applied to chairs made during the Restoration period of Charles II. They are somewhat Dutch in influence and have turned legs, high backs with elaborately carved top rails, and are usually cane backed and seated.

The RIBBAND BACK, which became fashionable in the second half of the 18th century, is a chair-back which is carved in ribbon patterns. Chippendale designed a number of them and most of the best chair designers at one time or another made ribband backs.

RIESENER WORK, so called after the great French craftsman Jean Henri Riesener (1734–1806), is an extremely elaborate form of marquetry work which became fashionable during the Louis XV and Louis XVI periods. Very delicate designs of musical instruments, flowers, etc., are executed in some of the finest marquetry work ever made. Examples of Riesener's own work can be seen in the Wallace Collection in London.

RIVEN woodwork is very simple wood furniture that has been riven or cleaved by the adze. Only found in mediaeval pieces or very primitive country work.

ROCOCO is the term for the type of decoration that became fashionable in France in the reign of Louis XV. Compounded from the French words *rocaille*, rockwork, and *coquille*, a shell, the rococo style uses these forms as characteristic ornaments. Edge outlines often resemble dripping water, while the general effect of rococo is always asymmetrical and delicate. The term is sometimes

wrongly applied to baroque, with which it should not be confused, for rococo is much more feminine and delicate. Chippendale among others introduced a certain element of rococo into some of his designs, although in general English designers and cabinet makers never attempted the true delicacy and extreme elaboration of the French.

ROMAYNE WORK is a term applied to early Tudor adaptations of Renaissance details, especially heads in the classical or 'Roman' style—from which the word derives.

The ROSETTE is one of the most widely used of all motifs in furniture as in architecture. This decoration of a stylized rose shape was first widely adopted during the Renaissance and has remained popular ever since. The term is also applied to a small rose-shaped glass ornament used to conceal the heads of screws in glass- and picture-framing.

A ROUNDABOUT CHAIR is circular in shape, low-backed, and with elbows. Used in studies and offices, it originated in the late 18th century and very many examples were made during the Victorian period.

A ROUNDEL is the name given to a small decorative medallion, originally circular in shape, but later applied to oval and other shapes used decoratively on furniture.

A ROUT STOOL is a long narrow stool, usually with cane panels, designed for placing along the walls in ball-rooms, etc. The term derives from the Regency word 'A Rout', meaning any convivial assembly or meeting.

The RUNNER is the piece of wood placed on either side under drawers to allow them to slide freely. The term is also applied to *lopers* (*q.v.*), as well as to the connecting pieces of wood between the legs of chairs and other articles of furniture.

RUSHBOTTOM chairs are country-made pieces in which local rush-work is used for the seats rather than cane as in more elaborate pieces.

'S' SCROLLS, as the name indicates, derive from the shape of the letter. In Carolean and William and Mary chairs the arms are often 'S' scrolled, while the motif has been used in every variety of furniture and interior decoration.

The SABRE leg is a very distinctive style which became widely used during the Regency period and the first half of the 19th century, particularly for dining-room chairs. The front legs curve forward in a sabre shape, while the back legs are either perpendicular or sabred outwards. Sabre legs are often decorated with reeding or fluting.

The SALTIRE, or St. Andrew's Cross, is another term for X-shaped stretchers as used underneath tables and chairs, where the stretchers cross one another in the middle.

SATYR masks as ornamentation have been used on furniture since classical times. They first became popular in England during the Renaissance, but were most widely used during the Classical Revival of the 18th century.

SCAGLIOLA, from the Italian *scaglia*, a reddish limestone, is the name given to an imitation stone made of plaster mixed with glue, and variously coloured or diversified to look like marble. The Adam brothers used scagliola for table tops, particularly pier tables. As a substitute for marble the substance was widely used during the late 18th and early 19th centuries.

The SCALLOP shell has been one of the most widely imitated natural forms in furniture and interior decoration. Derived from the bivalve mollusc, it has been particularly popular since the 17th century onwards.

G

A SCROLL, as its name implies, is an ornamental design imitating a rolled piece of paper or scroll, and usually designed to be viewed in section or edgewise.

SCROLL FOOT, of 'S' shape, is another name for the *Flemish foot* (*q.v.*).

SCROWLED is an old-fashioned term meaning carved.

SCRUTOIRE is an old anglicism for a bureau or escritoire.

SEAWEED marquetry, which was particularly fashionable in the William and Mary and Queen Anne periods, is a stylized usage of intertwined foliage or stalks. Another term applied to it is Endive marquetry.

The SECRETARY is yet another anglicism for an escritoire or writing desk. As an accurate definition, the term should really be applied only to a desk or bureau which is surmounted by a bookcase. Some of the most attractive pieces of cabinet work have been achieved in the forms of secretary bureaux.

The SEDAN CHAIR, which can scarcely be defined as an article of furniture, was at the same time an object upon which cabinet makers and other skilled craftsmen lavished their attentions. The origin of the word is obscure. Essentially it was an enclosed carriage for one person designed to be carried by two bearers on poles or shafts. In big cities such as London, or resort towns like Bath and Brighton, the sedan chair was usually a highly decorated object, with painted panels of wood or of papier mâché. It originated, it would appear, in the 18th century and disappeared with the improvement of the streets and sidewalks within one hundred years.

SEIGNEURIAL CHAIRS were stately and high-backed chairs designed for the use of the master or *seigneur*. The term

is usually applied to early chairs of the Gothic or Renaissance periods which were often designed to have a canopy over the head, and in the lower half there was a drawer for the stowage of documents and personal possessions.

The SERPENTINE FRONT is a particularly attractive example of furniture design where the front of a bureau or wardrobe is shaped in a snake-like curve. It is less pronounced than the bombé front (q.v.) and became very popular in 18th-century England.

A SETTEE is a long seat designed for more than one person, having a back and arms. Possibly originating from a double chair, it was introduced into England in the Carolean period during which time the seat was either wooden, or, a little later, caned. The settee in one form or another has been made ever since, although from the 18th century onwards the seat and even the back have been upholstered.

The SETTLE is the ancestor of all settees, sofas, etc., and was originally a joiner-made piece of furniture which derived from the antique bench. In essence, it is a bench with back and arms added to it, but from the Elizabethan period onwards the lower part tended to incorporate a chest. Jacobean settles were quite often elaborate pieces of furniture, made of oak and ornamentally carved.

The SHELL motif became particularly fashionable in England during the 18th century, being copied from the rococo style of France. The scallop and the oyster shell were the two most frequently copied in furniture decoration.

A SHIELD BACK chair is, as its name indicates, one which has the back in the form of a stylized shield. Some

extremely elegant examples were made in the late 18th century, particularly after designs by Hepplewhite.

The SHOE is the term most often applied to the disc below the foot of a chair which is designed to prevent it from harming the carpet. It is also a technical cabinet-maker's word for the projection at the back of a chair's seat rail, designed to receive the bottom of the splat (*q.v.*).

SIDE CHAIRS are the armless chairs comprising a dining-room suite, as opposed to the two armed 'carver' chairs set at each end of the table. From the 18th century on-wards side chairs became a normal part of the dining-room furniture. In earlier days the less important members of the family or guests had sat on benches or stools, chairs being reserved for the more important members.

A SIDE TABLE, another variety of the pier table (*q.v.*), was designed to be lodged against the wall and was an ancestor of the sideboard. Elaborate side tables, such as ones designed by William Kent, ultimately evolved into the even more elaborate pier tables of the Adam brothers.

The SKIRT or skirting piece (see also APRON) is a strip of wood beneath the front of a chair seat or other piece of furniture, and is designed to conceal the constructional details.

A SNAKE FOOT is a comparatively rare type of furniture foot found on some light pieces made in the 19th century, and designed to look like a snake's head.

The SOFA, a term almost synonymous with the *Ottoman*, is a deeply upholstered settee originating from the stuffed furniture of Turkey (hence Ottoman). First reaching England in the 18th century, the sofa remains basically a 19th century piece of furniture and has little to do with

the craft of the furniture designer or cabinet maker. Some sofas are backless, some have two ends, others only one, but all are either sprung and upholstered or deeply upholstered.

A SPADE FOOT is a four-sided tapering furniture foot somewhat similar to a spade in shape. It is quite commonly found in items of 18th-century furniture.

A SPANDREL is technically the triangular space between a rectangle and the sides of an arch which it encloses. In furniture terms it is applied to this space in woodwork, but mainly to the ornament in the corners of clock faces.

A SPANISH FOOT is a variant of the hoof or goat-shaped furniture foot, but distinguished by the fact that the foot is grooved or reeded. Very rare in English work but found on the Continent in the 17th century.

SPINDLES are small pillars usually placed in rows to form 'galleries'. Derived in shape from the working spindle, they are most commonly found in the standard 'spindle-backed' Windsor chair.

SPIRAL TURNING is synonymous with 'barley sugar' twist turning and is turned lathe work which was particularly popular in the Carolean period.

The SPLAT is the centre section of a chair-back, forming the main support between the top rail and the seat. Originally no more than a structural feature, it reached extreme elaboration during the 18th century in the designs of the major chair makers and cabinet makers.

SPOOL TURNING, found mainly in simple country or provincial work—especially on chairs—is a type of lathe turning based on the pattern of a series of spools.

The SPOON BACK chair dates from the reign of Queen

Anne and has a wooden back, shaped for convenience rather like the bowl of a spoon.

SPRINGS, accepted nowadays as a major item in chairs, beds, sofas, etc., were first introduced in the second half of the 18th century. They did not play a great part in the craft of the furniture designer until the 19th century when mass-production of springs became possible.

A SQUAB, deriving from the Swedish word for loose flesh, is a stuffed cushion or, in early days, a cushion designed to fit into the grooved seat of a wooden chair.

The STILE is the upright piece of wood in framed or panelled furniture, also the vertical piece in a door or window.

STRAPWORK is a style of carved ornament resembling leather strapping, consisting of narrow bands interlaced into patterns. Found in Elizabethan and Jacobean work, it was later adapted as an ornamental device in the 18th century for such things as splats of chairs.

The STRETCHERS are those sections of wood which form bracing pieces in chairs, tables, etc., between the legs. Originally they were purely structural, but in the 18th century they were often used as little more than ornament.

STRINGING is a term denoting thin lines of fine inlay designed to contrast in colour with the main background wood.

A STUMP BED is a bedstead without posts—something remarkable until the 19th century. The bed has a head-board but no footboard at the end.

The SUTHERLAND TABLE is almost synonymous with the Pembroke (*q.v.*) but is distinguished by the fact that, when its flaps are lowered, the top is so narrow that it is only a few inches wide.

A SWAG is a form of dropping ornament much used in furniture and interior decoration, and consisting of fruit, flowers, or drapery.

The SWAN NECK was probably French in origin, but was adopted by Chippendale among others. It consists of two opposed curves which touch one another and then conclude in a scroll.

A SWELL FRONT, also known as a Sweepfront, is a curved or bombé front in furniture.

The TABLE CHAIR, sometimes called a monk's seat, is an early Tudor or Elizabethan chair where the back can be made to swivel over the arms and so form a small table.

TABLE DORMANT is an old French term for a long table similar to the English refectory table.

A TABOURET is a French word loosely used to cover small drum-shaped stools (similar to a tabor or small drum).

The TALLBOY is similar to a Highboy (q.v.) being basically a chest mounted upon another chest. This type of chest-of-drawers was made throughout the 18th and 19th centuries.

A TAMBOUR FRONT is a roll-top on a desk and constructed out of thin lattices of wood glued to canvas. Originating in the 18th century, it was extensively used throughout the Victorian era.

TARSIA—See INLAY.

The TEA POY is a small table, first introduced in the 18th century, and designed to contain under its hinged top a number of tea caddies. Made in mahogany, and often an elegant small piece of furniture, the tea poy is invariably set on a central pillar and has either a round base or four legs.

TENON—See MORTISE.

The TERMINALS or terminal ends are the extreme points of a piece of furniture and are often finely decorated.

A TESTER is literally the canopy over a four-poster bed. It is sometimes applied to the whole bed itself. A half-tester, which became increasingly popular in the Victorian period, extended only over the top half of the bed.

THERMING is a process of turning that gives something of the same effect as square moulded work. The term is also applied to a tapered foot or support set upon the square legs of tables.

A TORCHERE is similar to a vase stand, but is usually fitted with candle holders.

TREEN, derived from 'tree', is a generic term used to describe small articles such as boxes made out of wood.

TRENCHER was the ancestor of the plate, being a circular flat piece of wood on which the food was served. It still survives in the modern household bread-board.

TRUSSING CHESTS were mediaeval chests used for transporting the family valuables, clothes, etc., and had iron rings on both sides through which poles could be passed for transporting them between two horses.

TWIST TURNING is a type of turning in which the undulating members run diagonally across the column and not horizontally as in most forms of turning. Commonly called 'Barley twist', it was very popular in the late 17th and early 18th centuries.

UPHOLDER is an old English word for an upholsterer, and it is quite common to find in 18th-century advertisements a tradesman describing himself as 'Cabinet maker and Upholder'.

An URN STAND was a small table designed to carry a tea urn under which was a spirit lamp. There is usually a small slide drawer in the front on which the tea pot could be placed while it was being refilled.

VARNISH as used in furniture is a transparent resin mixed with drying oils and designed to preserve cabinet work. The object of varnish is to heighten, by glazing, the distinctive colour and grain of the woodwork.

VENEERING is the process of gluing thin pieces of varied and valuable woods to the face or carcase of a cheaper wood. Early hand-cut veneers were about one-eighth of an inch thick, but the introduction of mechanical cutting later reduced this so that Victorian veneers may be no more than one fiftieth of an inch thick. Veneering came to England from Holland during the William and Mary period, but had been known on the Continent for a long time before this.

VERNIS MARTIN was an 18th-century varnish taking its name from its French maker Simon-Etienne Martin. It was an imitation of oriental lacquer—which had long baffled European craftsmen—and Vernis Martin was the nearest approach to it in Europe. It was widely used, and copied, by cabinet makers and lacquerers in England in the mid- and late 18th century.

A VITRINE is a French china cabinet made with glass sides and doors and is often elaborately decorated. It originated in the late 18th century but continued to be widely made throughout the Victorian period.

A VOYDER is an old English term for a turned wooden bowl in which discarded food, etc. was thrown.

WAINSCOTING is a corruption of a Dutch word and means essentially oak panels used to line the walls of a room. A

considerable amount of imported oak from the Continent, including Holland, was used for this purpose.

The WARDROBE with a tall hanging cupboard set above a small nest of drawers was introduced from the Continent during the reign of Queen Anne. Subsequently, in the 18th century, it became an elaborate and sophisticated piece of furniture.

The WASHSTAND which developed as a specialized piece of furniture in the 18th century was designed to hold a basin for washing, as well as a ewer for the water. A small drawer in the base held soap, etc. Usually supported on three slim pillars terminating in three feet, and quite often an elegant small piece of furniture.

The WELLINGTON CHEST, supposedly called after the Duke, is a tall and narrow chest of drawers which became fashionable in the early 19th century and was made throughout the Victorian period. An early form of filing cabinet, its series of small drawers could be locked by means of a hinged wooden flap which ran vertically right down one side.

WELSH DRESSERS are made of oak and were used throughout the Welsh countryside for storing, as well as displaying, the family cups, and pots, etc. The lower half forms a cupboard. Some very fine pieces in their simple style were made, and these have now become quite expensive collectors' items.

A WHATNOT is a Victorian term for a small tiered table which was used for displaying chinaware, small objects of art, etc.

The WHEEL BACK is an attractive design resembling a wheel, found in both country and more sophisticated chair backs.

The WIG STAND, often confused with the 18th-century washstand, and somewhat similar in appearance, was designed to hold the wig when the owner was in bed, and to allow it to be combed out and arranged.

The WINDSOR CHAIR, traditionally first made at Windsor in the Queen Anne period, has a solid wooden seat carved to fit the body, with a spindle back and spindle-supported arms. More elaborate versions sometimes have quite decorative central splats (*q.v.*). The legs are usually turned and joined by stretchers. An example of excellent practical design, Windsor chairs are still being made identical in appearance to those of three hundred years ago.

A WING BOOKCASE is a bookcase with a breakfront (*q.v.*) in the centre, which, having a greater depth, is designed to hold deeper volumes than the two wing sections.

A WING CHAIR is a synonym for a draught chair (*q.v.*) and is of Carolean origin. High-backed and upholstered, it has two projecting wings either side of the sitter.

A WORKTABLE is a Victorian development of Sheraton's pouch table (*q.v.*) and has a silk pouch beneath the top to hold the silks, threads, embroidery, etc. The top often incorporates a small writing table.

X-CHAIRS are the most ancient type of chair having evolved from the Faldstool (*q.v.*). The legs at both front and back cross each other in the style of a folding stool. Although in the Middle Ages they were mainly ecclesiastical, they were revived again for home use during the Renaissance and were revived yet again during the Victorian era when the Gothic style became fashionable.

A YORKSHIRE CHAIR is a colloquialism for a type of chair that was made during the Commonwealth period.

There are usually two semicircular cross-rails in the back, and these are often decorated with carving. The front legs may be turned but the back legs are usually plain. The seat is solid wood but sometimes designed to take a drop-in cushion.

CONCLUSION

It is fortunate that, for the aspiring furniture collector or the student, this country is furnished with some of the finest museums in the world. There can be no excuse for anyone who wishes to learn about the subject being disqualified by not being a rich man. No rich man, indeed, could afford to buy the inestimable wealth of furniture and interior decoration that is to be found in museums ranging from the Victoria and Albert to the Wallace Collection, the Soane Museum, and innumerable others.

There can be no better advice to anyone who wishes to do no more than buy some reasonably good 'Victoriana' for his or her home, than that they should spend some hours over a year or so looking at furniture in our great national collections. Only in this way is a real eye for the subject acquired—and when one combines this with the fact that there are several specialized library collections (particularly, again, in the Victoria and Albert Museum), which deal with the fine arts and the crafts, then the student has no reason to complain that he cannot acquire information.

Quite apart from this, it is important to go to local auction rooms and sales—not so much to buy as to look at and to handle pieces, and then to find out why at a later date such-and-such a piece will realize a great deal more money than another. At the same time, it is essential that the beginner in this field does not expect to find many bargains in 'junk' shops or on street corners. In the second half of the 20th century bargains hardly exist. Everyone is far too knowledgeable. This is not to deny that, very

occasionally, they can be found—but it is to say that no one should for a moment think that he is likely to run across them. Generally speaking, the occasional and remarkable examples of private buying (where a master-piece has been found for practically nothing) are nothing to do with luck, but may be the culmination of years of research and painstaking plodding through auction rooms and shops.

Furniture, as has been said before, is only a microcosm of social history, and indeed of history generally. The man or woman who is armed with a knowledge of history can far more easily detect the real age and provenance of a piece of furniture than can someone who comes to the subject armed only with a specialist knowledge. Indeed, if in this way only, an appreciation of furniture broadens one's life, for if one becomes interested in furniture of the Regency period it is inevitable that one should go on to look at the pictures, prints, books, architecture, jewel-lery, and silverware that were created during the same years. From this point, there is a natural progression to the background of war, politics, society, and economics that created the situation in which this particular type of furniture was born.

The subject of furniture is nowadays extremely well documented, and there is not a period—or even an in-dividual piece of furniture—that has not received the attention of a number of expert writers and specialists. The beginner in the subject will find that quite often these writers are at variance one with another about techniques, or the usages and functions of the objects under discussion. This should not be allowed to depress him, or to make him suspicious of the subject. So long as there is healthy argument and disagreement, so long

will there be progress in the serious study of the home lives of our ancestors. After all, a great deal of any man's or woman's time has always been spent under their own roof, and one can learn a very great deal about the people who formed us by studying the chairs in which they sat, the beds they slept in, and the tables at which they ate. When one comes to the Victorian period, for instance, it is quite possible to distinguish the changing fashions in clothes by the changing fashions in chairs (a woman in a bustle skirt could not possibly have sat down in a Tudor or Jacobean chair).

A knowledge of architecture and of architectural styles can be of great help to the newcomer in the field of furniture. The architects have always, and quite naturally, exerted a great influence upon the interior decorators and furniture makers. It is noteworthy how many architects from Adam to Mackintosh have designed furniture. This is very natural, for the fittings and furnishings within a house should reflect the proportion of the rooms, and thus inevitably the proportion of the exterior.

Some knowledge of architecture, then, can be a help— and far less errors in the attribution of pieces of furniture would be made if the dealers and buyers concerned had any acquaintance with architectural styles. For instance, no one with any real knowledge of Gothic architecture could ever be deceived into thinking that a piece of Victorian Gothic was anything other than a reflection of Barrie's and Pugin's House of Commons.

It is important to acquire some knowledge of woods, woodwork, and the whole craft of the joiner and the cabinetmaker. This is not so difficult as it sounds, for there are few people who are not within walking distance of some kind of woodworker—and it is only a basic

understanding of how wood is treated, and how it can be used, that is really necessary. (No one in their senses will accept a brass screw in a piece of furniture that from its theoretical date and age would have been dowelled, or tongued-and-grooved.) The recognition of the many woods used in furniture is again only a matter of experience. But, just as there are few people who cannot distinguish between walnut and mahogany, so—after a comparatively short length of time—the furniture student should easily be able to recognize rosewood inlay from tulipwood inlay.

'The proper study of mankind is man' wrote Alexander Pope. As a corollary to that, it would be permissible to add—one of the best ways of studying man is to study his furniture.

ILLUSTRATIONS

OF

FURNITURE
AND ITS ORNAMENTATION
1485–1830

WITH
COMMENTARY

GENERAL DETAILS

CASTORS AND METAL MOUNTS

The right metal mounts can contribute greatly to the good
looks of a piece of antique furniture although casters, for
example, may not always be the same date as the furni-
ture they serve. The earliest (1) were swivel jaws with
castor wheels of hardwood, in occasional use from about

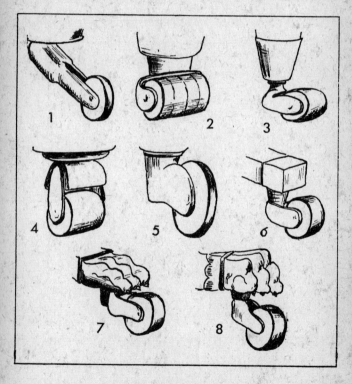

1700. By the 1740s a more practical design had been developed (2) consisting of a broad roller constructed of discs of leather. Brass rollers date from the 1770s. The low-set roller (3) was popular and may be found with a tapering socket for the leg. An alternative was the peg and plate (4). A taller wheel castor (5) may date from the end of the 18th century. The collector is more likely to find designs comparable with figures (6), (7) and (8) which were socketed and given substantial lion paw ornament to fit the early 19th century range of out-jutting feet on sofas and couches, as well as sofa tables and the long-popular style of library and dining table with central pillar and four massive projecting feet.

KEY ESCUTCHEONS

Key escutcheons were more important than handles on much early furniture and make interesting study. Figures 9 to 14 indicate changing moods from Tudor days to about 1700. The key and hasp plate (9) has massive wide-spreading outlines for secure attachment to a heavy chest. (10) is a slimmer alternative. The iron plate fitted flatly to the front of the chest, the locking movement safely sunk into the wood. The additional projecting metal around the cupboard or aumbry keyhole (11) may be found too as a safety measure around a chest hasp, to protect it from being forced. The shield shape was popular in the early 17th century and much care was given not only to the outlines but to the delicate chamfering of the edges. (13) and (14) show the change in style developed in the second half of the 17th century as cabinet furniture covered in decorative veneers of walnut was enriched with mounts of brass. (13) shows early

treatment decorated with engraved lines and punch marks. The more elaborate modelled ornament that developed towards the end of the century included even forms of the crown and cupids or putti design that had proved popular in other post-Restoration furniture work.

Key escutcheons shown in figures 15 to 19 continue the outline through the first fifty or sixty years of the 18th century. (15), (16) and (18) illustrate a fashionable use of keyplates in cast brass following the outlines of accompanying handle plates on chests of drawers and the like, the handles being in the 18th century's newly popular bail shaping. They illustrate the change from simple outlines with bevelled edges to more decorative outlines enriched with surface engraving, and thence to pierced shapes

(1720s onwards). At the same time an alternative to the key escutcheon was a long narrow shape suitable for a cabinet door (17). By the mid-century, when 'Chinese' frets were popular, slightly asymmetrical outlines in the rococo mood (19) became fashionable.

Key escutcheons of about 1750 to 1810 included many extremely handsome, elaborate mounts, especially in the 1750s–60s. These are particularly noticeable on furniture in the 'French' manner—drawing-room commodes and the like. (20) shows an elaborate rococo piece and resembles a design issued by Thomas Chippendale as late as the third edition of his famous *Director* (1762). (21) is a symmetrical shape with something of the French cabochon enrichment found then in furniture carving, while (22) is

an elaboration of C-scrolls, also associated with rococo ornament. Lock plates (23) to (26) reflect the neo-classic fashion that developed in furniture from the 1760s. (23) illustrates the development in the last quarter of the 18th century of mounts shaped by stamping from sheet brass. It must be stressed that the simplest brass keyplates might be used with elaborate handles through the second half of the century (25), and towards the end of the century on such pieces as dressing glasses, the tiny drawers might have knob handles and simple key escutcheons of ivory or bone (24). (26) is a Regency type showing how the ubiquitous honeysuckle might be combined with the bell flower in smooth brass.

HINGES AND METAL WORK

Hinges from Tudor days to the 1660s passed through phases comparable with those noted for key escutcheons. (27) and (28) are examples of iron work with chamfered edges, the straps and flowered heads intended to strengthen chest or trunk. Figure 29 shows a simpler hinge of cross staples from a 17th-century chest lid. On early cupboards the collector may note hinges in the shapes known as butterfly (30), H (31) and cockshead (32), the last a handsome style associated with early 17th-century furniture. In all these examples the hinges are of iron and fixed with nails, not screws.

Developments of brass mounts from the 1660s onwards included delightful hinges in H outline in the later years of the century, either plain (33) or incised (34). (35)

shows a detail typical of the magnificent mounts found on Oriental lacquer cabinets and on their European imitations in the late 17th and early 18th centuries. But it has been thought wise to include also illustrations of two typically confusing mounts from early Victorian days when the romantic mood led to a flooding of the market

with haphazard imitations of 'Gothic', 'Elizabethan' and 'Jacobean' styles. (36) and (37) show the kind of confused elaborations of ironwork that may be found.

Metal work on tables was interesting through and beyond the 18th century. (38) to (40) show table hinges. The rule hinge (38) is for a folding table—that is, a table in which the flap folds back on top of the fixed section. It was of necessity attached to the edges of both sections. The

groove and tongue joint (39) was an early experiment for the junction of a falling flap—hanging down when out of use as in the gate-leg table—and the fixed table top, with the hinge underneath but a little unsightly. In the more lasting fashion known as the rule joint (40) the shaping of top and flap ensured that the hinge remained invisible.

An early use of decorative metal work may be noted on the door panels of lacquer and japanned cabinets (highly ornamental but also taking some of the rub of use (41)), and on the delicate legs of mid-18th-century furniture, such as tables in the 'French' manner (42). (43) shows the substantial style of brass honeysuckle ornament inlaid into the glossy surface of dark-toned Regency furniture and most typical of the metal work of the period.

HISTORY
1485–1660

Styles and construction methods of the JOINER introduced in this early period may be traced through much later work. Here are three details of chest construction showing (44) an early style of boarded chest consisting of vertical and horizontal planks nailed together and (45) a less clumsy development of this with shaped end support and decorative gouge cutting. The fully developed panel construction (46) has corner uprights and crossrails secured by mortise-and-tenon joints (see Tables drawings). These hold the intervening panels without nails or glue so that the wood can respond to atmospheric changes. Below are two details of simple panels (47, 48) showing advance to more decorative detail in moulded edges but retaining the traditional stone-mason's splay at the bottom (49) shows

elaborately mitred projecting ornament in the heavy manner of the mid-17th century.

PANELS offered opportunities for a range of treatment when joiners and their customers accepted the panel construction. Here are three examples of carving: the linenfold retained from late Gothic ornament (50), the somewhat later and more elaborate carving known as the I or parchemin panel (51); and the rounded arch, a Renaissance

fashion of Elizabethan England (52). All would help to counteract panel warping. The flower design (53) is typical of inlay work in ivory, boxwood, etc., or early Stuart days, less elaborate than subsequent marquetry. The panel (54) shows typical mid-Stuart ornament in carefully applied mouldings, and (55) shows details of other glued-on ornament of this period consisting of

spindles and bosses turned in the round and then split lengthways.

Early CHAIRS were massive articles. These three backs show the common Elizabethan style of chairs framed in cresting rail (56), the greater width and elaboration of this

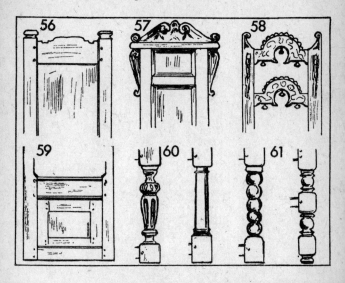

rail in the early 17th century (57) and the development of an open back in a style of 17th-century chair known as the Yorkshire–Derbyshire chair with arching top and cross rails (58). The panelled-in chest-like style of many Elizabethan chairs tended to give place to decoratively turned legs left square as solid blocks to allow for tenoned joints, seat rails and stretchers. Two legs (60) are Elizabethan, and two are in the ball and reel, outlines of Stuart days (61).

PILLAR CARVING at this time (62) shows that this was a period of magnificent uninhibited wood ornament. The early, well-balanced bed pillar (62a) tended to be replaced by the late Elizabethan style incorporating a massive cup-and-cover bulb motif (62b). This motif is shown in the four adjoining details (62c, d, e, f). At its most decorative

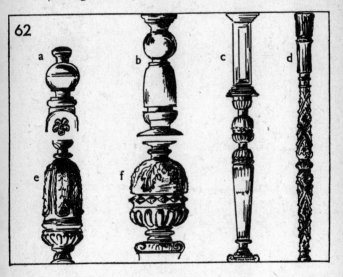

it included a deeply gadrooned 'cover' and acanthus leaf carving on the 'cup'. This tended to be elongated and less deeply carved in the 17th century and on a table leg, for example, one may find the outline turned but not carved, while on cupboard furniture there was a tendency to reduce ornamental pillars to pendant knobs.

At this period great attention was given to the TIERED SIDE TABLE, forerunner of the sideboard and used to

parade a rich man's gold and silver plate and known as a
cupboard. This might consist of several tiers of open
shelves with deep apron friezes. When a frieze included
a drawer this was grooved at the sides to rest upon fillets
of wood in the frieze ends (63). Carving on uprights of

such a cupboard often included the guilloche (64); and
(65) shows the types of decoration found on the aprons
or friezes of the shelves—(a) geometrical inlay, (b) deeply-
projecting gadroon carving, (c) floral inlay, and (d) carving
in the formal patterns known as strapwork.

TABLES, too, changed through this early period from
primitive construction to the substantial mortise-and-
tenon jointing. (66) shows the end of an early table fixed
with pegs for quick dismantling in the big communal hall,
and beside this is shown detail of the peg and stretcher

(67). (68) shows a mortise cut in the side grain of, for example, a table leg, to receive the tenon or tongue cut in end grain, such as the table stretcher. Both show holes drilled for dowel pegs. The shapes of peg and hole, and the exact placing of the holes, determined the lasting

security of such joints. (69) shows details of the low stretchers in moulded or T section found on Elizabethan tables and (70) typical table edge mouldings.

THE LATE STUART PERIOD—CHARLES II TO QUEEN ANNE, 1660–1714

This period witnessed the ascendency of the cabinet maker, influenced by the wealth of new and lavish building. CABINETS themselves acquired a new importance, marked by much interesting cornice detail. The four

silhouette outlines shown in (71) are typical of late 17th century straight-topped cabinet furniture, that on right

including a swell-fronted drawer. (72) shows single and double cornice arches viewed from the front to show the change of outline associated with the early 18th century.

DRAWERS on tallboys and the like acquired a new decorative importance. These five diagrams are of drawers slightly open to show their fronts and the treatment of their surrounds. In the oak tradition of the previous period some drawers were still fronted with raised mouldings (73). But the general interest was in flat-faced walnut veneers for cabinet work (74) and in examples (75) and (76) these are set into half-round and double-reeded mouldings as a slight concession to the earlier mood. In

(78) the drawer front extends slightly beyond the framework of the cabinet, which could then be finished with plain veneering. The ornament was then concentrated on the drawer front itself which, while completely flat, suggests panelling with a cross-grained walnut veneer

border around narrow bands of contrasting diagonal grain known as herringbone or feather pattern. The veneered front to the drawer required a construction change shown in (77): this was from the old simple dovetail on the left to the lapped dovetail on the right that avoided gluing the veneer to end grain of wood.

CABINET LEGS followed much the same changes as chair legs. In the 17th century the stand for a cabinet was

treated largely as a separate entity: in (79) the examples top
left and right show twist turned and cupped knee designs
of the late 17th century with flat, waved stretchers; in
between are ornate legs of stands made for Oriental
cabinets. Below, (left) are two flat board legs cut in

silhouette to suggest more expensive turned work. In the
centre are late 17th-century popular bun foot and the
bracket foot associated with 18th-century cabinets, chests
of drawers and the like. On the right is an indication of
how the cabriole leg, an important feature of the period,
was applied to early 18th-century tallboys, etc.

In CHAIRS, this period saw an extensive change of styles,
materials and methods (80). The main change was from

straight lines (top left) to sloping backs and curving arms which often showed an interesting outward scroll end as well as the elbow dip (top right). The back and seat might be given the resilience of caning (bottom left, centre) and the tendency to greater ornateness towards the end of the

80

century was expressed in extremely tall backs with elaborately carved arching crest rails (bottom right).

The early years of the 18th century saw greater comfort for the sitter's back including the upholstered wing chair (81, top left) and various designs of simple splat. In the centre top the four lines indicate the changes in the general shape of the chair back from cresting rail to floor level through this period, culminating in the back-fitting waved splats.

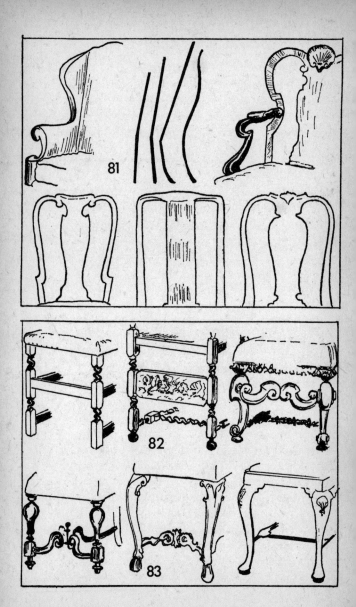

CHAIR LEGS shared the change to more ornamental curves and thence to simpler curving outlines. Here (82) are three examples of increasing complexity of leg and stretcher towards the end of the 17th century, with the front stretcher plain at first, then wide and carved, often with the crown-and-cupids motif and later in S-scroll outline. Below (83) are, front left to right, the end-of-century swelling legs and diagonal stretchers, followed by the development of the cabriole leg, still often with stretchers but with ornament mainly concentrated on the shell or leaf carving on the out-curving knee. The hoof was an early foot to the cabriole leg but the most enduring favourite was the simple pad (right).

Among much occasional furniture, LONG-CASE CLOCKS became important items of furniture in this late Stuart

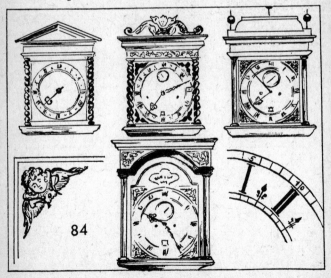

period. Here (84) the top illustrations show characteristic features of hood and dial of around 1670, 1700 and 1710, contrasted with the arched dial below of the following period, introduced around 1720. To the left of the arched dial is a spandrel for the corner of the dial: this was at its simplest in the early 'winged head' design; the dial detail (right) shows early features before the Arabic minutes figures became disproportionately large.

TABLES included many folding designs for occasional use (85). The two specimens (top) have tops folding back on themselves in contrast to the falling flaps of the gateleg

85

table. They are for writing and for cards but when closed would serve as attractive side tables. The lower diagrams show alternative support arrangements, the heavy

representing the underframing and the dots the leg movements. The card table (lower right) has a double-hinged underframing to extend the legs.

ORNAMENT of this period was dominated by the technique of veneer, at its most elaborate when the thin covering of decorative wood was composed of numerous small fragments in contrasting tones known as marquetry (86). The flower spray (top left) was a colourful Dutch notion soon

86

followed in England by leafy arabesques (top centre). Geometrical patterns (top right) in light and dark woods might be inlaid into solid wood or introduced as part of the veneer. But other cabinet makers used the natural grain of the wood veneer to compose balanced patterns known as parquetry (lower left and centre). The oyster

pattern (left) was often composed of veneers cut from a
branch of laburnum. The escallop shell (right) is typical
of the period's carved ornament.

The Early Georgian Period—1714-60

This vastly important period saw a general change to more
angular outlines, as expressed in PEDIMENTS for cabinet
furniture (87). Especially popular was the broken pedi-
ment with central finial, and this strong architectural

87

outline was often stressed by dentil moulding and classic
carved detail such as the egg-and-tongue motif (top right).
The broken pediment with curving scrolls was known as
the swan-neck (bottom left). The pagoda top beside it
(bottom right) was a 'Chinese' whim of the mid-18th
century.

CABINET MOULDINGS reflect a gradual change from walnut veneers to substantial mahogany. Here ((88) top left and top right) are shown chamfered corners of tallboys veneered in walnut with, between them, equally typical moulding work in solid mahogany. Below are contrasting

88

treatments of the mid-century for a corner of a fashionable bombé commode (left) and a pilaster-cornered desk (right). Between them is a drawer front showing the simple cockbead edging that became general during this period.

CABINET GLAZING was revolutionized by the development of mahogany. The two drawings show the heavy walnut-veneered bars of the beginning of the period (top left) and

the delicate frets achieved in mahogany at its end (top
right). Between are details of moulding bars in silhouette.

Below are mirror crestings: in early Georgian gesso (left),
in mahogany flat-cut in the mid-century manner (centre),
and in the full splendour of rococo carving (right).

CHAIRS at their most splendid (90) include ornate de-
velopments of the splat back-carved (top left), pierced
(top centre) and both carved and pierced in ribbon pat-
tern (top right). Below, the ladder back (left) might be
pierced as here shown, too, and there was a vogue towards
the end of this period for 'Chinese' frets (centre) and
'Gothic' church window outlines (right).

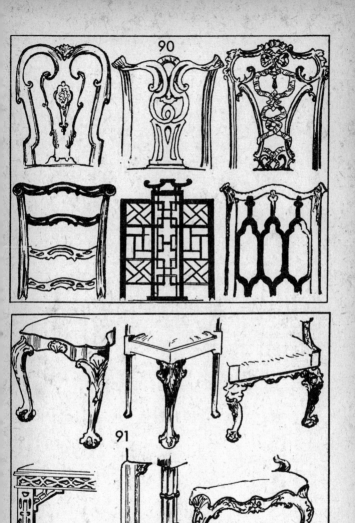

CHAIR LEGS showed elaboration of the cabriole outline often richly carved in mahogany and free of stretchers (91). The top row shows a single chair with waved seat rail (left), a corner chair for a desk (centre) and a low-set easy chair (right). Below are mid-century notions: the 'Chinese' fret piercing applied to straight—not tapering—leg and seat rail (left); two 'Gothic' legs in cluster-column style (centre), and the lighter interpretation of the cabriole known as the French leg (right).

Chairs for less wealthy households (92) included various spindle backs (top left, right) and ladder backs (top centre)

92

with straightforward legs and stretchers and the range of Windsor types (below) that had comb back (left) or hoop back (right) dowelled into a saddle-shaped seat, as shown

in the centre. At the bottom (centre) is a detail of a projection at the back of the seat designed to receive additional diagonal struts behind the splat for greater strength to the backward-slanting back.

Some TABLES (93) had massively carved legs, as in the card table and side table (top left and centre), in contrast to the delicate perforations and slender cluster-column legs of some serpentine-shaped occasional tables (top right). For dining, the gate table (bottom left) had falling flaps

and two of its four legs hinged to open (thus differing from the gateleg table which had additional legs for supporting the flaps). Pillar and claw tables, now sometimes known as tripod tables, became popular: a notable detail here (bottom right) is the elaborate 'birdcage' sometimes

found under the top, that allowed the top to be lifted off if the sideways wedge was withdrawn.

FURNITURE FEET of this period (94) might be as simple as the pad (top left) or carved as lion paw (top 2nd left) or ball-and-claw (top 3rd left) and formal variants (top right). In the centre row the Spanish foot (left) lingered

from the previous period. The early heavy scroll (centre) was developed into particularly graceful scroll and knurl designs (bottom left and centre) while for cabinet furniture the bracket foot might be given an ogee curve or show chamfered corners (bottom right).

ORNAMENTAL DETAIL (95) at this period was dominated at first by the architectural mood of cabinet furniture and

side tables and the like might also show such motifs as the Vitruvian scroll (top left), egg-and-tongue (top centre), and dentil moulding (top right) and the variations of the Greek key pattern shown immediately below (centre). Minor ornament included bead mouldings (centre right) for mirror fillets and the like. All this was in contrast to the more fantastic ornament introduced in many minor rooms around the mid-century such as 'Chinese' angular frets (bottom left) and 'Gothic' church window notions (bottom right) and such carved motifs as the French-style cabochon (centre bottom).

THE LATER 18TH CENTURY 1760–1800

PEDIMENTED FURNITURE expressed the fashion of the period for sweeping curves and urn finials in contrast to

the rococo fantasies of the immediate past. The changes
within this period to more supple grace of line may be
noted by comparing the upper and lower pediments
shown in (96), and also the central detail of moulding—

96

typical heavy leaf carving of the third quarter of the
century (centre top) and equally typical arcaded 'pear-
drop' moulding fashionable in the fourth quarter (centre
bottom).

In CHAIRS the general change at first was from the broad-
topped cupid's bow cresting to softer, more rounded out-
lines. The massive cabriole leg acquired the more graceful
curve, often called the French leg, with a scroll or knurl
foot. Here (97) are shown, from left to right, two scroll
feet and an inward-turning knurl foot; also the straight

tapering leg that went with other neo-classic detail. On the right are two examples of typical treatment for more workaday chairs for dining, etc.; where instead of low-relief neo-classic carving, there might be wave moulding or merely edge-chamfering and where stretchers were often used for greater strength, usually in H form with the cross stretcher set back a little from the front.

Many handsome CHAIRS are associated with the 1770s
and 1780s in lighter and more flowing lines. Here (98)
left and right are shown typical treatments, the whole
line of arm, seat rail and leg being regarded as a unified
composition. The lyre back (upper centre) was popular,
sometimes with wire 'strings', while for comfort there
was (below) the wide, low bergèe chair. Ornament in-
cluded reeding and carving in low relief.

Chairs in the last years of the century were generally
squarer than before, with short backs (99) top left and
centre, sometimes showing horizontal or diagonal (top

99

centre) bars instead of a central splat, and with high-set
arms forming squarish outlines with their vertical sup-
ports (bottom left). The mood was somewhat severe in

contrast to the preceding ovals and vase shapes; but legs showed a change from the tapering square-cut outlines of the preceding years and were more often shaped by turning, still tapering and sometimes reeded with notably delicate treatment of the vase-shaped foot. Here (bottom centre) these details are shown in contrast to the period's farmhouse and garden chair in Windsor style (top and bottom right) with saddle seat and often with hooped back to enclose a splat and plain turned spindles. The popular wheel splat here illustrated is an end-of-century introduction, often found, too, in modern work. The legs below, dowelled into the saddle seat, are linked and strengthened by the 'crinoline' or 'cow's horn' stretcher, consisting of a hoop linked by short diagonals to the back legs.

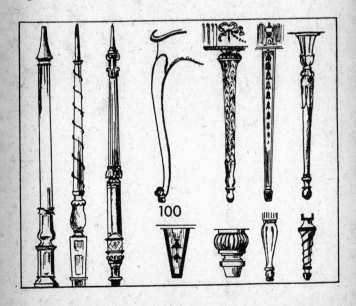

100

PILLARS for beds and the LEGS and FEET of contemporaneous chairs, tables and similar furniture show much sharing of a very limited range of detail (100). The three bed pillars here (left) show the changes in fashion observed in work inspired by patterns published by Chippendale, Hepplewhite, and Sheraton. To the right are typical table legs, all tapering, but showing the gradual change from the 'French' modification of the cabriole through square-section to more slender turned design. The tapering, symmetrical feet below are from the period's chest furniture, never more delightful in their delicate ornament.

The SIDEBOARD in previous periods had been merely a side table, but this was now developed (101). The three

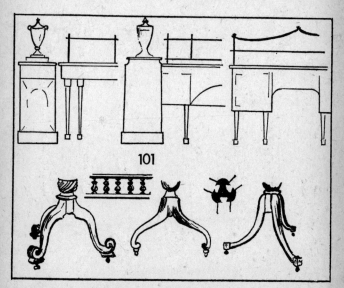

101

upper sketches show: the table flanked by urn stands; the table and stands combined as a unit; subsequent popular modification of this design. Below is shown how the pillar-and-claw or tripod table developed. The legs' bold 'grip' dwindled into more effeminate curves. Between these legs are shown details of the popular spindled gallery often found on such a table and a note of the way the legs or 'claws' were dovetailed extremely effectively into the base of the pillar.

CHEST FURNITURE (102) was generally capacious and well-constructed. Under the table top, often in serpentine

102

outline in the 1760s and 1770s, there might be concealed dressing table fitments, including folding mirror and compartments for toilet preparations, so that a single

room could be used for dressing and for entertaining guests (top left). The bureau desk (top right) often had a cylinder lid late in the century, curving back inside the body of the piece. Below (left) is shown part of a 'library table' and part of a lighter chest of drawers (right), indicating the range of treatment for drawer-furniture. The tambour cupboard (centre) was a late detail in sideboards, wash-stands and other pieces. The door was flexible and conformed to a curved outline by being composed of narrow vertical slats.

MIRRORS of this period are interesting (103). The flamboyant rococo asymmetry of the period before had

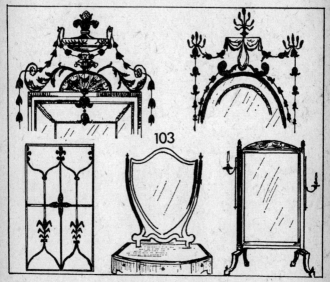

103

set an example of richness now continued in the carefully symmetrical detail of neo-classic urns, swags, trailing

bell-flowers, husks and the like, much of it in gilded composition over cores of wire. The glass might be rectangular or elliptical (top left, right). Late in the period cabinet glazing bars also tended to be decorative, overlapping the glass where previously they had been severely functional (bottom left). Toilet glasses might be elliptical, or in the shield shape then known as a vase shape (bottom centre), and were augmented by long 'horse' dressing glasses (bottom right). (The use in England of the term 'cheval' came later.)

ORNAMENT on expansive furniture surfaces (104) such as commodes and wardrobes might be composed of applied

104

mouldings, gracefully carved (top left); or panel moulding might be suggested by flat veneer borders as it had been

early in the century (top right). The 'panels' now might be elliptical, and a favourite outline on much provincial furniture was the line of dark and light chequers known as 'stringing'. But much ornament, whether inlay, marquetry or paint, kept to the neo-classical favourites of urn, bellflower, and honeysuckle (bottom centre). The marquetry conch shell (bottom left) was popular (contrasted with the escallop shell of the century's beginning) and conventionalized flower and fan motifs (bottom right) are innumerable, the wood often shaded.

THE REGENCY PERIOD, STRICTLY DATING TO 1810–20 BUT NOW MORE USUALLY CONSIDERED IN FURNITURE STYLES TO COVER THE YEARS FROM ABOUT 1800 TO 1830

CABINET DETAILS show the prevailing taste for low, wide furniture with little ornament to detract from its smooth

105

veneers (105). Above are three typical bookcase or cupboard heads including the honeysuckle motif, again in favour. Below, the love of brasswork is shown in two designs for wire grills, frequently substituted at this time for wooden bars and glass. The mirror (bottom centre) is the popular convex type with balls set in the gilded frame and surmounted by a statuesque eagle.

CHAIRS at their best are distinctively different from those that came before and after. Their inspiration was derived from the period's more archaeological approach to the classic mood, as distinct from the casual liking for neo-classic ornament that pervaded the previous period. The models were still Greco-Roman but design was considered as well as ornament. Animal heads and paws are often noted. The details here (106) are typical of arms and

backs, showing the liking for a wide, low cresting rail,
high square-cut arms and often upholstery between arms
and seat as well as on part of the back, although a lighter
alternative here was caning which was in fashion once
again.

The three CHAIR BACKS shown here (107) indicate popular
ornamental treatments. The medallion cresting (top left)
is painted with a classic scene; the partly-upholstered
central specimen has the incised 'rope twist' detail of

107

around 1805; the broad, curving cresting (top right) is
ornamented with metal inlay. Below, leg details include
typical forward and outward curves, often associated with
dipped seats. The straight legs with heavy reeding or
turning are associated with the late years of the period.

Five typical CHAIR OUTLINES that indicate the exciting notions of the Regency (108). These are single chairs and are particularly interesting for their ways of associating back and seat rails while including the back-swinging

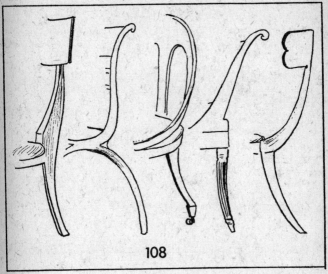

108

back leg, then fashionable. These are exceptionally pleasing to the eye, but presented many problems to the chair-maker, and were soon superseded by the more conventional outlines of the early Victorian chair.

COUCHES AND SETTEES were popular and designs derived from classic sources. Some collectors differentiate between the design for lying on—the couch or sofa with one high scrolling end and one lower end sometimes entirely lacking a scroll support—and the settee, a widened chair intended to accommodate several people sitting up, which

was entirely symmetrical. Here (109) the sofa end (top
left) and the settee end (top centre) show contrasting leg
designs; the third alternative in settees was the type of

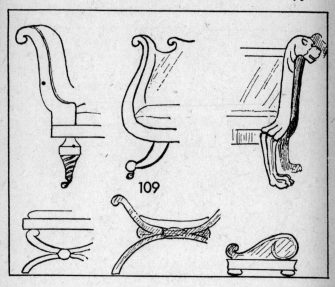

109

support known as the lion monopodium with lion's head
and massive paw shaped as a single unit (top right).
Below, outlines taken from classic sources are shown in
the period's popular stools (left and centre) and footstool
(right).

LIBRARY FURNITURE (110) such as heavy desks and com-
parable low book-shelves included many styles of tapering
pilaster work so that essentially rectangular pieces of
furniture could present something of the tapering sil-
houette then admired. This was presented in, for example,
the sideboard pedestal (top right). Here the pilasters (top

left and third left) include fluted pillar and simple rope twist. The most ambitious was the Egyptian part-figure with head and bare feet carved in full detail (top second left).

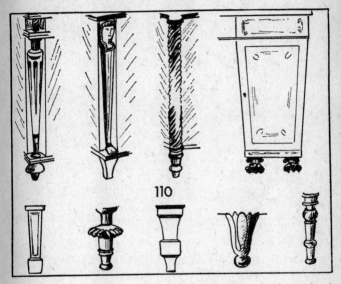

110

Below are cabinet furniture feet including the lotus bud design (second from right). But much cabinet work was mounted on solid plinths and it is rare to find the brackets or French feet of the previous decades.

Regency TABLES included many long trestle styles (111). Above are three typical table ends, which were frequently linked by long central stretchers. The sofa table is often found with end flaps supported on fly brackets, and fitted for games with reversible chess boards and compartments for games materials. Tables for the centre of the room (bottom left and right) show

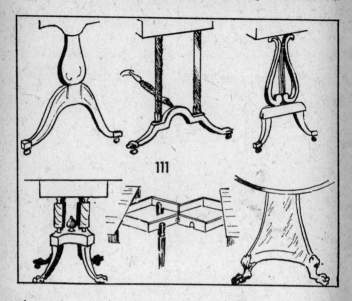

111

alternatives to the most usual single pillar on four claw feet. In the centre is a detail of a dining table showing the extension of the framework in the middle, on the lazytongs principle, that allowed for insertion of additional table leaves.

ORNAMENT in the Regency period (112) showed great use of classic motifs, including much flat brass inlay (left centre) that went splendidly with the heavy tones of rosewood and mahogany without breaking the smooth outlines. Some ornament, such as unambitious leaf patterns, was more cheaply applied with paint, a notion continued from the previous period and found on chair backs, light little secretaires, and the like (top left). The honeysuckle remained widely popular and is shown here

112

as part of a familiar ornament for such pieces as the aprons of sofa tables (top right) and more simply as a single motif quickly stamped from metal and as easily applied to chair back or table leg (bottom right). The caduceus motif (bottom left)—staff of Mercury, herald of peace—is also often associated with this period. Lower centre is an example of a change of approach to ornamental detail, the desk pigeon-holes being topped by painted representations of draped swags.

In carved ornament (113) the collector is particularly aware of a lack of imagination, so that a few acceptable motifs are overworked, especially such details as hoof and paw feet (top left, second left) and the more ambitious lion monopodium (top right centre). Sometimes in this the animal's head and paw were separated by heavily carved

classic acanthus leaves (top right). Below (left, centre) are
details of the Egyptian figure motif found on desks, beds,
bookcases, occasionally in full relief pillar work. The most
enduring favourite, however, was the lion's head in full
relief as a corner ornament. In brass, with a ring between
its teeth, it was endlessly popular ranging in size from
drawer handle to door knockers (bottom right).